Sabine Seymour

Fashionable Technology
The Intersection of Design, Fashion, Science, and Technology

 Springer Wien New York

Fashionable Technology

The Intersection of Design, Fashion, Science, and Technology

Sabine Seymour
www.fashionabletechnology.org, www.moondial.com

This book is sponsored by

ImpulsProgramm creativwirtschaft
by austria wirtschaftsservice

bm:uk

Bundesministerium für
Unterricht, Kunst und Kultur

www.ufg.ac.at

Kunstuniversität Linz

Kulturabteilung der Stadt Wien,
Wissenschafts- und Forschungsförderung

© 2008 Springer-Verlag/Wien
Printed in Austria
SpringerWienNewYork is a part of
Springer Science + Business Media
springer.at

Cover Image
Philips Design
Back Cover Image
Gene Kiegel, www.genekiegel.com
Graphic Design
Mahir Mustafa Yavuz
Research Assistance
Hannah Perner-Wilson
Copy Editor
Kai Eric Hylfelt

Printing and binding: Holzhausen Druck & Medien GmbH, 1140 Vienna
Printed on acid-free and chlorine-free bleached paper

SPIN: 12530687
Library of Congress Control Number: 2007933580
With 267 colored figures
ISBN 978-3-211-74498-7
SpringerWienNewYork

Contents

Preface

Fashion and technology, science and design are contrasting notions that will be explored in this work. The idea for this book arose a few years ago when I realized the need for reference material for my students and fellow researchers. In addition, I wanted to convey my concept on the amalgamation of technology and fashion. Over the years more people and more people have become interested in the ever-expanding field of fashionable technology. Some approach it purely with regard to future style while others are drawn to its technical potential and the combining of 'hard' technology with 'soft' textile. The many precedents that were brought to my attention resulted in a proposition to create a comprehensive collection of projects and resources about fashionable technology.

The theoretical discourse in this book intends to provide an initiation to fashionable technology. It addresses the major concepts and provides a detailed bibliography that points to additional publications. The list of materials, blogs, institutes and events affords a starting point for further explorations in this expanding field. Many of the projects in this book are conceptual in nature and others are actual commercial products. However, all capture the imagination in their various proposals on the future meaning and purpose of clothing. Some of the projects were slightly difficult to categorize singularly as they incorporated aspects that were applicable to diverse chapters yet all of these projects are inspirational and stimulating.

This book aims to present a compact body of work in the field of fashionable technology.

CHAPTER **ONE**

1 Theoretical Discourse

I Fashionable Technology

Fashionable Technology[1] refers to the intersection of design, fashion, science, and technology.

Fashionable Wearables

Fashionable wearables are 'designed' garments, accessories, or jewelry that combine aesthetics and style with functional technology.

As designers of fashionable wearables, we view end users as fashionable beings who are attentive to style and the powerful potential of wearable technologies. Our design philosophy is based on the notion that garments are the immediate interface to the environment and thus are a constant transmitter and receiver of emotions, experiences, and meaning.

> '... the electric age ushers us into a world in which we live and breathe and listen with the entire epidermis'[2]

Marshall McLuhan's observation describes the garment as being an interface to the exterior mediated through digital technology. Fashionable wearables have great expressive potential that is amplified through the use of technology. The limitless possibilities for the immediate dynamic personalization of clothing are fascinating and current experimentation in the area is showing great promise. Today, fashionable wearables are mediators of information and amplifiers of fantasy.[3]

In our contemporary world fashion is synonymous with style, dress, adornment, decoration, and clothing. As a communication medium it has unlimited potential. Many wearers of technology are engaged through the mechanisms of fashion. However, fashionable wearables are much more than mere fashion. They incorporate technological elements that transform them into interactive interfaces.

1 Sabine Seymour coined the term Fashionable Technology in 2000.

2 McLuhan (1995, 122)

3 In chapter 11 Rheingold (2000) addresses Alan Kay's characterization of a fantasy amplifier.

I Context

'An aesthetic explanation is not a causal explanation.'[4]

The context of use is tremendously important when creating meaningful fashionable wearables. While aesthetically pleasing design is an integral part of the success of a fashionable wearable, the context truly determines the functional and expressive definition of a fashionable wearable. Early wearables were functional but awkward to wear and to look at. Today wearables are rapidly rising to meet the fashion world on its own terms by producing garments that are both stylish and comfortable. Personalization of wearables allows for new modes of self-expression, which is an essential factor in making fashion items that appeal to the public.

Functions

'All clothes have social, psychological and physical functions.'[5]

Through technology the functions of clothing can be enhanced and new ones are defined. Material (or physical functions) functions are protection, concealment, and attraction. Cultural functions (including social and psychological functions) are communication, individualistic expression, social or economic status, political or religious affiliation.[6]

Fashionable wearables can enhance the cognitive characteristics of our epidermis. Our clothing is often referred to as our second skin. Today this is more than just a metaphor as advances in technology produce fabrics that mimic many of the skin's properties.

4 Wittgenstein, Ludwig edited by Barrett, Cyril (2007, 18)

5 Bolton (2002, 10)

6 Barnard (2002, 49–71) describes the various functions of clothing.

Fashionable wearables range in levels of expressiveness versus functionality.

expressiveness functionality

1 The fashionable wearables in the high fashion realm are expressive and the functionality is less important.
2 The fashionable wearables have a defined function and some need to be stylish. Sportswear and health-monitoring garments require this duality.
3 The functionality is the focal point. In workwear the necessity for personal expression is limited by strict pre-defined functionalities and restrictions.

Degree Of Body & Technology Integration

» Handheld (i.e. mobile devices)
» Wearable (i.e. fashionable wearables)
 » Clothing is the container for technology
 » The technology is physically embedded into clothing or textile substrates
 » Technical and scientific advances are integrated into the fabric
» Implanted (i.e. implants, tattoos)

The current degree of integration between the body and technology demonstrates the level to which our bodies are rapidly becoming extensions for technical advances.

I Technology

Technology and fashion are not as distant from each other as it might first seem. The thread-up and thread-down of the weaving process corresponds to the 0 and 1 binary logic of computer circuitry.[7]

Wearable Computing

Ed Thorpe and Claude Shannon revealed the first wearable computer in 1966. It was a cigarette-pack sized analog computer with four buttons to indicate the speed of a roulette wheel and the predicted results were transmitted by radio to an earpiece. In 1981 Steve Mann created a backpack-mounted computer to control his photographic equipment. [8]

> 'A wearable computer is a computer that is subsumed into the personal space of the user, controlled by the user, and has both operational and interactional constancy, i.e. is always on and always accessible.'[9]

The term 'wearable technologies' refers particularly to the electrical engineering, physical computing, and wireless communication networks that make a fashionable wearable functional. Today, the development rate of wearable technologies is accelerating rapidly and our vision is becoming reality. Processing power is doubling at light speed, components are miniaturizing, alternative energies are becoming viable options, and ubiquitous computing is pervasive.

Embedded Technologies

Embedded technologies influence the wearability, comfort and aesthetic of a fashionable wearable. The incorporation of technology depends on the context of use and the desired interaction between the fashionable wearable and its surrounding environment. The main technical components[10] used for the creation of fashionable wearables are:

7 Seymour, Sabine in Lumsden (2008)

8 Rhodes, Bradley: A brief history of wearable computing: www.media.mit.edu/wearables/lizzy/timeline.html (1998)

9 Mann, Steve: Definition of Wearable Computer: http://wearcomp.org/wearcompdef.html (1998)

10 O'Sullivan & Igoe (2006) offer an overview of all components used in physical computing.

» Interfaces (connectors, wires, antennas, …)
» Microprocessors
» Inputs (sensors, …)
» Outputs (actuators, …)
» Software
» Energy (batteries, solar panels, …)
» Materials (electronic textiles, enhanced materials, …)

The microprocessor is a single-chip computer that can run and store a program. It collects and computes data derived through various interfaces from the input sources. This computation is necessary to address the outputs on either the garment itself or to signal external devices. Cell phones typify external devices that are able to compute and deliver extensive data through diverse communication networks.

▌Inputs

The required interaction with the fashionable wearable determines the input and output. Active inputs can be consciously controlled by a wearer using a tactile or acoustic feedback system that allows an intuitive use of the garment. Passive inputs are typically biometric data gathered from the body or automatic data feeds via wireless transmission using environmental data.

Origin	Inputs (Examples)
Person	pressure, bend, motion, biometric data, sound, visuals, humidity, proximity, orientation, displacement, smell, acceleration
Environment	light, humidity, sound, temperature, smoke, micro-particles, visual

Textile Sensors

Body-sensing technologies must be close to the skin to be effective and are the perfect candidates for integration into a textile. 'Fibre sensors, which are capable of measuring temperature, strain/stress, gas, biological species and smell, are typical smart fibres that can be directly applied to textiles'.[11] Through textile sensors our physical and emotional state can be captured through the ever changing properties of our epidermis. Sensors can detect blushing, sweating, and variations in tension and temperature. The actuators then respond by producing specific types of output.

Embedded Sensors

Today many fashionable wearables are using conventional sensors to capture data. These sensors are embedded into the fashionable wearable and their proper placement on the garment is essential to be able to capture the requisite data. Typical embedded sensors measure a variety of data types ranging from proximity to smell. They can collect data derived from the human body as well as environmental data like light, humidity, temperature, sound or smoke. The data is captured as input and computed using a microprocessor.

11 Tao (2001, 4)

▌Outputs

A garment is seen, felt, touched, heard, and smelled. The many output options can stimulate any of our five senses.

- » Touch
- » Sound
- » Visual
- » Scent
- » Taste

The variables captured from the input sources are software-based data and consequently allow computation that in turn determines the output. Outputs can stimulate the senses of the wearer or his audience. For example shape memory alloys change the silhouette of a fashionable wearable making it a visual interface for an audience and a tactile experience for the wearer. In another case a motor, initiated by data processed via a microprocessor, activates scent capsules. The options are endless and depend on the requirements. The table below provides suggestions for outputs to address specific senses.

Sense	Ouputs (Examples)
Visual	LEDs, thermochromic inks, photochromic inks, EL wires, E-ink, (alphanumeric) displays
Sound	speakers, buzzers
Touch	motors/actuators, shape memory alloys, conductive yarns, conductive fabrics
Smell, Taste	scent capsules

I Communication

The simple act of showing or sharing emotion takes on new meaning when two people are connected via a wireless network. If one thinks of the other the jewelry or garment can now react. This immediate feedback over distance can be achieved by wearable technologies and wireless communication.

Ubiquitous Computing

At the Xerox Palo Alto Research Center Mark Weiser coined the term 'ubiquitous computing'.[12] Ubiquitous means that computing is seemingly present everywhere, but in the case of wearables it is actually embedded in clothing and accessories. Wearables are true extensions of the idea of incorporating ubiquitous computing into our everyday objects. In the late 1990s IBM coined the term 'pervasive computing', which is often used synonymously with ubiquitous computing.[13]

Wireless Communication

Wireless communication allows for the transmission of data without the use of wires. The ability to distribute data over wireless networks from a system attached to the body was a significant turning point in the development of wearables. Below is a list of the most common wireless communication and navigation systems used in the design of fashionable wearables.

- » UMTS (Universal Mobile Telecommunications System)
- » GPRS (General Packet Radio Service)
- » GMS (Global System for Mobile communications)
- » WIFI
- » Bluetooth
- » IR (Infrared)

Location-based:
- » GPS (Global Positioning System)
- » Cell triangulation

12 Weiser, Mark: The Computer for the 21st Century In Scientific American: http://nano.xerox.com/hypertext/weiser/SciAmDraft3.html (1991, 94-100)

13 Hansmann (2001, 11)

On The Body

Thomas Zimmerman and Neil Gershenfeld conceived the term Personal Area Network (PAN) at the MIT Media Lab in 1995. It describes a concept for transferring data using the body's own electrical conductivity. Today PAN is used to describe self-contained networks on the body. The term Body Area Network is used similarly and was derived from the medical field.[14]

The transfer of data captured from the body can be transferred via a wide range of networked communication protocols over distances. In addition the data can be distributed on the body through textile-based conductive wires or transmitted via textile antennas.

14 Lee (2005)

I Materials

The use of enhanced materials and textiles in conjunction with current research in nanotechnologies, biotechnologies, and digital technologies will lead us to a fashionable wearable that is a true integration of essential function and aesthetic design.

Electronic Textiles

Technically enhanced textiles are significant enablers in the creation of fashionable wearables and are generally referred to as electronic textiles. 'An electronic textile refers to a textile substrate that incorporates capabilities for sensing (biometric or external), communication (usually wireless), power transmission, and interconnection technology to connect sensors and microprocessors to allow such sensors or things such as information processing devices to be networked together within a fabric.'[15]

Nanotechnology & Microfibers

Nanotechnology operates on a molecular level. Carbon nanotubes can provide thermal and electrical conductivity while allowing the textile to maintain the touch and feel of a typical textile.[16] The manipulation of molecules produces microfibers. The microcapsules in microfibers can contain a variety of active agents such as medication, vitamins, anti-bacterial products, or moisturizers. Microencapsulated PCMs (Phase Changing Materials) can be applied as a finish on fabrics or infused into the fibers during the manufacturing process to provide a buffer against temperature swings.[17]

Biomimetics

Biomimetics is an area of biotechnology where the processes and properties of nature are being mimicked through the use of bioactive materials. We now have the capability to grow our own versions of nature using tissue engineering and culturing materials from live organisms like spider silk, human skin cells, and transgenic goats.[18]

15 Berzowska, Joanna in Jeffries (2005, 60)

16 www.nanotex.com

17 www.outlast.com

18 Braddock Clarke & O'Mahony (2006)

∎ Energy

The computation of captured data through microprocessors on the body requires energy that today is delivered primarily by batteries. However, a battery's life is limited and its effects on the human body have yet to be evaluated in depth. The quest for alternative energy sources for fashionable wearables is essential. Developers of fashionable wearables will have to find new and improved solutions to acquire the needed energy that will allow microprocessors to operate reliably.

Alternative Energy

Organic photovoltaics can generate enough electricity to charge a battery worn on the human body while allowing for a more sustainable approach. Solar energy is frequently used as a power source and uses solar panels incorporated onto the surface of a fashionable wearable.[19]

An interesting and attractive alternative energy source for intelligent clothing is the human body itself, which can generate power derived through body movement or fluctuations in body temperature. Today the energy that can be harvested through human kinetics or bodily heat-exchange can only be measured in microwatts. Thus it is currently too small to drive wearable technologies. True sustainable energy production for wearables has still a ways to go despite recent breakthroughs in fuel cells and energy harvesting fiber-based nanogenerators.

[19] Stuart, Irvine in Kasap & Capper (2006)

I Garment Construction

Embedded technologies in the garment and the functionalities integrated into the electronic textiles influence the 'wearability'[20], comfort and the aesthetic of a fashionable wearable. Considering these factors is an essential part of the design process when creating user-centered fashionable wearables. Designers have to have a comprehensive understanding of the purpose, the user, the interaction, and in commercial applications, the right price point. An appealing design in combination with an intuitive interface will make for a successful fashionable wearable.

Design Considerations

The many considerations for the construction of fashionable wearables are based on body ergonomics, perception, functionality, technology, materials, energy and environmental impact. The table below can be used as a guideline for the construction of fashionable wearables.

Factor	Considerations
Body ergonomics/ wearability	placement, form language, human movement, proximity, sizing, attachments, weight, accessibility, heat, body shape, comfort, cut of the garment, compartments
Perception	aesthetics, look & feel, design, cultural and psychological functions
Functionality	usable interaction with the system (inputs & outputs), wearer's control, modular construction for multi-purpose
Technology	ubiquitous computing, sensor technology, embedded systems design, physical computing
Materials	interactive or reactive materials/textiles, electronic textile, washing/cleaning, shielding, durability
Energy	batteries, solar, kinetic, fuel cells
Recycle	ecological, biodegradable, modular construction for dissemble

20 Gemperle, Francine et al: Design for Wearability:
www.ices.cmu.edu/design/wearability (1998)

Garment Interfaces

Basic clothing as a wearable is thousands of years old. Our interaction with conductive metal-based buttons, zippers, or hooks has become intuitive and these items can easily be modified to act as switches that close or open an electronic circuit. Traditional garments can be great interfaces that can be modified for use as a fashionable wearable.

Modularity

The cut of a fashionable wearable should allow for the incorporation of a modular system to house the supporting computer components. These components need to be able to be easily exchanged or replaced due to changes in standards, failure, or the simple fact that the garment may need to be washed.

I Issues

Interdisciplinary

'a fashion designer creating a new collection might be slightly puzzled by the engineer's use of the word design'[21]

The emergence of conductive and electronic materials demands a greater collaboration between scientists, technologists and designers when creating wearables. The 'technocraft'[22] and do-it-yourself (DYI) movements combine various disciplines in their work and cultivate the beginnings of interdisciplinary collaborations.

Life Cycles

Clothing and technology have different life cycles. An electronic component may have an estimated life span of 3 years or more and a typical article of clothing might be disposed of after a couple of seasons. Making a workable integration between the two is a challenging preposition. In addition, garments are generally produced in the thousands versus electronic components, which are produced in significantly larger numbers for cost efficiency due to a much longer R&D phase.

Recycling & Health

Energy for smart garments usually comes from batteries, which are thrown away once their lifespan expires, causing huge environmental problems. The life cycle of digitally enhanced devices is getting shorter and shorter. What happens with all the potentially hazardous components?

The health implications of fashionable wearables have yet to be researched. The issues around electromagnetic frequency, battery leakage, and the signals of wireless communication remain points of controversy among scientists.

21 Lawson (1997, 3)

22 Marcus Fairs describes the technocraft movement in the article Technocraft in Wallpaper magazine, March 2007.

CHAPTER **TWO**

2 Electronic Fashion

Hussein Chalayan
London, UK

Biography: Hussein graduated in 1993 from London's Central St Martins School of Art and Design and launched his own label in 1994. He uses film, installations and sculptural forms to explore perception and the realities of modern life, with particular interest in cultural identity, migration, anthropology, technology, nature and genetics. His work is presented at his shows and in art galleries, while his clothing is available in boutiques worldwide. Hussein has directed several short films. Sponsored by Turquality, he represented Turkey in the 2005 Venice Biennale with Absent Presence, featuring Tilda Swinton. In 2005 the Groninger Museum in the Netherlands hosted a ten-year retrospective of his work. In 2006 Hussein Chalayan was awarded an MBE in the Queen's Birthday Honour's list. Soon after he was also awarded Design Star Honoree by The Fashion Group International in New York.

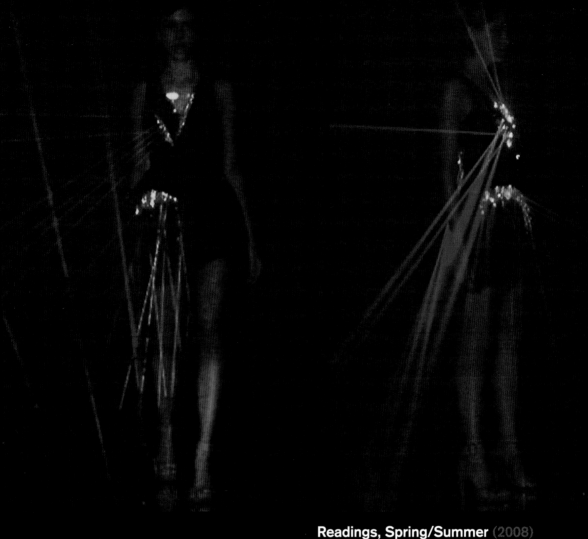

Readings, Spring/Summer (2008)

London, UK
with Swarowski, ShowStudio

Keywords: light, laser, crystals

Readings is the title of the Spring/Summer collection and is also a film collaboration with leading crystal innovator Swarovski and Nick Knight's fashion broadcasting company SHOWstudio. The highlight of the collection is inspired by ancient sun worshipping and contemporary celebrity status. Laser lights are beamed through Swarovski crystals, reflecting light from the garment and bouncing it off mirrors surrounding it, thus representing the interplay between the scrutinized figure and the audience.

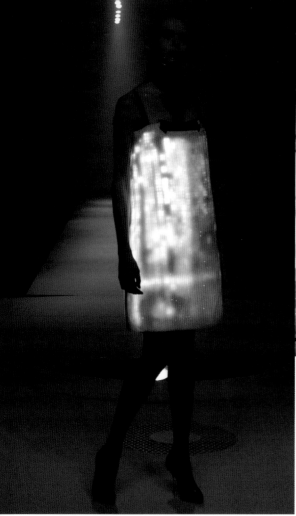

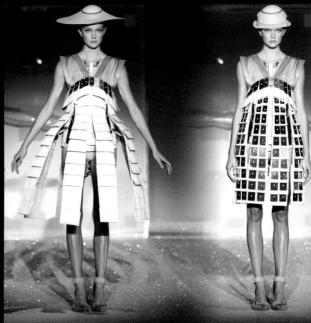

One Hundred and Eleven Spring/Summer (2007)

London, UK
with Swarowski

Keywords: mechanics, transformation

An association with Swarovski has led to a collection that transcends a 111-year history of fashion and reveals a modern and unique vision. Each of the five beautifully hand constructed, mechanical dresses, represents a particular period in fashion history, incorporating contemporary vision and complex engineering. 1895 is the starting point for the collection, consisting of a full-length skirt with a tightly pulled in waist on a gown with a high, frilled neckline. This transforms into a looser fitting dress with a hemline that rises to the calf reflecting the style of 1910. In turn, this seamlessly morphs into a 1920s flapper dress comprised of a loose layered knee length skirt with a plunging neckline. The metamorphosis continues right up to the present day.

Airborne, Autumn/Winter (2007)

London, UK
with Swarowski

Keywords: display, LEDs, film

Hussein pushes the boundaries of fashion by integrating the latest LED technology into his fashion collection. The collection uses climate as a metaphor and reflects our primal feelings towards nature and the cycles of weather. An LED dress consisting of 15,600 LEDs, combined with crystal, displays short abstract films that correspond to the arrival of a particular season.

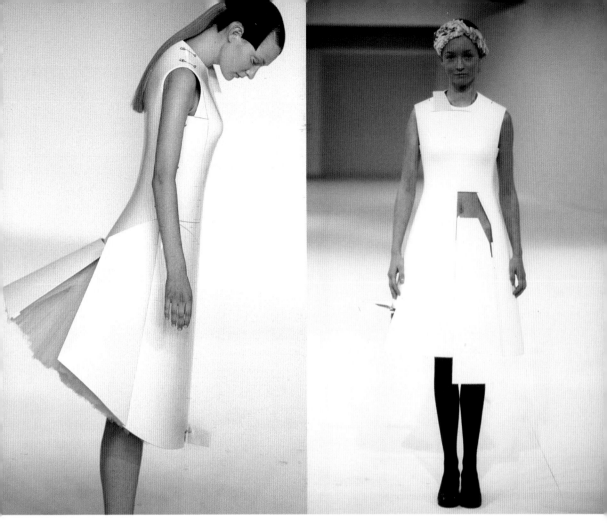

Before Minus Now
Spring/Summer (2000)
London, UK

Keywords: remote control, fiberglass

The collection focuses on the relationship between humans, nature and technology. A number of the dresses have irregular geometric shapes with stiffly protruding panels. The Remote Control Dress is operated with a remote control that opens the fiberglass panels of the dress to reveal the tulle inside.

Echoform, Autumn/Winter (1999)
London, UK

Keywords: airplane, electronics, fiberglass

The main theme of the collection was speed and its associated technologies. The Airplane Dress is a fiberglass construction with a flap that can be operated electronically and moves like an airplane wing.

Ying Gao
Montreal, Canada

Biography: Ying's two areas of interest are fashion and media arts. She studied fashion design at the Haute école d'arts appliqués in Geneva, Switzerland and at the Université du Québec à Montréal's fashion school. She earned a Masters degree in Multimedia and went on to acquire professional experience in Paris, Montreal and Beijing. Her artistic creations have been shown in several galleries and were featured in a number of publications such as Textile View and Vision (Beijing). In addition she is a member of the research institute, Hexagram. The central theme of her work is air. Air is light, intangible and poetic, and when infused into a garment, the garment transforms itself and seems inhabited by an elusive body. Inspired by air, she seeks to bring aesthetic form to the immaterial by creating interactive clothing that is both playful and illusionary.

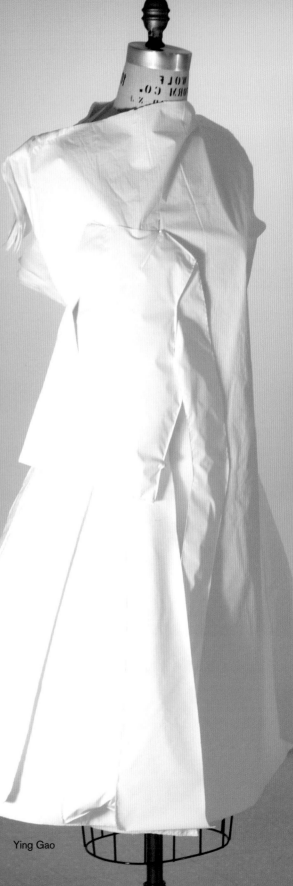

Ying Gao

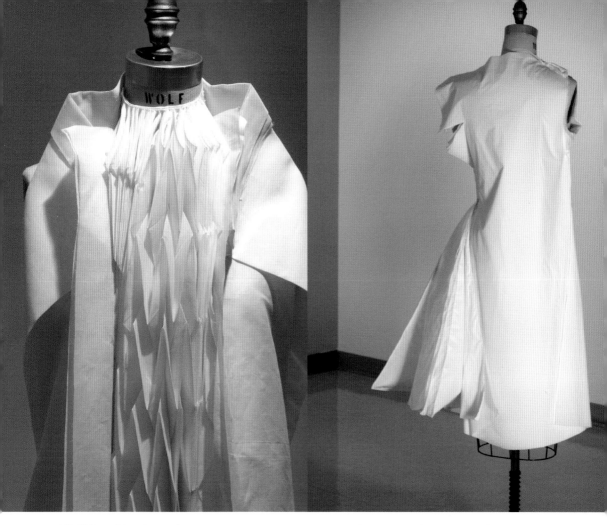

Walking City (2007)

Montreal, Canada

with Simon Laroche, Anne-Marie Durand-Laflamme, Isabelle Giroux, Annie Hébert

Keywords: pneumatic dresses, origami, fashion design, media art

Walking City stands at the crossroads between fashion design and media arts. It focuses on the creation of three dresses, which react to their immediate environment. Ying inserted a pressure detector in the back of the dress, which retracts when it's touched. In the second dress, a sound detector senses the wearer's breath and activates the dress, which gracefully unfurls. The third dress is animated when approached. Each garment is connected to a pneumatic system that allows air to enter and exit; this system paces the garment's 'breathing' and analyzes the wearer's movements and sounds the wearer produce. The garment's physical changes are achieved through fluctuations in the volume of air. Influenced by origami this project is also a tribute to Archigram, a collective of British architects whose projects involved designing temporary, inflatable structures as modular residences.

Materials: organdie, various electronic components

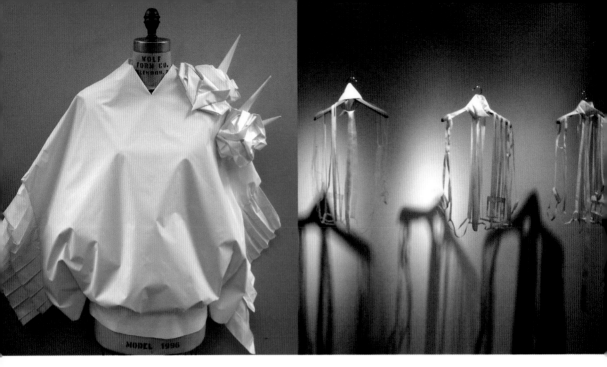

Living Pod (2007 – ongoing)

Montreal, Canada

with Simon Laroche, Anne-Marie Durand-Laflamme, Isabelle Giroux

Keywords: inflatable coats, origami, fashion design, media art

This project consists of two pneumatic and interactive coats that represent a pair of fraternal twins. While at first glance they appear identical, Garment B actually mimics the transformations of Garment A in sequential and fixed intervals. When an individual, dressed in Garment A, engages in a conversation with a third party, the frontal area of the garment is subjected to structural modifications generated by inconspicuous bursts of air within its numerous folds. Although there is no apparent reason for its sudden transformation, Garment B mimics these bursts a few moments later, tripling in size and becoming odiously flashy.

Materials: nylon, non-woven interfacing

Index of Indifference (2006)

Montreal, Canada

with Anne-Marie Durand-Laflamme, Isabelle Giroux

Keywords: internet data, survey, clothing structure, shirts

The number of Internet users who vote daily through interactive opinion surveys that are 'indifferent' to political, economic or cultural issues shocked Ying. With a software program, she complied and manipulated this statistical data concerning neutrality in order to modify the basic structure of 10 men's shirts over the course of four weeks.

Materials: organdie, non-woven interfacing

Ying Gao

Angel Chang
New York, New York, USA

Biography: Angel is a New York based fashion designer who explores bleeding edge trends in fashion and technology. Inspired by smart fabrics and designing for the future, she collaborates with engineers and interaction designers to develop new ways of dressing for the cosmopolitan woman. She was chosen as a recipient of the prestigious 2007 Ecco Domani Fashion Foundation Award. That same year, she received the Cartier Women's Initiative Award to develop her business and support her unique vision. PAPER magazine listed her as one of the 'stars of tomorrow' in their 10th annual 'Beautiful People' issue. Angel most recently served as a design assistant at Donna Karan Collection and previously worked in the design studios of Viktor & Rolf and Marc Jacobs. She received an MA in Modern Art from Columbia University and a BA in Art History & Visual Arts from Barnard College.

Angel Chang

Fall (2007)

New York, New York, USA

with Mouna Andraos, Sonali Sridhar

Keywords: fashion, ready-to-wear, camouflage, heat-sensitive

Conductive textiles turn this velveteen Edwardian jacket into a functioning MP3 player. In addition, a camouflage print made with thermochromic inks adorns the inside of a velveteen coat dress. Interaction designers Mouna Andraos and Sonali Sridhar developed this innovative heat-sensitive ink concept. The history of military camouflage drives this concept and influenced the thermochromic pattern on the pleated pieces in the collection.

Inspiration: WWII secret agents.

Spring (2008)

New York, New York, USA

Keywords: fashion, ready-to-wear, heat-sensitive

The Manhattan map print was developed in conjunction with Red Maps, which publishes guides for the design-centric crowd. The heat-sensitive print on the top only becomes legible when exposed to warmth.

Inspirations: International Spy Museum in Washington, DC

Angel Chang

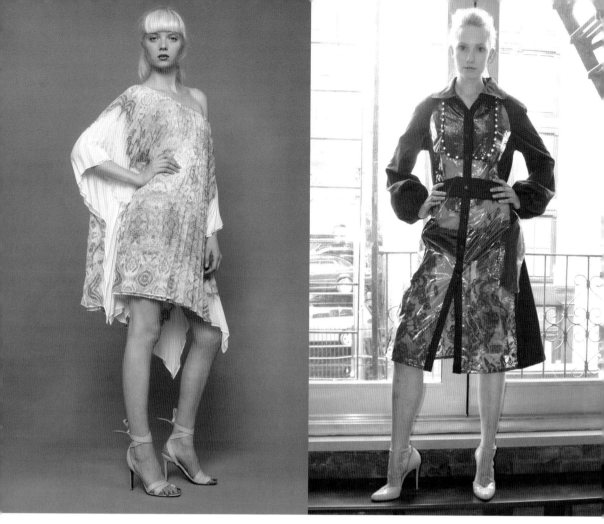

Spring (2007)

New York, New York, USA
with Ted Southern, Mouna Andraos, Sonali
Sridhar

Keywords: fashion, ready-to-wear, heat-sensitive, sun,
light, experiments

Artist Ted Southern collaborated on a see-through raincoat that features LEDs powered by two AA batteries and activated by a magnetic on/off snap. The sleeves and collar are made of breathable waterproof cotton and embossed with flowers using a traditional leather technique. In addition, Sonali Sridhar and Mouna Andraos developed the concept behind the silkscreen inks that change color depending on the surrounding conditions. The print on the pleated dress changes color instantly in both hot weather and with body heat. Other prints appear immediately in sunlight. While the flirty six-layer chiffon number remains white indoors, a yellow geometric print appears once she steps outdoors.

Inspirations: Tamara de Lampicka, French army tanks, Laduree in Paris

Angel Chang

37

CuteCircuit
London, UK

Biography: CuteCircuit is a wearable technology and interaction design company, founded by Francesca Rosella and Ryan Genz. Francesca and Ryan both hold a Masters degree in Interaction Design from the Interaction Design Institute Ivrea. Francesca is a fashion designer (Valentino, Esprit) and architect and Ryan an artist and anthropologist. CuteCirucit products were featured at WIRED NextFest for two consecutive years. CuteCircuit was awarded the First Prize at Cyberart Conference in Bilbao, Spain and the Hug Shirt was nominated as one of the Best Inventions of The Year by Time Magazine. Many of CuteCircuit product have been featured in books, magazines and newspapers worldwide.

M-Dress (Mobile Phone Dress) (2007)
London, UK

Keywords: telecommunication, mobile phone, soft electronics, solar powered, gestural interface

The M-Dress is an elegant silk jersey dress that is also a functional soft electronics mobile phone. The M-Dress accepts a standard SIM card and allows the wearer to receive and make calls without carrying a cellular phone in their pocket or purse. The M-Dress was designed after research showed that women who wear fitted garments, with small or no pockets, often miss calls because mobile phones are awkward to carry. To allow women to stay connected while remaining stylish, CuteCircuit designed the MDress. The wearer needs only to insert their SIM card into the small slot underneath the label. The dress is then ready and uses the same phone number as your usual phone. When the dress rings, the simple gesture of bringing your hand to the ear will allow the sensor to open the call. When done talking the gesture of releasing the hand downwards will close the call. CuteCircuit introduced special gesture recognition software to allow the M-Dress to work in an easy and intuitive manner.

SkateHoodie (2007)
London, UK

Keywords: MP3 player, CuteSwitch tactile switch, waterproof, interactive sportswear, active wear, music

The SkateHoodie allows skaters to listen to their favorite soundtrack while skating without having to carry an iPod. SkateHoodie users upload music to their jacket by connecting a USB drive to a special plug located in the jacket's sleeve. Stereo surround sound speakers are built right into the hood lining. The SkateHoodie protects the skater by incorporating special shock-absorbing materials and is lined with reflective Lycra for added night visibility. It also features the CuteSwitch, a brand new soft and stretch switch technology.

PhotoPhore (2007)
London, UK

Keywords: swimwear, renewable energy, light up textile

The Photophore swimsuit lights up when in contact with water and is best suited for swimming at night. It is made of an antibacterial textile and protects the wearer's skin from allergy. It is inspired by the photophore, a light-emitting organ, which appears as luminous spots on various marine animals.

Hug Shirt (2002 – ongoing)

London, UK

Keywords: human-human interaction, emotional communication, touch sensors, telepresence, haptic telecommunication

The Hug Shirt allows users to exchange the physical sensation of a hug over distance. The Hug Shirt is a Bluetooth accessory for Java enabled mobile phones. When a wearer touches their own shirt, sensors embedded in the fabric capture the sender's hand position, pressure and hug duration. Using special software running on the phone, the hug data can be sent to a friend anywhere in the world. When a friend receives a 'hug message' on their phone, their Hug Shirt will start to vibrate and get warm in the same spot that you touched on your shirt.

Irene, SAAB Lifestyle Garment (2006)

London, UK

Keywords: digital lifestyle, SAAB, interactive clothing, location-based

Irene is a two-piece urban ensemble composed of a blouse and pants. The pants are embroidered with jewel-like metallic environmental sensors while the blouse features an information display on the forearm and is wirelessly connected to any network. The user can verify her schedule and other information while on the move. A cluster of film-thin flexible solar cells on the blouse provides the necessary power to operate the system.

Kiss-Me (2006)

London, UK

Keywords: interactive wedding gown, conductive embroidery, heat-formed textiles

The Kiss-Me wedding gown and suit are made of pure Indian silk in vibrant colors of emerald green and sapphire blue. At the conclusion of the wedding ceremony, when the couple hugs, two unspoken personal messages of love are passed between them. The messages are shown on a miniscule display integrated inside the trim of the clothes.

Emotional Clothing: KineticDress (2004, 2007)

Rome, Italy & London, UK

Keywords: emotionally responsive clothing, adaptive clothing, sensors, electroluminescent embroidery, movement

The KineticDress is made of an elastic textile embedded with sensors that capture the wearer's movements and interaction with others. The sensor data is displayed through the electroluminescent embroidery that covers the external skirt section of the dress. The algorithmic program that controls the KineticDress is designed to follow the pace of the wearer: a still pose, when sitting alone shows a black dress, when the wearer starts moving and interacting with others the dress slowly lights up with a blue circle pattern.

Emotional Clothing: Skirteleon (2004)

Rome, Italy

Keywords: color changing fabric, adaptive clothing, emotionally responsive clothing, mood sensors, self-expression

Skirteleon, or skirt chameleon, is a skirt that changes color and pattern according to the activity and mood of the wearer. Manufactured with CuteCircuit engineered laminated textile, the Skirteleon changes color on-demand, upon user interaction or during the course of a predefined time period. The initial color state is blue but upon user interaction, through touch or sensor data, diverse colors and patterns would present themselves.

A-Nerve (2002 – 2004)

Rome, Italy

Keywords: telecommunication, intimate interface, shape-changing textile

Accessory Nerve is a Bluetooth enabled mono-sleeve for mobile phones. When the user receives an incoming call, the fabric creates a unique pattern of pleats that identify the caller. If the user is in a meeting or busy, they can flatten the pleats back into the original position, automatically sending the caller a text message that says 'I'll call you back later'. The Accessory Nerve uses a novel textile visual language to exchange greetings and information in a subtle and intimate way.

CuteCircuit

Kerri Wallace
London, UK

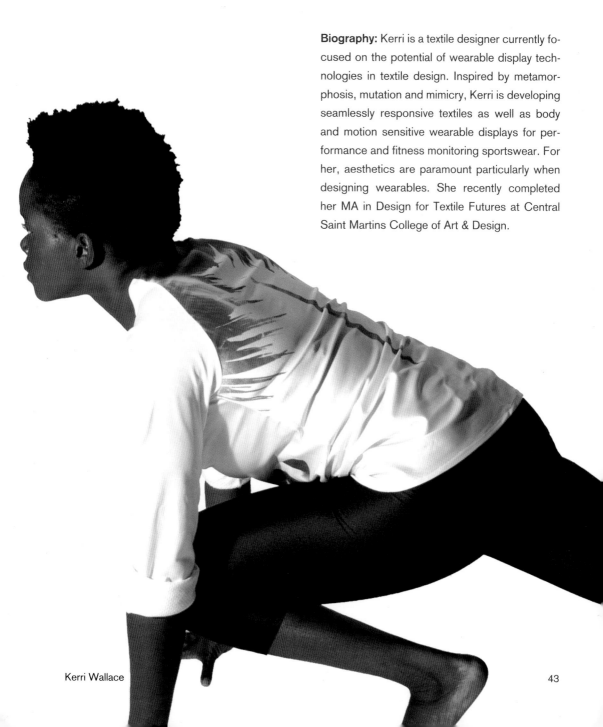

Biography: Kerri is a textile designer currently focused on the potential of wearable display technologies in textile design. Inspired by metamorphosis, mutation and mimicry, Kerri is developing seamlessly responsive textiles as well as body and motion sensitive wearable displays for performance and fitness monitoring sportswear. For her, aesthetics are paramount particularly when designing wearables. She recently completed her MA in Design for Textile Futures at Central Saint Martins College of Art & Design.

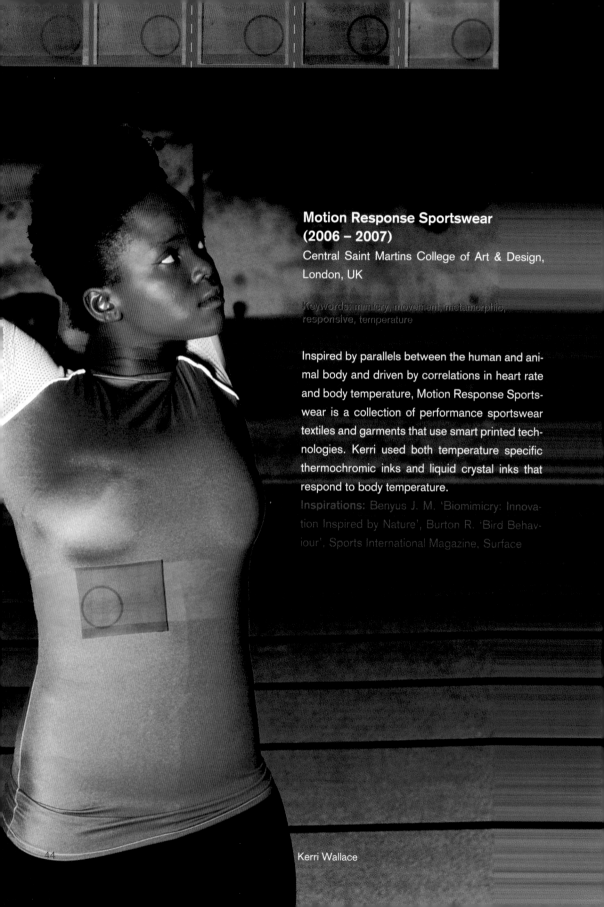

Motion Response Sportswear
(2006 – 2007)
Central Saint Martins College of Art & Design, London, UK

Keywords: mimicry, movement, metamorphic, responsive, temperature

Inspired by parallels between the human and animal body and driven by correlations in heart rate and body temperature, Motion Response Sportswear is a collection of performance sportswear textiles and garments that use smart printed technologies. Kerri used both temperature specific thermochromic inks and liquid crystal inks that respond to body temperature.

Inspirations: Benyus J. M. 'Biomimicry: Innovation Inspired by Nature', Burton R. 'Bird Behaviour', Sports International Magazine, Surface

Kerri Wallace

Elena Corchero, lostvalues
London, UK

Biography: Elena explores clothing, textiles and design technologies. She believes that when a technology is added to an ancient medium like textiles, there is a need to respect and explore its history and traditions. She spent her childhood at her mother's fashion studio and later studied fine arts. She joined MIT's Media Lab Europe specializing in smart textiles and wearable technologies. She recently completed an MA in Design for Textile Futures at Central St. Martins College and is currently a research fellow at Distance Lab.

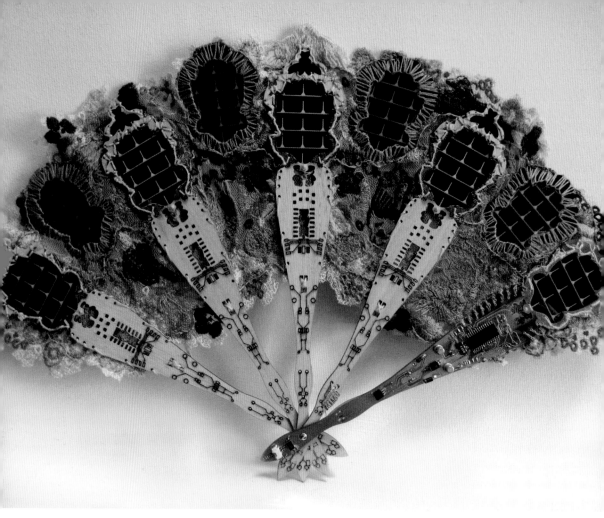

Solar Vintage (2007)

Distance Lab, Scotland, UK & Central Saint
Martin's College of Art and Design, London, UK
with Crispin Jones

Keywords: eco, solar, accessories, vintage, light

Solar Vintage is a collection of solar powered
embellished accessories for the eco-fashion-
minded. The pieces are charged when used
outdoors during the day and become ambient
decorative lights for the home in the evening. The
collection aims not to hide technology, but rather
to disguise it in a beautiful and stylistic way. Elec-
tronic components are integrated directly into the
textile and embroidered using conductive thread.

The materials are divided into wood-based (wood
pieces, cellulose-based fabrics and threads) and
electronic (resistors, LEDs, uncoated circuit
boards, conductive threads). The solar cells used
are organic, flexible, and none-silicon-based. The
textile illustrates the eco-narrative by displaying
images of endangered birds with their corre-
sponding species name in Latin.

Inspirations: endangered birds, 'Solar Light'
by Damien O'Sullivan, couture collections by
Christian Lacroix, Fan Museum London, V&A
Museum London, Ross Lovegrove, Robert
Frenay 'Pulse', 'We shall become silhouettes'
song by The Postal Service, Spanish traditional
accessories

Elena Corchero, lostvalues

whiSpiral (2005)

Human Connectedness Research Group, MIT
Media Lab Europe, Dublin, Ireland
with Stefan Agamanolis

Keywords: keepsakes, voice, relationships, touch

The whiSpiral is a spiral-shaped wool shawl that explores how technology can enhance the way keepsakes evoke memories of loved ones. Circuitry integrated directly in the textile allows your friends to record short audio messages at different points in a spiral-shaped shawl. These messages are whispered back each time you wrap yourself in the shawl, or when caressing different parts of the fabric.

Elena Corchero, lostvalues

47

Ebru Kurbak & Ricardo Nascimento & Fabiana Shizue

Linz, Austria & London, UK

Biography: Ebru is a PhD candidate and lecturer at the department of Space and Design Strategies at the University of Arts and Industrial Design in Linz, Austria. She received her MSc degree in Architecture from Istanbul Technical University. Her focus is on investigating spaces and objects and the implications of their physical and non-physical aspects. Ricardo is completing his Master's degree at the Interface Culture department at the University of Arts and Industrial Design in Linz. He has degrees in International Relations from PUC in São Paulo and in Multimedia Design from the Art Center SENAC, Brazil. He explores the body-environment relationship and develops interfaces and autonomous adaptive systems for interactive installations and hybrid environments. Fabiana is a freelance illustrator who graduated from the Fine Arts School of São Paulo, Brazil. Her interests are colors, shapes, textures and textiles and her work has appeared in fashion magazines, books and advertisements all over the world.

Taiknam Hat (2007 – 2008)

Ogaki, Japan & University of Arts and Industrial Design, Linz, Austria

Keywords: electromagnetic pollution, electro smog, horripilation, birds, hats, fashion, wearable technologies, kinetic art

Taiknam Hat is a kinetic hat that reacts and animates in response to changing levels of surrounding radio wave signals. The project's goal is to develop awareness of the increase in electromagnetic pollution by emulating horripilation, an automatic instinctive reaction of living creatures to sources of irritation and stress. The Taiknam Hat uses horripilation in birds as a visual and tactile metaphor to express our bodies' irritation towards electromagnetic radiation while verifying its presence.

Inspirations: The study and observation of birds.

KnoWear, Peter Allen & Carla Ross Allen
Brooklyn, New York, USA

Biography: Peter and Carla co-founded KnoWear design studio in 2000. Together they have created projects that focus primarily on how nomadic technologies redefine spatial environments and secondly on how the body and technology interact. Their collaboration consistently produces objects that provoke thought and provide beauty. KnoWear has exhibited their work internationally at such recognized venues as The Cooper Hewitt National Design Museum, National Museums of Scotland, Zech Zollverein, Tyne & Wear Museums, MOCA Taipei and Eyebeam Atelier. KnoWear projects have been featured in numerous books and well known monthly publications.

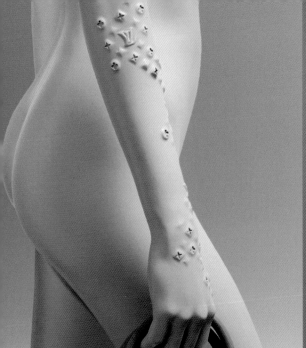

BrandX (2007)

Brooklyn, New York, USA

Keywords: luxury, seduction, commodification, junkie, horrific

KnoWear's series BrandX imagines a skin disease caused by brand addiction. Three brand addiction scenarios are put forward using full size mannequins in glamorous poses, each depicting an area of the body ravaged by a logo induced disease. Scenario 1 shows a rash of logos on the face and neck streaming from Fendi Havana Zucchino sunglasses. Scenario 2 focuses on the arm with logos flowing from a Louis Vuitton Alma handbag. Scenario 3 focuses on the foot, ankle, and calf with a rash of logos growing from Gucci Malibu Stilettos.

Materials: fiberglass, cast resin, Gucci Stilettos, Fendi sunglasses, Louis Vuitton handbag

Inspirations: David LaChapelle, Hussein Chalayan, Ross Lovegrove, Philippe Stack, Marilyn Miniter, Dan Tobin Smith, Adbusters, Vogue, Frame, Surface, 'A Space Odyssey'

Aerial (2006)

Essen, Germany

Keywords: seduction, horrific, natural, synthetic, software

Aerial is a personal media garment. Working with satellite radio technology, Aerial allows the user to create their own media space using the body as the point of conductivity. Aerial consists of three components: a receiver, a glove controller and soft speakers integrated into the hood. It was a 2006 Cooper Hewitt entry for the Second Skin Exhibition.

Materials: vacuum formed foam, silk, cashmere wool

DNA (2006)

Essen, Germany

Keywords: seduction, horrific, natural, synthetic, software

DNA is a garment with an integrated wireless communication device and digital wallet that allows the user to shop and communicate without carrying additional electronic devices. DNA's main component is a scarf programmed to recognize the owner's DNA, introducing a new tool to combat identity theft. The second component to DNA is an accessory designed with small loops that allows the wearer to style how the scarf is integrated into the overall garment. It was a 2006 Cooper Hewitt entry in the Second Skin Exhibition.

Materials: vacuum formed foam, silk, cashmere wool

FTS, Façade of The Synthetic (2005)

Eyebeam Atelier, New York, New York, USA

Keywords: seduction, horrific, natural, synthetic, software

FTS is a garment that features digital tattoos with product logos and dynamic images combined in video form called 'Body Billboards'. The digital tattoos use the skin as the canvas, while the garment has framed openings to allow viewing of the tattoos. FTS suggests that the next frontier of advertising will not be print; rather skin will be rented out for branding opportunities.

Materials: vacuum formed foam, silk, cashmere wool

KnoWear, Peter Allen & Carla Ross Allen

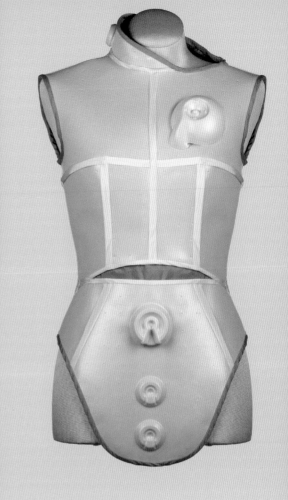

Skinthetic (2002)

Brooklyn, New York, USA

Keywords: seduction, horrific, natural, synthetic, software

Skinthetic is a design proposal suggesting how consumer branding will extend to the human body in the future. The digital renderings illustrate how the Chanel iconic quilt design might be integrated into the human form. It was shown at Skin at the Cooper Hewitt.

Materials: digitally manipulated photo, fiberglass, resin cast logos

TechnoLust (2000)

Brooklyn, New York, USA

Keywords: seduction, horrific, natural, synthetic, software

TechnoLust is a wireless and self-sufficient gaming suit. The bold erotic design merges softness of skin with hard electronic lines that suggest replacement of erogenous zones with technology. It was shown at Skin at the Cooper Hewitt.

Materials: vacuum formed foam and silk

KnoWear, Peter Allen & Carla Ross Allen

CHAPTER **THREE**

3 **Interactive Interfaces**

XS Labs
Montreal, Canada

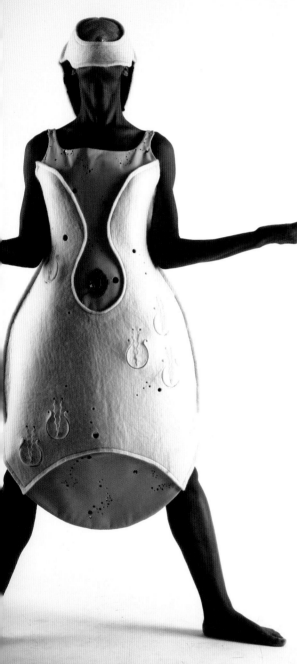

Biography: XS Labs was founded in 2002 by Joanna Berzowska and is a design research studio with a focus on innovation in the fields of electronic textiles and wearable computing. Many of the XS Lab's electronic textile innovations come from combining the traditional techniques of textile manufacturing with contemporary materials that have various electro-mechanical properties. This enables XS Labs to construct complex textiles with electronic properties. Joanna is an Associate Professor of Design and Computation Arts at Concordia University and a member of the Hexagram Research Institute in Montreal. She received her Masters of Science from MIT for her work entitled 'Computational Expressionism' and subsequently worked with the Tangible Media Group of the MIT Media Lab. She co-founded International Fashion Machines in Boston and holds a BA in Pure Math and a BFA in Design Arts. Her collaborators include Marcelo Coelho, Vincent Leclerc, and Di Mainstone. Vincent recently graduated with a Masters Degree from the MIT Media Lab and teaches Physical Computing at Concordia University. Di trained in fashion design at the Central Saint Martins College of Art in London. She worked with Sara Diamond at the Banff New Media Institute to create a series of electronic fashion garments.

Skorpions (2007)

Montreal, Canada
by Joanna Berzowska, Di Mainstone
with Marguerite Bromley, Marcelo Coelho, David
Gauthier, Francis Raymond, Valerie Boxer

Keywords: shape memory alloys, Nitinol, electronic
textile, kinetic garments, electronic fashion, smart
materials, conductive yarns, augmented garments

Skorpions are a set of kinetic electronic gar-
ments that move and change on the body in
slow, organic motions. They have anthropomor-
phic qualities and can be imagined as parasites
inhabiting the skin of a host. They breathe and
pulse, controlled by their own internal program-
ming. They are not interactive artifacts insofar as
their programming does not respond to simplistic
sensor data. They have intentionality. They are
programmed to live, to exist, and to subsist. They
are lifelike behavioral kinetic sculptures that ex-
ploit characteristics such as control, anticipation,
and unpredictability. They have their own person-
alities and their own fears and desires. Skorpions
integrate electronic fabrics, the shape-memory
alloy Nitinol, mechanical actuators such as mag-
nets, soft electronic circuits, and traditional textile
construction techniques. The cut of the pattern,
the seams, and other construction details be-
come important components of the engineering
design. Skorpions are a comment on the history
of garments as instruments of pain and desire.
They hurt you and distort your body as did cor-
sets and foot binding. They emphasize our lack
of control over our garments and digital technolo-

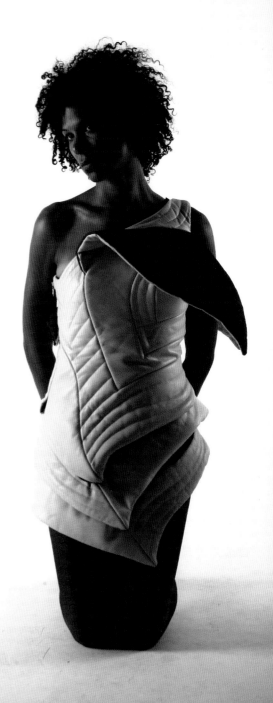

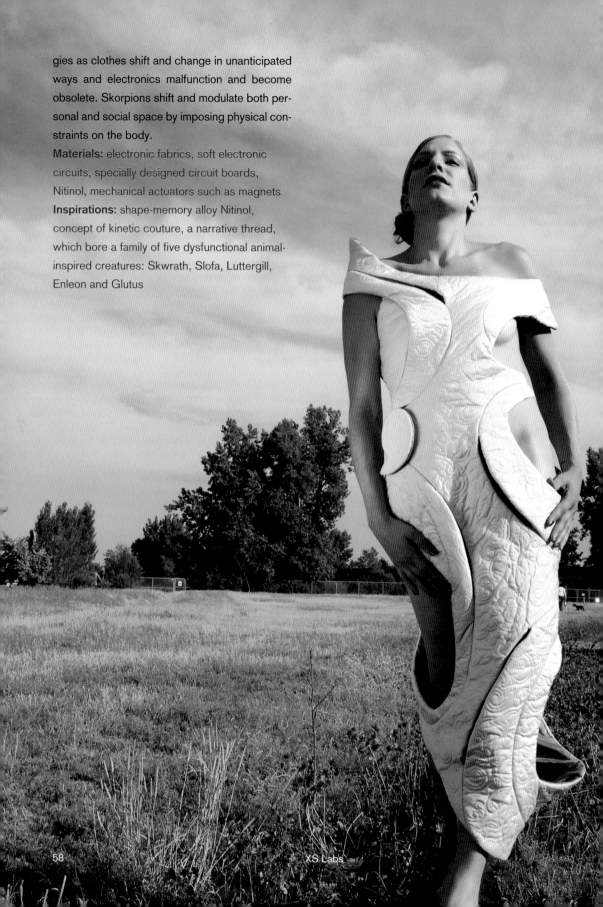

gies as clothes shift and change in unanticipated ways and electronics malfunction and become obsolete. Skorpions shift and modulate both personal and social space by imposing physical constraints on the body.

Materials: electronic fabrics, soft electronic circuits, specially designed circuit boards, Nitinol, mechanical actuators such as magnets

Inspirations: shape-memory alloy Nitinol, concept of kinetic couture, a narrative thread, which bore a family of five dysfunctional animal-inspired creatures: Skwrath, Slofa, Luttergill, Enleon and Glutus

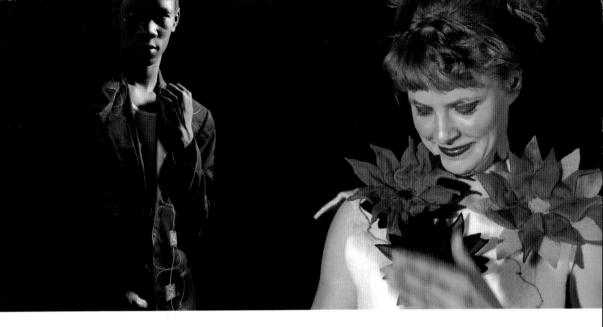

Accouphène (2006)

Montreal, Canada

by Vincent Leclerc, Joanna Berzowska

Keywords: ubiquitous computing, sound interface, electronic fashion, smart materials, conductive yarns, sound augmented garments

The Accouphène tuxedo is decorated with 13 soft speakers, created by embroidering decorative coils of highly conductive yarn on the front of the jacket. A central circuit sends pulses of energy through the coils. Sounds are generated when the sleeve of Accouphène, which contains a stitched magnet, is moved over the coils. Accouphène creates a 3D sonic environment around the human body that can be activated and modulated through hand movement and the twisting and compression of the cloth. When powered, the speakers generate a weak magnetic field that reacts to a strong magnet positioned in close proximity to the fabric. The magnet's strength and its distance from the embroidered coil determine the amplitude of the sound.

Materials: conductive yarn, embroidery machine, rare earth magnets, custom electronics, speakers

Kukkia and Vilkas (2005)

Montreal, Canada

by Joanna Berzowska, Marcelo Coelho, Hanna Soder

Keywords: shape memory alloys, Nitinol, electronic textile, kinetic garments, electronic fashion, smart materials, conductive yarns, augmented garments, felt

Kukkia is an expressive and behavioral kinetic sculpture that develops a visceral relationship with the wearer. The Kukkia flowers frame the face and slowly open and close over time, like a caress. The felt and silk petals provide relative rigidity and integrate stitched Nitinol (a shape memory alloy) wire, which enables the slow, organic movement. Vilkas is a dress with a kinetic hemline on the right side that rises over a 30 second interval. It is constructed of heavy hand-made felt and uses a very light yellow cotton element that contracts using hand-stitched Nitinol wires. When heated, the Nitinol easily pulls the cloth together and creates a wrinkled effect. The hemline is programmed to rise autonomously and not in response to any external or internal input.

Materials: electronic fabrics, soft electronic circuits, specially designed circuit boards, Nitinol, mechanical actuators such as magnets

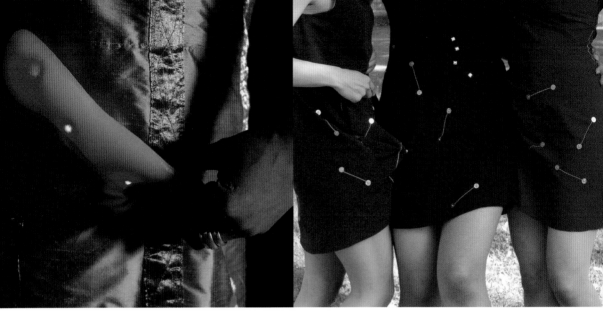

Leeches (2004)

Montreal, Canada

by Joanna Berzowska

Keywords: electronic garments, smart clothes, conductive textile, power distribution

The Leeches dress, constructed with stitched conductive organza stripes, functions as a soft, wearable, and reconfigurable power-distribution substrate for attaching individual silicone-coated electronic modules (the 'Leeches') that illuminate the dress. The Leeches can be attached in a variety of positions and configurations. They are held in place by magnetic snaps, which act both as mechanical and electrical connections. A single power module can be attached at the shoulder and can power up to ten Leeches. The red LEDs inside the Leeches suggest power-hungry creatures that, once attached, suck or draw power (the metaphoric 'blood') from your body. The Leeches dress provides comment on the potential dangers of electromagnetic fields emanating from electronic garments.

Inspirations: Development of safe, efficient, ecological, and cheap portable power sources.

Constellation Dresses (2004)

Montreal, Canada

by Joanna Berzowska

Keywords: electronic garments, smart clothes, conductive textile, power distribution

The Constellation Dresses are covered with twelve magnetic snaps arranged over the torso and thighs and connected in pairs using a single line of conductive thread. LEDs are integrated into the dresses in a design that resembles a constellation. Sets of snaps act as switches that, when connected to the snaps of another dress, complete circuits that light up the LEDs. The magnetic snaps act as a mechanical and electrical connection between bodies. Their irregular placement induces wearers to create playful and compelling choreographies to connect their circuits.

Inspirations: Development of safe, efficient, ecological, and cheap portable power sources.

XS Labs

Blazer (2003)

Montreal, Canada

by Joanna Berzowska

Keywords: retinal persistence, ubiquitous computing, light interface, electronic fashion, smart materials, conductive yarns, text-augmented garments

Blazer integrates light emitting diodes into the fabric by employing existing textile construction methods, to create a simple emissive display. The system takes advantage of retinal persistence to make sense of an apparently random pattern of flashing lights. When the body is still, we see noise. When the body is in motion, the noise becomes a message: text is displayed. The snaps are modified snap buttons with a translucent cap prong. A small hole was drilled in the studs and 3mm high brightness blue LEDs were added. The snaps also serve as a contact switch to start the flashing of the LEDs. When the buttons are snapped, they start to emit flashing light that appears to have a random behavior. Metallic silk organza is a great base for creating contact switches and grounding common elements of a circuit. Blazer is built with 4 layers of the synthetic fabric to isolate the various elements of the circuit.

SoundSleeves (2003)

Montreal, Canada

by Joanna Berzowska, Vincent Leclerc

Keywords: ubiquitous computing, sound interface, electronic fashion, smart materials, conductive yarns, sound augmented garments

SoundSleeves are a set of disembodied sleeves that are joined at the back using a narrow band of textile and covered with conductive strips of silver metallic organza. When users flex or cross their arms, a sound is synthesized within the sleeves and played through miniature flat speakers. The strips are individual variable resistance switches but, when considered as a whole, they become a body-scale flex sensor that can be used to generate sounds. They become an extension of the body; when our body language is tense and protective (crossing our arms, for instance), the pitch of the sounds becomes higher, as if signaling danger. The stitched circuit board connects each element to the few 'hard' parts of the system: a PIC16F84A, a 3V watch battery and speakers. The connections to the PIC are done using conductive epoxy to avoid the fragility associated with solder connections.

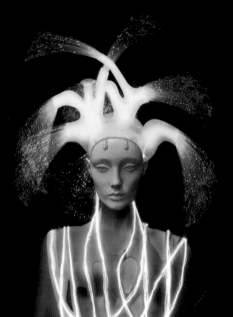

Suzi Webster
Vancouver, Canada

Electric Dreams (2007 – 2008)
London, UK & Vancouver, Canada
with Jordan Benwick

Keywords: dreams, felt, fibre-optics, eeg electrodes, electricity

To illuminate can mean to make something brighter and lighter, or it can mean to make something clearer or more understandable. Electric Dreams explores both of these meanings of illumination and makes the relationship between light and thought tangible and visible. The private and fleeting daydreams of the dreamer are transformed into a shifting and ephemeral display of light and color. EEG electrodes monitor the dreamer's brainwaves. This signal is read by a custom microcontroller circuit, which amplifies and interprets the electrical signals of the brain to control shifts of color via red, green, and blue light emitting diodes embedded in a hand-molded felt headdress. End-lit fibre optic cables transport the LED light through the headdress. This light and color becomes a visible extension of fleeting thought processes. Side-lit fibre optics carry these light impulses into the body of the garment to emphasize the distribution of the nervous system throughout the skin of the body. The design of the garment and headdress is based on the universal archetype of the tree of life.

Biography: Suzi completed a BFA at Emily Carr Institute in Vancouver, Canada and an MFA at the Slade in London, UK. She now teaches at Emily Carr in the Digital Visual Arts department. Technology enables us to listen in on the mysterious and invisible signals that emanate from our bodies. Mostly this data is used for medical purposes, but Suzi transforms this private bio information into a metaphoric, wearable display of color, light, sound or vibration. Recent exhibitions have included Node London 06, How Smart Are We at the Royal Institute of British Architects, Artefact at the Foundation for Creative Art and Technology in Liverpool, and Cyborgs: Man or Machine at Dott 07 Design Biennale in Newcastle, UK.

Felt (2007 – 2008)

London, UK & Vancouver, Canada

with Jordan Benwick

Keywords: portable audio player, crocheted copper wire belt, vibration, micromotors

This hand crocheted copper wire belt transforms portable audio into music that is felt as well as heard. Felt uses a customized microcontroller to interpret the audio and adjust the internal frequency of micromotors that then vibrate copper wires in sync with the wearer's sound track.

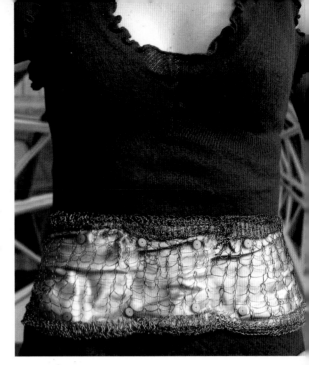

Barking Mad (2005 – 2006)

London, UK

with Jordan Benwick

Keywords: coat, proximity sensors, gsr sensor, flat panel speakers, crowds

Barking Mad was designed to help shy, stressed people deal with situations of urban overcrowding. Proximity sensors respond to infringements on personal space by emitting the sound of a barking dog through flat panel micro speakers in this ultimate urban survival coat. The sounds ranges in strength from a poodle's yap to the bark of a rott–weiler, depending on the level of infringement.

Electric Skin (2006)

London, UK

with Jordan Benwick, K Patterson

Keywords: Elumin8 printed LEDs, silk, sensors, breath, electricity

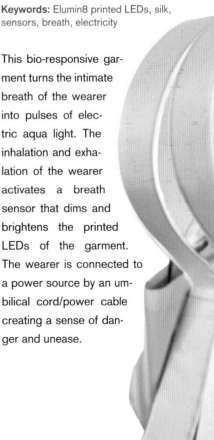

This bio-responsive garment turns the intimate breath of the wearer into pulses of electric aqua light. The inhalation and exhalation of the wearer activates a breath sensor that dims and brightens the printed LEDs of the garment. The wearer is connected to a power source by an umbilical cord/power cable creating a sense of danger and unease.

Barbara Layne, Studio subTela

Montreal, Canada

Biography: Barbara is a Professor at Concordia University in Montreal and a member of the Hexagram Institute. She has lectured and exhibited internationally, including the Dorrego Gallery at the Metropolitan Museum of Design in Buenos Aires, the Ivan Dougherty Gallery in Sydney Australia, and the International Biennale of Design in St. Etienne France. Her work has been supported with numerous grants including the Canada Council for the Arts, SSHRC, Hexagram, and the Conseil des arts du Quebec. In Addition, she is the Principal Investigator of Hexagram's infrastructure grant from the Canadian Foundation for Innovation. Barbara is the Director of Studio subTela, working with graduate student researchers on the development of intelligent cloth structures for the creation of artistic, performative and functional textiles.

Jacket Antics (2007)

Montreal, Canada

with Diane Morin, Hesam Khoshneviss, Maryam Golshayan, Meghan Price

Keywords: wearable electronics, intelligent fabrics, handwoven cloth, communication

Jacket Antics feature unique texts and designs scrolling through the LED array on the backs of two garments. When the wearers hold hands, the LED arrays presents a third, synchronous message that scrolls from one to the other, presenting a new pattern of communication. When the wearers release hands the message reverts back to the individual themes. The garments are constructed of handwoven cloth, made from traditional black linen yarns woven alongside light emitting diodes, microcontrollers and sensors. The capacity for interactivity in the animated cloth displays extend the narrative qualities of cloth and provide new possibilities for dynamic social interaction.

Material: linen, silver threads, Basic Stamp, Bluetooth

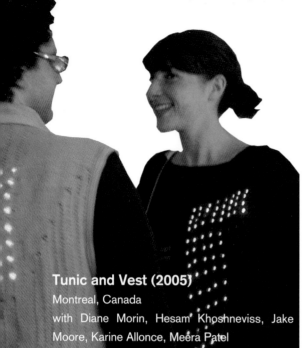

Tunic and Vest (2005)
Montreal, Canada
with Diane Morin, Hesam Khoshneviss, Jake Moore, Karine Allonce, Meera Patel

Keywords: wearable electronics, intelligent fabrics, handwoven cloth

The Tunic and Vest were early LED garments that used multi-strand, uninsulated wires in a unique wire-wrapping technique to create electronic circuits woven at the loom. The LED array of the tunic can be triggered from a distance via a Bluetooth device. Electronic components were intentionally exposed to accent the relationship between weaving and technology.

Materials: linen, wire, Basic Stamp, Bluetooth

Tornado Dress (2007)
Montreal, Canada
with Hesam Khoshneviss, Diane Morin, Meghan Price

Keywords: LEDs, light, storm

The Tornado Dress features a Mimaki print of a tornado by Nebraska storm-chaser, Mike Hollingshead. The lining of the dress has been embroidered with conductive threads and electronic components including super-bright white LEDs. Three small photocells have been embroidered to the outside of the dress and detect the amount of ambient light. Depending on the quantity of light that is sensed, different flashing patterns are triggered that are reminiscent of lightning effects that can accompany severe weather situations.

The Twining Vest (2006)
Montreal, Canada
with Diane Morin, Jake Moore, Hesam Khoshneviss

Keywords: wearable electronics, intelligent fabrics, handwoven cloth, performance

This vest was created for the performance, Twining, by choreographer-dancer, Yacov Sharir. Changing messages are transmitted wirelessly from offstage and displayed on the LED array worn by Sharir. Other dancers respond to the changing messages with improvisational movement in an exploration of new media communications.

Materials: linen, wire, Basic Stamp, Bluetooth

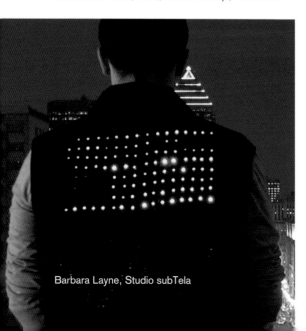

Barbara Layne, Studio subTela

Diana Eng
New York, New York, USA

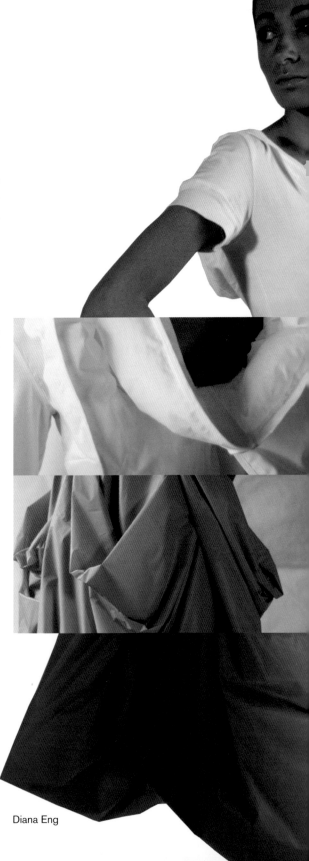

Biography: Diana uses technology to develop a new aesthetic, form, and functionality in fashion. Her design process follows the scientific method. Designs are created after an intense research process. Experimentation determines how the new technology will be made wearable and implemented into fashion. Diana has a background in fashion with a BFA in apparel design from the Rhode Island School of Design. Diana was a designer on Bravo's TV show 'Project Runway Season 2'. She has collaborated on projects with Yahoo and the University of Bath. Currently, Diana is developing a couple of DIY (do-it-yourself) books.

Inflatable Collar (2007)
New York, New York, USA

Keywords: inflatable fashion, air, collar, DIY

Inflatable Collar is a study of transformation and a look at clothing that moves independently while you wear it. A collar is traditionally used to help frame the face. Inflatable Collar mimics the motion of a blooming flower. It is a collar that blooms around the face. The collar is constructed from an air mattress inflator that is connected to a fabric collar that has an interior lined with a sealed plastic airbladder. The result is a shape-changing garment that transforms while being worn.
Materials: inflatable device hacked from inflatable air mattress, blouse/shirt/ tubing, plastic bagging, battery pack

Blogging in Motion (2006 – 2007)

Yahoo Hack Day, Berkley, California, USA
with Emily Albinski, Audrey Roy, Jeannie Yang,
Yahoo Research Berkley

Keywords: blogging, camera, photograph, GPS,
Flickr, Yahoo

A purse which involuntarily blogs your day. Each
time the wearer walks 30 paces, the purse takes
a photograph and automatically uploads it to a
blog online (www.BloggingInMotion.com). Time
and GPS location for each photo can also be
added to the blog. At the end of the day, blog
readers can trace back through the wearer's
footsteps by viewing the photographs.

Materials: Basic Stamp, Nokia phone,
pedometer, purse, Zonetag

Inflatable Dress (2003 – 2006)

Rhode Island School of Design, Providence,
Rhode Island, USA
with Emily Albinski

Keywords: inflatable, dress, air

Inflatable Dress is an exploration of how a design
changes through shape and color. Inflatable
Dress is a gown that initially fits closely to the
body but inflates to become bell shaped with
tendril-like spikes on the back and large pil-
lows of air on the sides. The silhouette of
the gown can be changed by varying the
amount of air.

Diana Eng

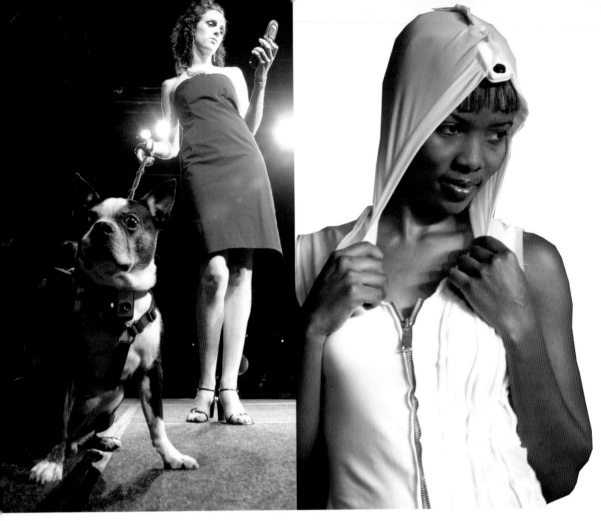

Pupsight (2006)

New York, New York, USA

with Emily Albinski

Keywords: pet, dog collar, Motorola, video, images

A camera collar system for dogs that allows owners to see their pet's-eye view. Owners can call the collar using a Motorola cell phone and receive real time video or images of what their pet is looking at. The collar can also send the phone photo messages of the dog's view at designated times of the day.

Materials: Motorola Homesight, dog collar

Heartbeat Hoodie (2004)

Rhode Island School of Design, Providence, Rhode Island, USA

Keywords: heart rate, basic stamp, hoodie, photograph, algorithm, camera

Heartbeat Hoodie explores the idea of involuntarily documenting parts of one's life using a camera that takes photographs when the heart rate increases during moments of interest or excitement. The camera is discreetly hidden in the hood. Basic Stamp construction allows algorithm analysis for detecting moments of interest as opposed to moments of excitement.

Materials: hoodie, camera, basic stamp, heart monitor

Diana Eng

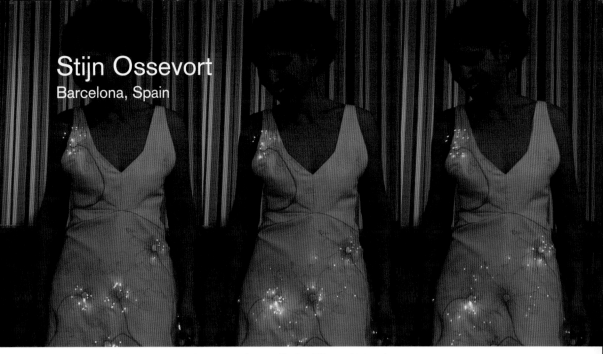

Stijn Ossevort
Barcelona, Spain

Biography: Stijn is a Dutch designer who studied both industrial engineering and art design. After completing his studies he worked as a free-lance designer for Ron Arad, Philips, Canary Wharf, the National Trust and as a tutor at Central Saint Martins College in London. His work is as diverse as his academic background and ranges from interactive jewelry to public sculptures. In 2001 he began to focus on wearable electronic devices and spent a year at the Interaction Institute Ivrea in Italy. While there he completed a project in creating user inspired wearable electronic devices. Soon after, he joined the Swiss Federal Institute of Technology (ETH) in Zurich as a researcher on wearable computing devices. He recently moved to Barcelona. Most of his work provides a critical view on the way we relate to our products.

Flare (2007)
SOS Design Studio, Barcelona, Spain

Keywords: dress, experience, surrounding, wind, light

Imagine you are wearing a woolen coat outside in the rain. The coat will start to generate a distinctive smell or might even shrink a little. These reactions can be used to give us a more comprehensive awareness of our surroundings. The Flare Dress does just that by perceiving wind. The dress has two fabric layers. The outside layer is covered with 15 'Dandelions'. Each flower consists of 32 LEDs that light up in a sequence that simulates dandelion seedlings being blown away. Only the flowers that face the wind become active. The windier it gets the more responsive the dress becomes.

Materials: silk, cotton, SMD LED's, microchips

QBIC - Wearable Computer in a Belt (2005)

ETH, Zürich, Switzerland
with Michael Lauffer, Fabrizio Macaluso

Keywords: wearable computer belt

The QBIC is a novel wearable computing system integrated into a fully functional belt. This system integrates the main electronics in the buckle of a belt and utilizes the belt itself as extension bus and mechanical support for add-ons. The USB, serial, and VGA connections are integrated into the leather of the belt. This makes the QBIC both comfortable and powerful enough to support a wide range of applications.

Materials: leather, aluminium, stainless steel, PU resin

Stijn Ossevort

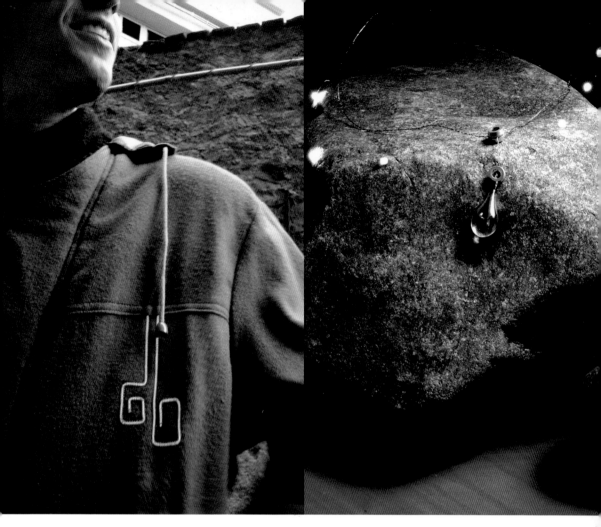

Compass Coat (2003)

Interaction Institute Ivrea, Italy
with Els Ossevoort

Keywords: compass, light, orientation

The Compass Coat is an extraordinary compass that indicates north by 'growing' plant shapes. In total 24 electro luminescent wires are embroidered, whichever points north starts to glow. The coat is inspired by the lack of natural elements in our urban landscape that we would ordinarily use for orientation.

Materials: wool, EL wire, magnetic resistive sensors, microchip

Perfume Jewellery Pieces (2002)

Interaction Institute Ivrea, Italy

Keywords: perfume, jewelry, light, air

A necklace and a ring set that enables lovers to communicate on a very subconscious level. Each piece can be activated when one of the lovers blows against it. The piece will respond with sparkling lights and will send a radio transmitted signal to the other jewelry piece which will in turn release a gentle perfume smell. Both pieces have been crafted into working prototypes.

Materials: silver, glass, SMD components

Maggie Orth
International Fashion Machines

Seattle, Washington, USA

Biography: Maggie is an artist and technologist who creates electronic textiles at her company, International Fashion Machines. Maggie is considered a pioneer in electronic textiles, fashionable computing, interface design, and art. Maggie holds a BFA in painting from RISD and a PhD from the MIT Media Lab. Her themes include the interaction of technology and electricity with the body, and what happens when the decorative arts collide with computation. Today, her work focuses on the development of electronic textiles as an artistic medium. She creates programmable color change textiles that combine woven electronic circuits, printed thermochromic inks and drive electronics. She also creates interactive textile and light pieces that explore the electrical and transmissive properties of textiles. In addition, Maggie acts as a consultant on fashionable computing to large fashion companies.

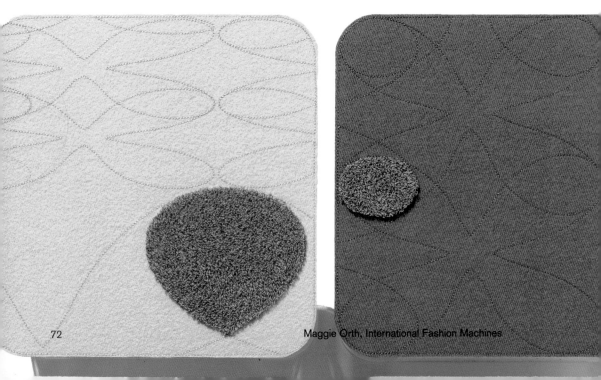

Maggie Orth, International Fashion Machines

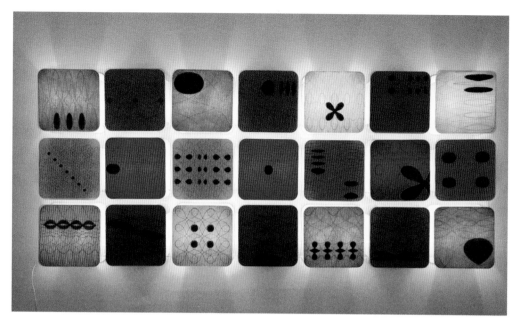

Petal Pusher, 2007

Seattle, Washington, USA

Keywords: electronic, e-textile, light art, textile sensor

Petal Pusher is an interactive textile and light installation that explores the hidden electrical and transmissive properties of felt, embroidery and fibers. Viewers touch soft, hand tufted sensors to light the felt panels, revealing color, textile structure, and pattern. Felt colors, textile structures and embroidery yarns were carefully selected to achieve a dramatic and surprising effect when lit from behind. The viewer's experience of this piece is immediate and sensual. Color, saturation, pattern and light reflection change as viewers illuminate different panels. These hand tufted sensors use a capacitive method of sensing. They are tufted from conductive yarn and charged with a small voltage. Touching them allows the electrical charge to flow from the yarn, through your body, to ground. Sensors detect this change in charge and send an electrical signal to control the light. For this limited edition work, 49 unique patterns were created. The patterns are machine embroidered onto wool felt.

Materials: 100% wool felt, rayon, conductive yarn, acrylic, lamp parts

Inspirations: Alexander Girard, Merit Oppenheim, Fur Cup, James Turrel

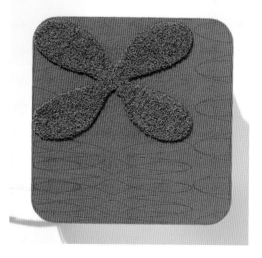

Maggie Orth, International Fashion Machines

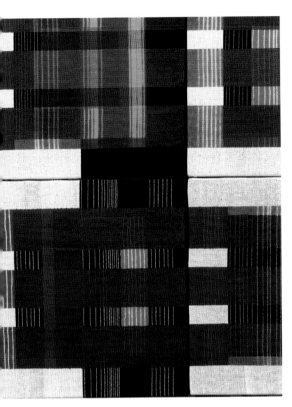

Running Plaid (2007)

International Fashion Machines, Seattle, Washington, USA

Keywords: color change textile, electronic textile, art

Touch a button to start the piece, which changes color over a 20 minute program. A woven repeat design is combined with compositional printed ink and gestural woven electronic yarns. Software explores regular patterns and randomly generated sequences. It is a black and white double weave.

Materials: conductive yarn, thermochromic ink, electronics, software

Inspirations: Alexander Girard, James Turrell, Daniel Rozin

POM POM & ESSENTIAL
Wall Dimmers
(2004 – 2007)

International Fashion Machines, Seattle, Washington, USA

Keywords: electronic textiles, light dimmer, product

The POM POM and Essential Wall Dimmers are a fun and funky alternative to the traditional plastic dimmer switch. Touching these soft textile switches dims the light. These products make a mundane activity sensual and question our assumptions about decorative form and function.

Materials: rayon, wool, conductive yarn, neoprene, electrical parts

Inspirations: Merit Oppenheim, Duchamp, Joseph Beuys

Maggie Orth, International Fashion Machines

Dynamic Double Weave (2004)

International Fashion Machines, Cambridge, Massachusetts, USA

Keywords: electronic textile, color change textile, electronic art

Dynamic Double explores how software can interact with a regular repeat design on a printed textile. Software explores regular patterns, randomly generated repeat elements and random sequences. 64 pixels hand woven on black, white, pink and navy double weave.

Materials: conductive yarn, thermochromic ink, electronics, software

Inspirations: Alexander Girard, Early America Double Weaves

Electronic Tablecloth (1999)

MIT Media Lab, Cambridge, Massachusetts, USA

with Rehmi Post, MIT Media Lab students

Keywords: electronic textile, electronic embroidery

The Electronic Tablecloth allows viewers to communicate and play games by touching a keypad embroidered into the tablecloth. Information (visual output) is displayed on the LED text displays in the centerpiece.

Materials: conductive yarns, rayon, appliquéd metallic silk organza, linen, sensing electronics, tag reader, PC, LED text displays, light emitting center piece

Inspirations: textile design, Art Nouveau textile and furniture design

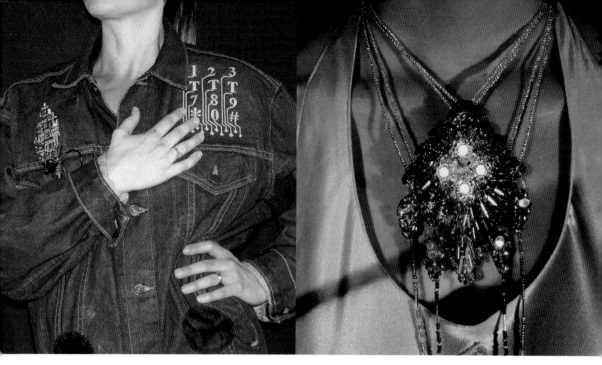

Musical Jacket (1997)

MIT Media Lab, Cambridge, Massachusetts, USA

with Rehmi Post, Joshua Smith, Joshua Strickon, Emily Cooper

Keywords: electronic textile, fashion, e-fashion, electronic embroidery

The Musical Jacket integrates a wearable MIDI synthesizer with an embroidered keypad. Sensing electronics place a small electrical charge on each number embroidered from conductive thread. When the wearer touches the number, the body draws the charge to ground. Electronics sense the change to trigger a musical event.

Materials: resistive yarns, metallic silk organza, power and data bus, electronics, speakers, MIDI synthesizer, batteries

Inspirations: Tod Machover, Joe Paradiso, Lori Anderson, Joseph Beuys

Firefly Dress & Necklace (1995)

MIT Media Lab, Cambridge, Massachusetts, USA

with Emily Copper, Derek Lockwood

Keywords: electronic textile, fashion, e-fashion

The dress is sewn with layers of conductive material separated by tulle and LEDs with conductive Velcro brushes are attached. As the wearer moves the Velcro contacts the conductive fabric and causes the LEDs to light. The necklace is powered by conductive tassels that brush an embroidered power plane on the dress.

Materials: metallic organza, conductive yarns, Velcro, LEDs, gold beads, silk, electronics

Inspirations: Thad Starner, MIT Media Lab Wearable Group, antique clothing, 'Meat Dress' by Jana Sterbak, 'Speaker Bra' by Charlotte Mormon, Joseph Beuys

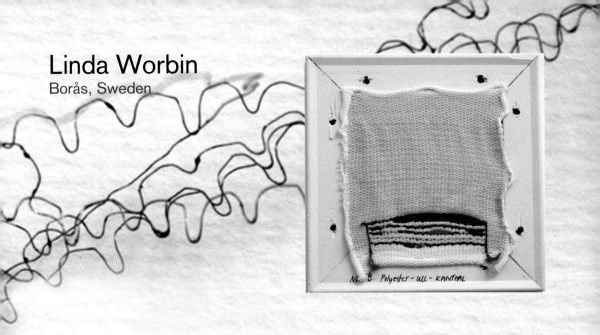

Linda Worbin
Borås, Sweden

No. 8 Polyester - ull - KANTHAL

Biography: Linda is a textile designer and PhD Student at the University College of Borås, the Swedish School of Textiles and Chalmers University of Technology, Gothenburg, Sweden. Linda's research is focused on designing dynamic textile patterns. Textiles that exemplify this are controlled by computational technology and have the ability to change expression during use. In her work, Linda explores dynamic aesthetic expression in textile patterns and structures.

Knitted Circuits And Irreversible Textile Patterns (2007 – ongoing)

Swedish School of Textiles, University College of Borås, Sweden

with Anna Persson

Keywords: dynamic textile patterns, textile circuits, experiment

The project is an example of a new technique used for designing dynamic patterns, in this case irreversible textile patterns. The textile structure and/or pattern is changed by applying voltage to the interwoven Kanthal thread, which first heats up and then affects the combined materials in different ways. Both natural and synthetic materials are used for diversity in aesthetic expression. By adding voltage at different times a dynamic and irreversible textile pattern is created.

Materials: Kanthal thread, cotton, wool, polyester in circular knitted and woven fabrics, BX24

Costumes (2006)

Swedish School of Textiles, University College of Borås, Sweden

with Amy Bondesson

Keywords: experimental design, dynamic textile patterns

This experimental design research project examined dynamic textile materials and patterns in a costume context. A collection of six costumes was made, each reacting to UV-light, temperature or voltage. Depending on environmental conditions and body movements, the visual expression of the costumes changes. Both the woven and knitted textiles are specially made for the costume project using thermo, photochromic, electro luminescent, conductive and traditional textile materials.

The Fabrication Bag – An Accessory To A Mobile Phone (2005)

Swedish School of Textiles, University College of Borås, Sweden

with Hanna Landin

Keywords: dynamic textile pattern, aesthetics as communication

A bag interacts with the mobile phone contained inside and changes its visual expression depending on the number of calls received and the identity of the caller. The bag's textile pattern responds to a computer program, which is reacting to the real time activity of the mobile phone.

Inspirations: 'Inside/Outside' by Katherine Moriwaki, J. Redström et al 'Informative Art: Using Amplified Artworks as Information Displays'

Linda Worbin

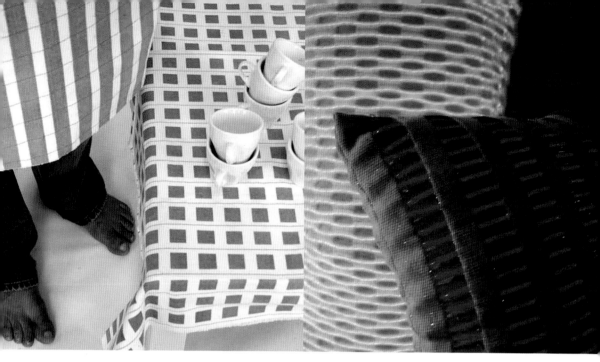

Textile Disobedience
(2003 – 2004)

The Interactive Institute, PLAY Studio & Swedish School of Textiles, University College of Borås, Sweden

Keywords: dynamic textile pattern, smart textiles

This project investigates textile patterns that are a bit disobedient in the sense that they behave differently to what we traditionally expect from textile patterns. Two types of dynamic textile patterns were designed. The tablecloth 'Rather Boring' has hidden messages that become visible when the tablecloth is exposed to heat. In 'Being Squared' a striped apron, when turned on, adapts to match the checked pattern of the tablecloth in a chameleon type reaction.

Inspirations: 'History Table' by Loop, International Fashion Machines, X. Tao 'Smart fibres, fabrics and clothing'

The Interactive Pillows
(2001 – 2002, 2004)

The Interactive Institute, PLAY Studio in collaboration with Marks Pellevävare & Swedish School of Textiles, University College of Borås, Sweden with Christina von Dorrien, Patricija Jaksetic, Erik Wistrand, Anders Ernevi, Daniel Eriksson, Johan Redström, Maria Redström

Keywords: dynamic textile pattern, aesthetics, communication, electroluminescent

The Interactive Pillows are based on the idea that the pillows should be able to interact regardless of geographical distance. When one of the pillows is hugged or leaned against, the pattern of the other pillow changes its aesthetic expression. The first generation of pillows were woven on a handloom and made of wool, electroluminescent wire and effect yarn. The second generation of pillows were made on an industrial weaving machine, using the same materials.

CHAPTER **FOUR**

4 Scientific Couture

Donna Franklin
Perth, Australia

Biography: Donna recently completed her Master of Arts at Edith Cowan University. During this time she collaborated in various projects working with microbiology technologies. Using performance, installation and film her projects explore themes such as the dynamics between art and science and the commodification of bodies and organisms. She is currently a tutor in Cultural History and Theory, SCCA, ECU. Donna has exhibited biological and non-biological works at BEAP04 Bio Difference: The Political Ecology, Hatched 05 PICA, BEAPworks06 in Australia, "Second Skin" ENTRY06, Vitra Design Museum in Germany and the Ars Electronica Festival 07 in Austria. Gary is a scientific technician with the FNAS teaching laboratories. Some of the art projects he has engaged with include sculpting with plant tissue and microbial specimens. Gary exhibited the Micro'be' Fermented Fashion project with Donna Franklin; Bioalloy and the Body Performance in Singapore 2006 and Bleeding Tent 1 & II in Venice and Kassel 2007 with S. Chandrasekaran.

Micro'be' Fermented Fashion
(2006 – ongoing)

Faculty of Natural and Agricultural Sciences
Teaching Labs in collaboration with Edith Cowan
University, Perth, Australia
with Gary Cass

Keywords: bio-textiles, living microbes (Acetobacter),
wine fermentation, commodity culture, vivo culture

Imagine a fabric that grows... a garment that
forms itself without a single stitch! The Micro'be'
project aims to develop innovative research into
the production of unique fermented garments
grown with a novel method that uses cellulose
creating bacteria. The Micro'be' team investi-
gates the practical and cultural biosynthesis of
microbiology to explore forms of futuristic dress-
making and textile technologies. A fermented
garment will not only redefine the meaning of tra-
ditional interactions between body and clothing
but will also examine the practicalities and cul-
tural implications of commercialisation. Micro'be'
fermented wear will be produced through bacte-
rial wine fermentation. This activity's by-product
is the synthesis of large quantities of cellulose
microfibrils synonymous to plant based cotton.
This collaborative project allows the biological
clothing to be worn on the body without issues of
fragility or outside contamination.
Inspirations: art and science collaborations,
theories on evolution

Donna Franklin

Seduction and the Sinister (2006)

The Faculty of Natural and Agricultural Sciences
Laboratories, The University of Western
Australia, Perth, Australia

Keywords: ethics, manipulation of body, spectacle, aestheticism, fetishism, art, fashion

The project examines the issues raised by wearing biological material. Garments contain hidden pockets of fungi that are revealed during the performance through the act of cutting, tearing and sewing. Biological textiles result from the manipulation of mycological practices. The horror of wearing fungi so close to the skin is hidden in the aesthetic illusion of vibrant fungi prints and luxurious fabrics.

Materials: silks, digital prints, organza, media, fungi, threads, film, projections, live performance bodies

Inspirations: Theodore Adorno, Guy Debord, Alexander McQueen, ORLAN, 'Metropolis'

Donna Franklin

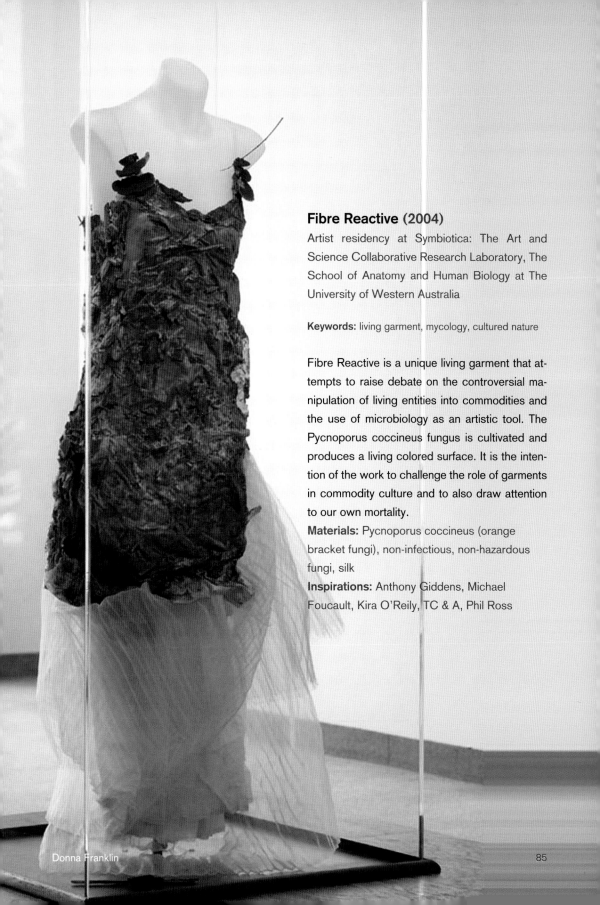

Fibre Reactive (2004)

Artist residency at Symbiotica: The Art and Science Collaborative Research Laboratory, The School of Anatomy and Human Biology at The University of Western Australia

Keywords: living garment, mycology, cultured nature

Fibre Reactive is a unique living garment that attempts to raise debate on the controversial manipulation of living entities into commodities and the use of microbiology as an artistic tool. The Pycnoporus coccineus fungus is cultivated and produces a living colored surface. It is the intention of the work to challenge the role of garments in commodity culture and to also draw attention to our own mortality.

Materials: Pycnoporus coccineus (orange bracket fungi), non-infectious, non-hazardous fungi, silk

Inspirations: Anthony Giddens, Michael Foucault, Kira O'Reily, TC & A, Phil Ross

Donna Franklin

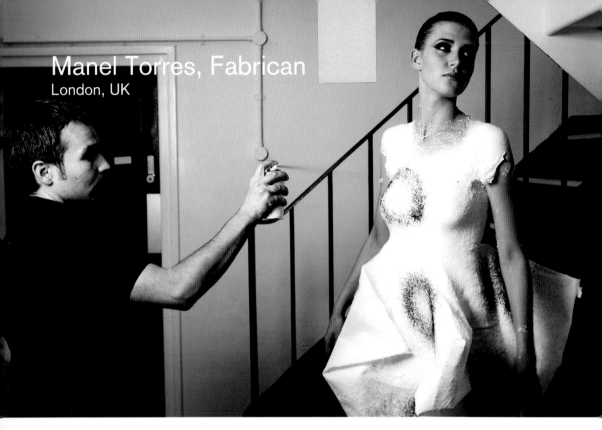

Biography: Manel is the Managing Director of Fabrican Limited, an academic visitor at Imperial College, a lecturer at the Istituto Marangoni, and a visiting lecturer at the Royal College of Art in London. He studied Women's Wear Fashion Design at the Royal College of Art. He thereafter embarked on a PhD at the same College and in collaboration with Imperial College in London. His research involved crossing the interrelating disciplines of science and fashion design. He has worked worldwide as a fashion designer and his work has been exhibited both nationally and internationally. He continues to consult in various areas of the fashion and scientific industries.

Spray-on Fabric (since 1997, 2007)
London, UK
with Paul Luckham

Keywords: magic, instant, mythological, original, unique, personal

Spray-on Fabric is a patented technology developed by Fabrican. It utilizes a suspension of polymers and suitable fibers which can then be easily sprayed on to any surface using either a spray gun or an aerosol can. The fabric is formed by the cross-linking of fibers which adhere to create an instant non-woven fabric. Intricate patterns can be created in a number of colors leading to a variety of aesthetically pleasing fabrics. With the prototypes, Fabrican has been able to use different types of natural and synthetic fibers and to incorporate scents and colors (from primary to fluorescent). An innovative non-woven material, Spray-on Fabric offers numerous possibilities for binding, lining, repairing, layering, covering and

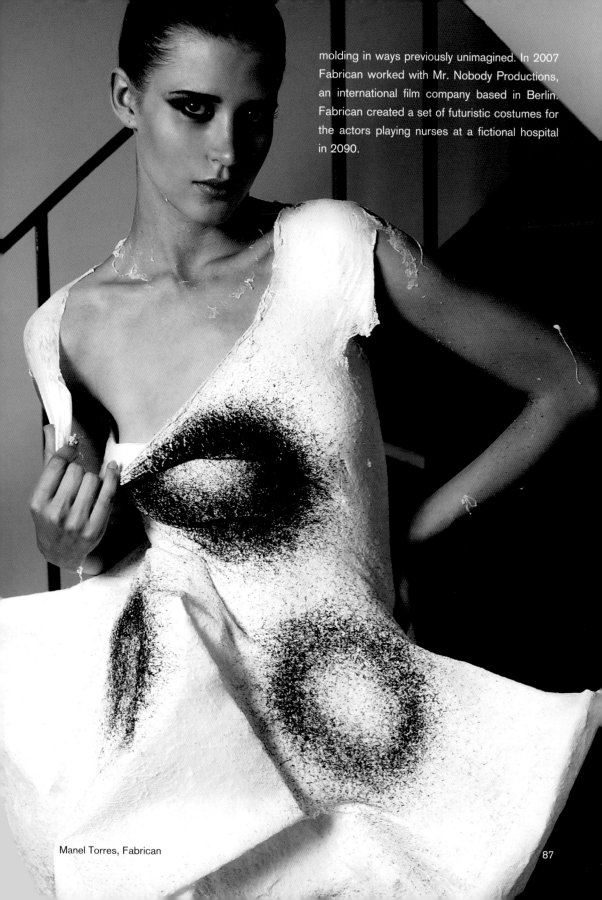

molding in ways previously unimagined. In 2007 Fabrican worked with Mr. Nobody Productions, an international film company based in Berlin. Fabrican created a set of futuristic costumes for the actors playing nurses at a fictional hospital in 2090.

Manel Torres, Fabrican

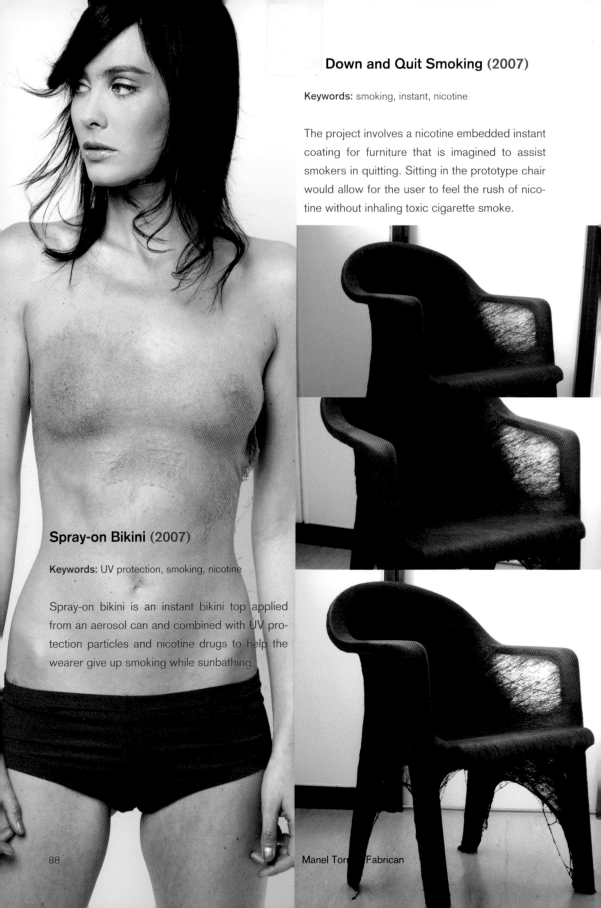

Down and Quit Smoking (2007)

Keywords: smoking, instant, nicotine

The project involves a nicotine embedded instant coating for furniture that is imagined to assist smokers in quitting. Sitting in the prototype chair would allow for the user to feel the rush of nicotine without inhaling toxic cigarette smoke.

Spray-on Bikini (2007)

Keywords: UV protection, smoking, nicotine

Spray-on bikini is an instant bikini top applied from an aerosol can and combined with UV protection particles and nicotine drugs to help the wearer give up smoking while sunbathing.

Manel Torres Fabrican

Tobie Kerridge
London, UK

Biography: Tobie is a research fellow in the Interaction Research Studio at Goldsmith University in London. He works on collaborative projects supported by Intel, France Telecom and the Engineering and Physical Sciences Research Council. His research explores how design methods can be extended to provide individuals with creative ownership of technology. He is also a visiting lecturer at the RCA, TU/e and Camberwell. Before graduating with an MA in Interaction Design from RCA, Tobie took a BA in English literature and Fine Art at Oxford Brookes University.

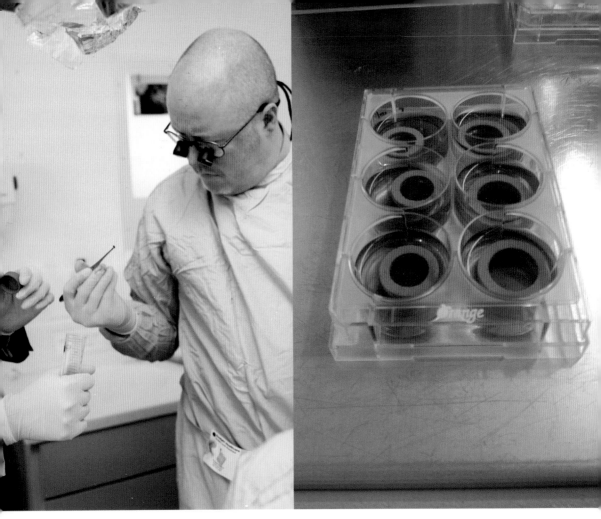

Material Beliefs (2007 – 2009)

Goldsmiths, University of London, London, UK
with James Auger, Elio Caccavale, Jimmy Loizeau, Susana Soares

Keywords: collaboration, interfaces, hybrids, engineering, design

Material Beliefs is a residency program that links engineers with designers. The aim of these reflective collaborations is to generate a body of work for public exhibition and engagement events. The project is focusing on technologies that blur the boundaries between our bodies and materials. It asks the question, 'how can we deploy design to invigorate a discussion about the value of these forms of hybridity?'

Tobie Kerridge

Biojewellery (2006)

Royal College of Art & Kings College, London, UK

with Nikki Stott, Ian Thompson

Keywords: tissue engineering, jewelery, design, ethics, engagement

Biojewellery is the fusion of scientific research and the art of jewelery. The team collaborated to create rings for couples. Bone tissue was cultured in a lab at Guy's Hospital, using cells donated by the couples. This tissue was then combined with precious metals to create the rings. The result: each person wears a unique object that contains their lover's actual DNA on their hand. A fragment of jawbone was taken during a wisdom tooth extraction. The extracted bone was then placed in a sterile container full of culture medium. The samples were cut into very small fragments and after three to five days, cells were moved out of the bone fragments. The cells were then cultured, resulting in millions of osteoblast cells, and then seeded onto ring shaped scaffolds. The scaffolds were incubated in a cell culture medium for six weeks to form new bone mineral. The rings are then placed in electroforming tanks where a low voltage electrical current plates them with a layer of precious metal.

CHAPTER **FIVE**

5 **Sensual**Being &
TangibleTouch

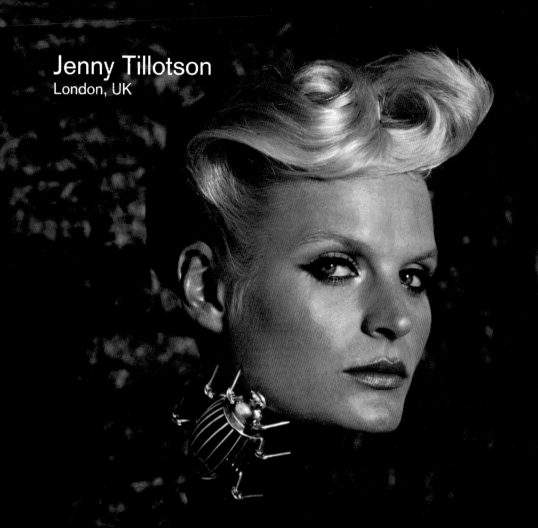

Jenny Tillotson
London, UK

Biography: Jenny is a Senior Research Fellow at the University of the Arts in London. She gained a BA in Fashion from Central Saint Martins and a PhD in Textiles from the Royal College of Art. Prior to her academic work she was a stylist and sensory designer. She has won major awards, has been widely exhibited, and is a 2006 FiFi Award nominee. She is the founder of Sensory Design & Technology, which specializes in the research and development of wearable wireless sensor networks and microfluidic devices for fragrance delivery which have therapeutic applications in 'emotional clothing'.

Jenny Tillotson

Scent Whisper (2006)

Institute of Analytical Sciences, Dortmund,
Germany & Central Saint Martins, London, UK
with Andreas Manz, Gareth Jenkins, Don
Baxendale

Keywords: scent, wellbeing, Scentsory Design

Scent Whisper is responsive jewelry that pro-
vides a new way to send a scented message. It
is inspired by the defense mechanism in spiders
and insects and focuses on bombardier beetles
that squirt predators with a high-pressure jet of
boiling liquid in a rapid-fire action. Two brooches
use microfluidics and a wireless remote sensor
linked to a fragrance-dispensing unit. The user
whispers a secret message into a spider brooch,
which transmits the message, via a humidity sen-
sor, to a beetle brooch worn by a partner, re-
leasing a minute spray of scent onto a localized
area and creating a personal 'scent bubble'. This
would benefit wellbeing, through olfaction stimu-
lation of the autonomic nervous system, and as a
novel communication system to send an aroma
message that could be seductive (pheromones),
protective (insect repellent), healing (lavender) or
informative (gas leak).

Inspirations: entomology: spiders and bombar-
dier beetles, Thomas Eisner 'For Love Of
Insects'

Scentsory Design (2005)

London, UK
with Guy Hills, Wendy Latham, Fraser Geesin,
Veshti Evens, James Feltham, David Briggs

Keywords: wellbeing, emotional fashion, aroma
rainbow

Scentsory Design explores the fusion of emo-
tional fashion with health and olfaction science.
It is a collection of responsive clothing that adds
more sensations to the fashion palette and cre-
ates radical new properties. The clothing forms
an intimate 'aroma rainbow' using microfluidics.
It pulses beneficial chemicals in controlled ways
that respond to personal needs.

Inspirations: JG Ballard, human body, mental
health issues

SmartSecondSkin (2004)

London, UK & Paris, France
with Adeline Andre

Keywords: scent, wellbeing, sensory systems

SmartSecondSkin is a scent delivery system that adds function to fashion by mimicking the body's senses, scent glands and circulatory system. Scented chemicals flow freely through the veins of the dress as the fabric selects and emits a scent depending on the wearer's mood. It has its own pseudo nervous system, which allows the garment to control, through olfactory stimulation, the emotional wellbeing of the wearer.

Sensitive Shoes (2004)

Central Saint Martins, University of the Arts
London, UK
with Steve McIntyre

Keywords: emotional wellbeing, reflexology, sensitivity, solar plexus

Sensitive Shoes is inspired by reflexology. As the wearer walks pressure points are stimulated by pressing down on sensor pads that correspond with reflexology points on the foot. Corresponding LEDs are enabled and glow from the underside of the sole. The ball of the foot touches on the solar plexus point, the centre of emotional energy, and offers a 'bath of light' so that the simple act of walking becomes a healing experience.

Jenny Tillotson

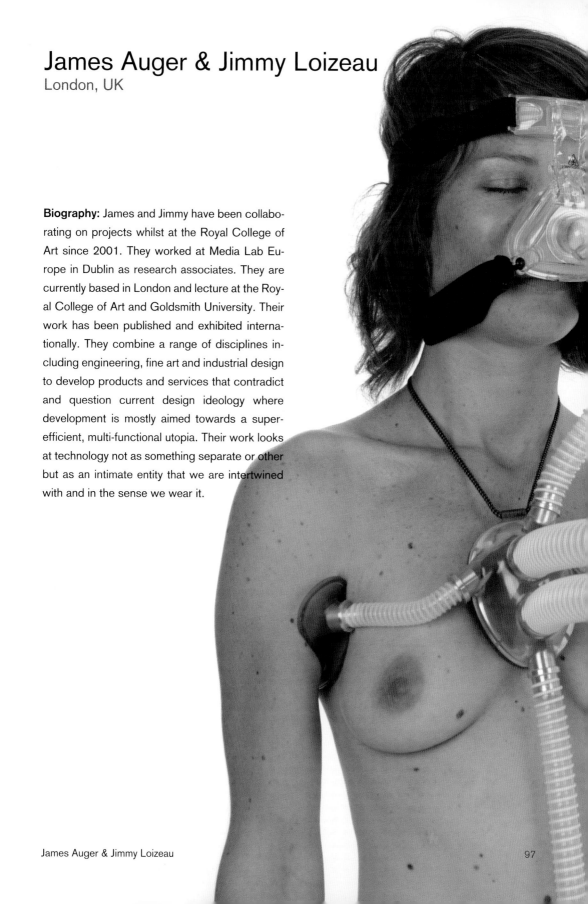

James Auger & Jimmy Loizeau
London, UK

Biography: James and Jimmy have been collaborating on projects whilst at the Royal College of Art since 2001. They worked at Media Lab Europe in Dublin as research associates. They are currently based in London and lecture at the Royal College of Art and Goldsmith University. Their work has been published and exhibited internationally. They combine a range of disciplines including engineering, fine art and industrial design to develop products and services that contradict and question current design ideology where development is mostly aimed towards a super-efficient, multi-functional utopia. Their work looks at technology not as something separate or other but as an intimate entity that we are intertwined with and in the sense we wear it.

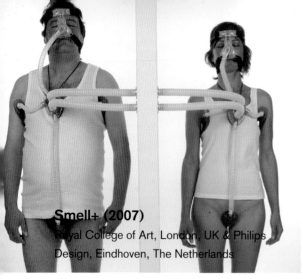

Smell+ (2007)

Royal College of Art, London, UK & Philips
Design, Eindhoven, The Netherlands

Keywords: olfaction, senses, communication

After a long hiatus, scientists have realized the
importance of the olfactory sense and its complex role in many human interactions and experiences. Research has proven that smell plays an
essential role in anything from sexual selection
to general wellbeing. However, smell is the one
sense where control is lost. Each breath we take
sends loaded air molecules over the receptors
in the nose and in turn send potentially gutteral,
uncensored information to the brain. Simultaneously our bodies are emitting sense and effecting others in ways we are only now starting to
understand. To facilitate control over both these
variables the smellsuit has been devised. Sealed
pouches encapsulate the apocrine glands preventing oxidation and channeling smells to a
chest mounted control unit. All input smells also
arrive here giving the wearer the choice of which
smell to concentrate on.

Materials: silicon rubber, epoxy resin, aluminum

Inspirations: C. Classen, D. Howes, A. Synnott
'Aroma', P. Suskind 'Perfume'

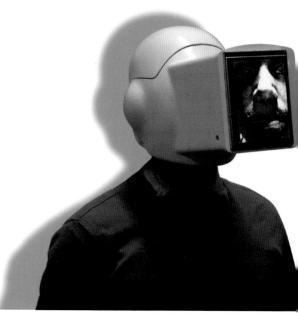

Interstitial Space Helmet
(2004 – 2007)

Dublin, Ireland & London, UK

Keywords: communication, virtual, presence, otaku

The Interstitial Space Helmet (ISH) is an experiential comment on contemporary communication
as mediated by technology. While interacting
with others via web cams and artificial personas,
the modern computer user might run into identity
problems when dealing with real people on the
physical plane. The ISH concept blurs these two
worlds, allowing the user to take elements of the
virtual into the physical realm.

Materials: polycarbonate, electronic media

Inspirations: Walter Pickler, Otaku generation

James Auger & Jimmy Loizeau

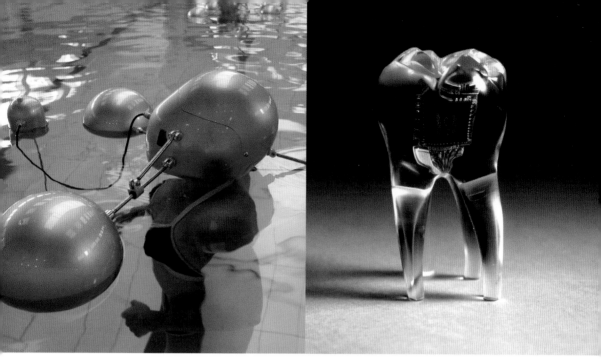

Iso-phone (2004)

Media Lab Europe, Dublin, Ireland

Keywords: communication, immersion, slow design, sensory deprivation

The Iso-phone is a telecommunication concept that can be described simply as a cross between a telephone and an isolation tank. The user wears a helmet that blocks out all unnecessary sensory input while maintaining the head above the surface of the water. The only sensory stimulus provided is a two-way voice connection to another person using the same apparatus in another location.

Materials: stainless steel, fibreglass, aluminium, electronic media, scuba mask

Inspiration: Walter Pickler, film: 'Altered States', Giles Gilbert Scott (designer of British red telephone box)

Audio Tooth Implant (2001)

Royal College of Art, London, UK

Keywords: implants, communication, cyborg, bionics

The Audio Tooth Implant is a radical new concept in personal communication. A miniature audio output device and receiver are implanted into the tooth during routine dental surgery. The tooth communicates with an array of digital devices. Sound information is transferred from the tooth directly into the inner ear by bone transduction and is totally discreet.

Materials: resin model with embedded chip

Inspirations: The 6 Million Dollar Man (1970s US TV program), Urban Myth of people hearing radio through teeth.

Adidas

Portland, Oregon, USA &
Herzogenaurach, Germany

Biography: ait is the research and development group of Adidas responsible for cutting-edge concepts and technologies for footwear, apparel and hard goods across all sport categories. The people at ait bring with them a vast and varied range of experience and expertise in industrial design, biomechanics, materials engineering, mechanical engineering, finite element analysis, advanced 3D CAD design and product development. Their research laboratories include facilities for high-speed motion analysis, motion tracking systems, traction testing, body-heat mapping and airflow analysis.

adidas_1 Basketball (since 2006)

Portland, Oregon, USA &
Herzogenaurach, Germany

Keywords: Basketball, cushioning, motor, shoe

A magnetic sensor in the heel senses the level of compression. This compression level is sent to a microprocessor that determines if the cushioning level is too soft or too firm. A motor driven cable system adapts the cushioning to make the shoe softer or firmer as needed. If the heel experiences no compression for five minutes, the shoe goes to standby mode to conserve battery life. A light on the shoe blinks to let you know the shoe is resting, but not turned off. If there is no compression after two hours, it switches itself to chill mode or off.

Adidas

adiStar Fusion (since 2006)

Portland, Oregon, USA &
Herzogenaurach, Germany
with Polar

Keywords: heart rate monitoring, running, wireless transmission

The adiStar Fusion system combines the benefits of a heart-rate monitor and a running monitor to view and analyze heart rate, distance, speed, and recovery rate data. The system includes a Polar Wearlink transmitter that measures and records every heartbeat and sends the data to the Polar RS800 running computer. The transmitter snaps perfectly onto the heart-rate sensors integrated into the front of adiStar Fusion shirts or bras. The Polar s3 sensor measures every stride from within the shoe and transmits data on speed, distance and cadence straight to the running computer. The synchronized data may even be downloaded for later viewing or analysis.

adidas_1 (since 2005)

Portland, Oregon, USA &
Herzogenaurach, Germany

Keywords: running, cushioning, motor, shoe

The adidas_1 uses a sensor and a magnet to determine whether the cushioning level is too soft or too firm via a microprocessor. It adapts with a motor driven cable system to provide the correct cushioning throughout the run. The motor, housed in the midfoot, receives the microprocessor's instructions and adapts by turning a screw, which lengthens or shortens a cable. The length of the cable determines the compression of the cushioning element.

Textronics
Wilmington, Delaware, USA

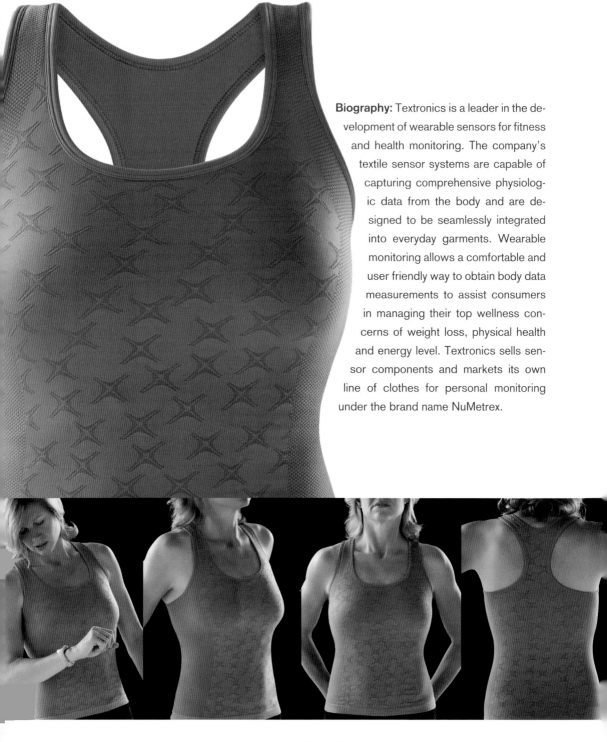

Biography: Textronics is a leader in the development of wearable sensors for fitness and health monitoring. The company's textile sensor systems are capable of capturing comprehensive physiologic data from the body and are designed to be seamlessly integrated into everyday garments. Wearable monitoring allows a comfortable and user friendly way to obtain body data measurements to assist consumers in managing their top wellness concerns of weight loss, physical health and energy level. Textronics sells sensor components and markets its own line of clothes for personal monitoring under the brand name NuMetrex.

NuMetrex Fitness Apparel (2007)

Wilmington, Delaware, USA

Keywords: smart apparel, heart rate monitor, fitness apparel, e-textiles

NuMetrex fitness apparel uses smart fabric technology to sense heart rate and transmit it to a wristwatch or exercise machine. The NuMetrex Heart Sensing Racer Tank is a sleeveless tank top and features a shelf bra where the electronic sensing technology is integrated into the fabric to monitor heart rate. A tiny transmitter snaps into a pocket in the shelf bra to send data to a compatible monitoring device. The NuMetrex Cardio Shirt for Men is constructed with special sensory fibers integrated directly into the garment. The conductive fabric moves comfortably with the body, picking up the heart's pulse and sending it to a compatible watch or cardio machine via a tiny transmitter that is snapped into a pocket on the shirt.

NuMetrex Sports Bra (since 2005)

Wilmington, Delaware, USA

Keywords: smart apparel, heart rate monitor, fitness apparel, e-textiles

The NuMetrex heart sensing sports bra pioneered textile sensing technology. NuMetrex apparel can be worn with the NuMetrex transmitter and compatible analog heart rate monitors. They are also compatible with the Polar Wearlink transmitter and all Polar heart rate monitors.

Textronics

Cati Vaucelle
Boston, Massachusetts, USA

Biography: Cati is a research assistant and PhD candidate at the Massachusetts Institute of Technology in the Tangible Media Group. Her extensive experience in electrical engineering and product design fosters her research on how our expectations of physical space are transformed by digital technology. She is fascinated by the spatial qualities of personal experience and explores the imaginary mechanics of recollection. She mines people's associative memory for elements in their life by creating expressive tools. She researches seamless sensory interventions that provide the wearers with the opportunity to use fashion as a supporting treatment.

Touch•Sensitive (2007)

Tangible Media Group, MIT Media Laboratory, Cambridge, Massachusetts, USA
with Yasmine Abbas

Keywords: apparel, wearable, haptic, massage therapy, sensory interface, fashion

The Touch•Sensitive apparel evolved from the observation that people need to sooth their bodies to protect themselves from everyday aggressions. The device consists of a matrix of clothing elements that allows transmission of tactile information through heat sensors, mechanically driven textural sensation and liquid diffusion. Its material is envisioned to detect the user's comfort level. Touch•Sensitive soothes and alliviates by detecting points of stress and delivering an electronically actuated massage.

Inspirations: Architectradure: http://architectra-dure.blogspot.com/, Neo-Nomad: http://blog.neo-nomad.net/, Marquart S., Morra J. 'The The Prosthetic Impulse, From a Posthuman Present to a Biocultural Future'

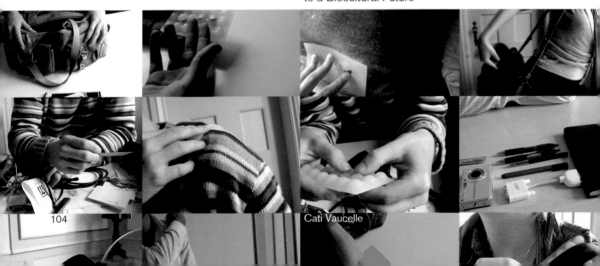

Cati Vaucelle

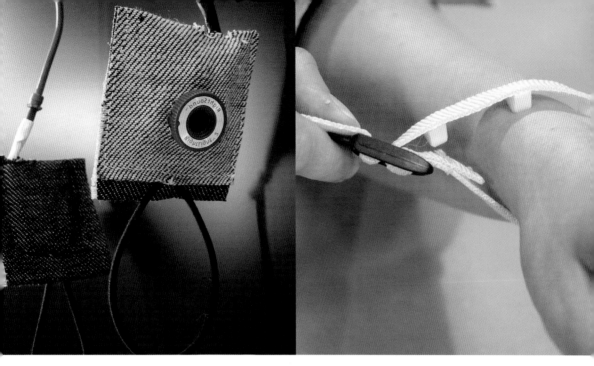

Picture This (2007)

Tangible Media Group, MIT Media Laboratory, Cambridge, Massachusetts, USA
with Hiroshi Ishii

Keywords: children, toys, accessories, video, gesture, film assembly

Picture This is a new input device for video capturing and editing. Designed for young children, ages five and up, it allows them to craft compelling movies through the motion analysis of their interaction with toys. Picture This is both a doll hand-bag and a doll audiovisual recorder. Children's favorite props alternately serve as characters and camera men in a film. As children play with the toys to act out a story, they conduct algorithmic film assembly.

Psychohaptics: A Series Of Wearables To Support Psychotherapy (2006)

Tangible Media Group, MIT Media Laboratory, Cambridge, Massachussetts, USA,
with Leonardo Bonanni, Hiroshi Ishii

Keywords: haptic, self-mutilation

Psychohaptics is a diverse set of touch modalities simulations that assist in the treatment of specific mental disorders. Based on the most promising touch-therapy protocols, haptic interfaces are implemented to support treatments at a local hospital. The interfaces include Cool Me Down: a flexible electronic cold wrap containing electronic heat pumps. Hurt Me: a wearable haptic device that generates controlled pain as a form of sensory grounding for persons with tendencies towards self-harm. Squeeze Me: a vest that simulates therapeutic holding. Touch Me: a system for the remote application of touch therapy similar to the Wilbarger Protocol.

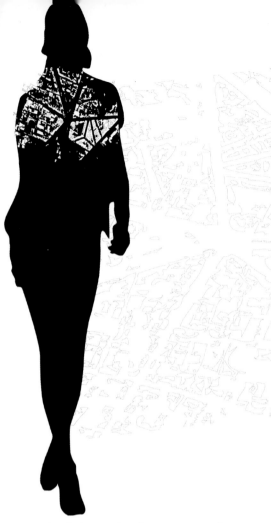

Taptap (2005)

Graduate School of Design, Harvard University & MIT Media Laboratory, Cambridge, Massachussetts, USA

with Leonardo Bonanni, Jeff Lieberman, Orit Zuckerman

Keywords: haptic, wearable, touch therapy, fashion design

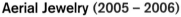

Aerial Jewelry (2005 – 2006)

Graduate School of Design, Harvard University & MIT Media Laboratory, Cambridge, Massachussetts, USA

Keywords: jewelry, fashion, aerial, satellite imagery

Aerial patterns of a city are transformed into jewelry. With the use of computer assisted drawing and computer fabrication GIS files from a location, e.g. a city, are imported and its shadows and interstices are engraved onto metal. These metal pieces become jewels. Each person could posses a distinctive jewel from his or her hometown.

Taptap is a wearable haptic system that allows nurturing human touch to be recorded, broadcast and played back for emotional therapy. Contained in a convenient modular scarf the haptic input/output modules provide a personalized affectionate touch. Taptap can be configured to record and play back a touch that is most meaningful to the each user. It is constructed from two layers of felt. An outer grey one and a pink layer that contains the haptic modules in specially designed pockets.

Cati Vaucelle

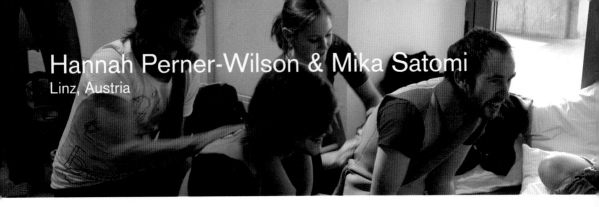

Hannah Perner-Wilson & Mika Satomi
Linz, Austria

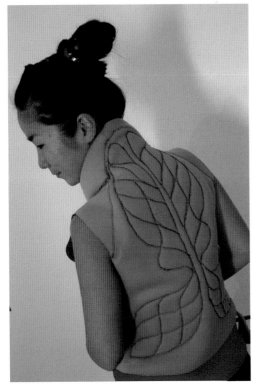

Massage me (2007)

Interface Cultures, University of Arts and Industrial Design, Linz, Austria & Interface Design, Bauhaus University, Weimar, Germany

Keywords: massage, multi user, interface, video games, touch, jacket, gamepad hack, DIY, human computer interface

Massage me is a wearable massage interface that turns a video game player's excess finger energy into a back massage for the innocent bystander. Playing Massage me requires two people, one to wear the jacket and receive the massage and another to play the game thereby massaging the wearer. The player is equally a gamer and a masseur. Soft flexible buttons made from layers of conductive fabric are embedded in the back of the jacket, turning the wearer's back into a gamepad.

Materials: stretch conductive fabric, foam, neoprene, iron-on, silicone, shielded wire, thread, game controller, game console (Playstation)

Inspirations: Stephan Freundorfer 'Joysticks, Eine illustrierte Geschichte der Game-Controller 1972-2004', Stewart Mitchell 'The Complete Illustrated Guide to Massage'

Biography: Hannah studied Industrial Design and Mika is currently a doctoral student in Interface Culture at the University of Arts and Industrial Design Linz. Massage me is their first collaboration project, however they continue to work together exploring the realm of wearable technology. They bring a spirit of humour to technology and a twisted criticism toward the stereotypes it creates. For them, technology is to be hacked, DIYed and modified to fit everyone's needs and desires.

Kai Eichen & Marit Mihklepp & Hanna Tiidus
Tallinn, Estonia

Biography: After graduating highschool Kai studied tailoring and pattern construction. She worked one year at a small t-shirt production studio which increased her interest in design. In 2004 she entered the Estonian Academy of Arts majoring in textile design.

Hanna decided to study textile design at the Estonian Academy of Arts after finishing art highschool. For one year she was an exchange student at the University of Ljubljana for jacquard weaving and graphical design. Since graduating she continues to focus on the fields of textile and graphic design. Marit loves to communicate with the world through textile design, which she has been studying at the Estonian Academy of Arts since 2004. Currently her interest lies in the virtual sphere of design focusing on electronic textiles, dynamic patterns, sound art and video.

Kai Eichen & Marit Mihklepp & Hanna Tiidus

SpringOn (2007)

Estonian Academy of Arts & The Estonian Information Technology College, Tallinn, Estonia with Margus Ernits, Kärt Ojavee

Keywords: eternal spring, starlight, sunny weather, warm feet, flowers

The project contains three objects: a carpet by Hanna Tiidus, a tablecloth by Kai Eichen and a pillow by Marit Mihklepp. Together they create a relaxing atmosphere of spring, nature, light and warmth. This project is inspired by the long, cold and dark Estonian winters when everybody tends to get seasonally depressed and frustrated. Traditional techniques such as silkscreen printing, embroidering, sewing, felting and weaving were combined with electronics to produce interior design objects. The electronic aspects are hidden so the pieces project a natural and warm feeling while containing a number of surprises. The carpet is woven on hand-looms and is made of 100% wool and felted wool. It includes a hidden heating system made from an electrical heating-blanket and a switch made of conductive fabric. The tablecloth is a silkscreened object with a floral pattern printed using regular ink. A hidden puzzle printed with thermochromic ink reveals itself upon contact with heat. The cloud-pillow is made of hand-embroidered textile, electro-optical fiber and swing-ropes. Inside there is thick foam rubber, 6 LED-systems and a switch made of conductive fabric.

CHAPTER **SIX**

6 Wearable Explorations

Despina Papadopoulos
Studio 5050
New York, New York, USA

Biography: Studio 5050 was founded in the summer of 1995 by Despina Papadopoulos. The Studio's mission is to stretch the boundaries of fashion, design, technology, art and ideas, and to engage in an open dialogue between these disciplines. Studio 5050 was featured in I.D.'s 40 January 2007 Issue, 'Celebrating the Collective', as one of the world's most interesting and promising collectives. Despina graduated from NYU's Interactive Telecommunications Program in 1994 after having received an MA in Philosophy from the University of Leuven, Belgium. The nature of the sublime and non-verbal communication led Despina to create a series of 'philosophy machines', experiments in design and technology, which probe the relationship between magic, technology and fashion. Despina has lectured extensively, her work has appeared in museums and galleries around the world and has been featured in many publications and magazines. She is an adjunct professor at NYU's Interactive Telecommunications Program. Her work for Interval Research Corporation and NCR's The Knowledge Lab has been awarded numerous patents. Zach is an electrical engineer who believes that the best use of technology is to make life more interesting. Zach graduated from the Interactive Telecommunications Program at New York University in 2007. He has been working with Despina, since October 2006, on the electronic modules that bring the Shadow to Light Collection to life.

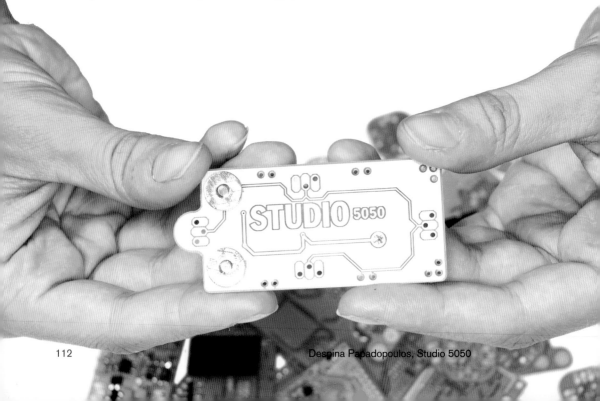

Golden Fleece, Shadow to Light Collection (2007)

New York, New York, USA

with Zach Eveland, Andrea Lauer

Keywords: modularity, flexibility, wearable Lego, magic, serendipity, humor, communication

Golden Fleece is a luxurious, gold leather, supple lambskin top that evokes the cut of samurai armor and hugs the body with a graceful drape. Side straps attaching to Sam-Brown buttons allow the top to be worn directly on the body or over a turtleneck and make this a versatile item. A meandering stitch-pattern made of conductive thread on the underside of the leather, turns the entire garment into a surface where small electronic units can be easily attached. Its modern urban armor, for the modern digital fashionistas who crave weaving their electronics as they like, when they like, where they like.

Inspirations: Greek mythology, Lego blocks

The Masai Dress, Shadow to Light Collection (2007)

New York, New York, USA

with Zach Eveland, Andrea Lauer

Keywords: ethnography, imagination, musical narrative, playfulness

Inspired by Masai wedding collars, this dress salutes both our global provenance and our desire to create our own soundtrack as we move about in mysterious ways. With every step, strings of hand-formed silver beads that hang from the collar brush against conductive threads sewn into the dress, generating a series of sounds. A leisurely walk or a night at a cocktail party turns into an improvisational performance. A long asymmetrical swoop in the back of the dress recalls Balenciaga's famed wedding dress, homage to a maestro who visually and aurally blends cultures, traditions and emotions. The dress comes in a luscious deep-sky blue silk jersey and white nourishing Sea-Tiva (75% cotton, 25% algae). It is a dress that heals both body and soul.

Inspirations: Masai wedding collars

Despina Papadopoulos, Studio 5050

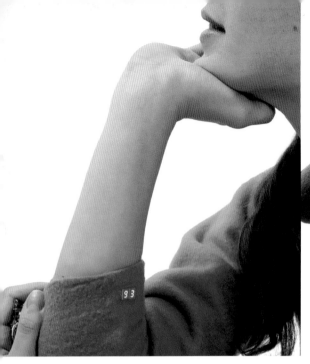

The T-Sweater, Shadow to Light Collection (2007)

New York, New York, USA

with Zach Eveland

Keywords: ambient reflection, awareness, modules, wearable one-liner

The T-Sweater is a snug, fleece sweater that sports a radiant yet discreet temperature-display on each sleeve (one in F° and the other in C°). The sweater's cut embraces the body on all sides. It is a cozy and sexy armor fashioned from fleece. Made of two interlocking panels, the sweater mimics early construction techniques where loom widths dictate the rules of construction and design. The old and new, our human path and a bit of humor make the temperature sweater a warm must-have addition to the wardrobe.

The Embrace, Shadow to Light Collection (2007)

New York, New York, USA

with Zach Eveland, Andrea Lauer

Keywords: communication, exchange, symbolic transfer of energy

The fitted dark-blue canvas hoodie sports the collection's abstracted logo in a pattern made of a futuristic silver conductive fabric. When two people wearing the hoodies embrace they actually power each other up through that pattern. The symbolic energy transfer becomes fully actualized and the embrace is instantly translated into an explosion of light and sound. Small white lights flicker in the back of each hoodie forming a big-dipper pattern while a faint heart beat sound is emitted. The designs of the hoodies themselves take their inspiration from the construction of early Siberian hooded coats and create an enveloping safe haven, a tranquil vestige of protection and romanticism. The hoodies also come in a luxurious, cashmere-like 100% bamboo basket weave - very huggable indeed.

Despina Papadopoulos, Studio 5050

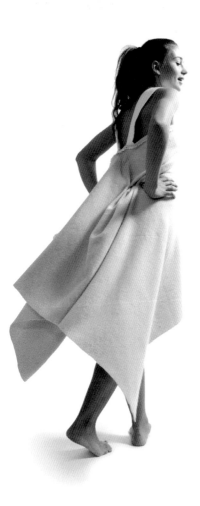

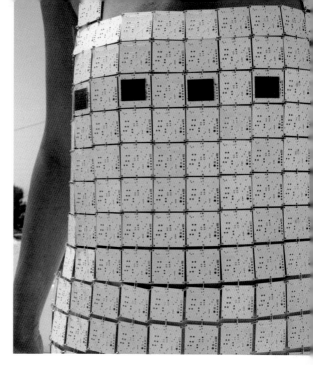

Day-for-Night (2006)

Residency at First Andros International, Andros, Greece & New York, New York, USA
with Jesse Lackey

Keywords: solar cells, modules, Paco Rabanne, reconfigurability, material exploration, beauty in electronics, perspective shift

The Flicker Dress, Shadow to Light Collection (2007)

New York, New York, USA
with Zach Eveland, Allie Haskell

Keywords: experimental fabric design, flickering, analog circuits, embodiment

Walk in the light, walk as light: a dress made in lusciously soft off-white cashmere. Tiny lights are sewn under the fabric. Each step activates the lights and the white wool becomes a shimmering, reflective surface. The dress design is simple and modular. A tight torso with a dramatic loose drape allows this dress to change length and to easily transform into a radiant shawl.

Day-for-Night, an homage to Paco Rabanne is a celebration of the beauty of electronics. It is a modular and reconfigurable dress comprised of 448 white circuit boards. Each tile is designed to accommodate a solar cell, a RGB LED, and jumper connectors. A control board provides power, communicates with the tiles, and links to a computer via RF. A microcontroller relays data to and from the dress via a 2.4 GHz RF link.

Despina Papadopoulos, Studio 5050

ClickSneaks (2005)

New York, New York, USA

with Thomas Gregoriades

Keywords: playfulness, anticipation, expectations, subversion

The ClickSneaks were conceived while walking down a cobblestone street, wearing a comfortable pair of sneakers next to a friend wearing high heels. The sound of the heels produced a rich aural echo. For the ClickSneaks the sound of the inspirational high heels has been recorded, only to be activated with each step the revamped sneakers take. The original 'click' sound is recorded on a voice chip, while a speaker, amplifier and an accelerometer acting as a 'switch', transform these seemingly normal sneakers into a flighty performance.

LoveJackets (1995, 2005)

New York, New York, USA

Keywords: love, communication, signals, objectiles

A pair of jackets emits, and polls for, a particular signal. Once the pair find and face each other within a 10 feet distance, the two beep, emitting a sound akin to crickets mating, and a pattern of LEDs starts blinking. Each jacket responds only to its unique opposite. The technology used is basic: an infra-red receiver and transmitter, a PIC chip that controls the LEDs, the speaker output and also sends out the 'bits' of code that allows the pairs to find each other. The components are attached to the circuit board via conductive fabric conduits.

Despina Papadopoulos, Studio 5050

Moi (2002)
New York, New York, USA

Keywords: jewelry, LED, light

Moi is about light and about the ability of all of us to appropriate light, and in doing so, inadvertently, appropriate technology. Moi is best received when people approach it as magical unexpected sparkle and not so much as technology. However, it is in fact made of the most basic parts present in almost all devices: an LED, wire and a battery.

mbracelet (1999)
New York, New York, USA & London, UK
with The Knowledge Lab, NCR

Keywords: relationship technologies, iButtons, expressivity, gestural interfaces, communication

The mbracelet explores wearable computing applications for financial transactions with ATM machines. It has 3 slots that can receive interchangeable iButtons. The mbracelet's mechanism was built onto a flexible circuit and molded in polyurethane in eight bright colors. A connection between mbracelet and a host is veryfied through a tri color LED grid. The mbracelet's 'plug' interface allows users to exchange messages by performing a cross handshake.

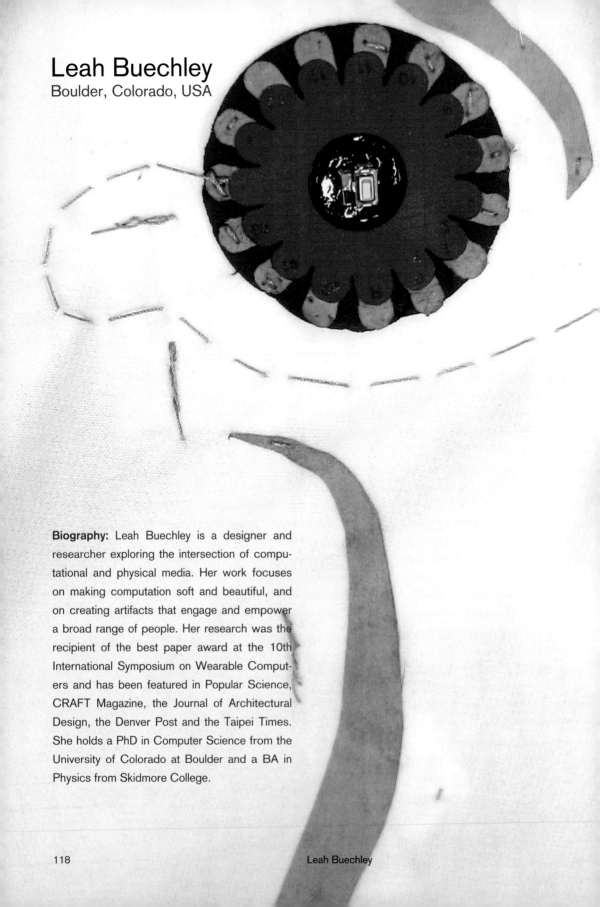

Leah Buechley
Boulder, Colorado, USA

Biography: Leah Buechley is a designer and researcher exploring the intersection of computational and physical media. Her work focuses on making computation soft and beautiful, and on creating artifacts that engage and empower a broad range of people. Her research was the recipient of the best paper award at the 10th International Symposium on Wearable Computers and has been featured in Popular Science, CRAFT Magazine, the Journal of Architectural Design, the Denver Post and the Taipei Times. She holds a PhD in Computer Science from the University of Colorado at Boulder and a BA in Physics from Skidmore College.

projectLilyPad Arduino (a construction kit for electronic textiles) (2007)

Craft Technology Group, University of Colorado at Boulder, Department of Computer Science, Boulder, Colorado, USA
with Fun Electronics, Arduino

Keywords: LilyPad, Arduino, e-textile construction kit, fabric PCBs, electronic textiles

The LilyPad is a construction kit that enables people to build their own soft, interactive wearables. Microcontroller, sensor, and actuator pieces can be sewn together with conductive thread (the stitching creates both electrical and physical connections) and then programmed to exhibit all sorts of behavior with the Arduino software. The kit allows people, designers, artists, hackers, and kids to experiment with e-textiles. The soft version is a research prototype based on fabric printed circuit boards. Each board is constructed out of laser-cut conductive fabric attached to a traditional cloth substrate. Every input/output tab of each module is attached to a conductive fabric petal on the flower-shaped boards. The hard version of the LilyPad replicates the design of the soft version on mass produceable traditional circuit boards. This commercial version sacrifices some of the aesthetic and sensual qualities of the original, but makes creative experimentation with e-textiles broadly accessible.

Materials: cloth, conductive fabric, resin, electronics

Inspirations: Lifelong Kindergarten Group at MIT, International Fashion Machines, Jean Baptiste LaBrune, Maurin Donneaud

e-textile construction kit version 1.0 (2006)

Craft Technology Group, University of Colorado at Boulder, Department of Computer Science, Boulder, Colorado, USA

Keywords: e-textile construction kit, electronic textiles, fabric PCBs

The first e-textile construction kit introduced the idea of a construction kit for wearables. However, it was not as elegant as the LilyPad. I designed the pieces with all the habits I had formed while designing traditional circuits; though soft, the pieces were bulky and square.

Materials: cloth, conductive fabric, resin, electronics

Inspirations: Lifelong Kindergarten Group at MIT, International Fashion Machines, Jean Baptiste LaBrune, Maurin Donneaud

Leah Buechley

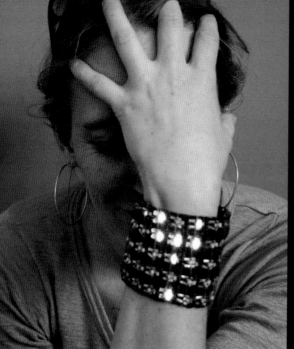 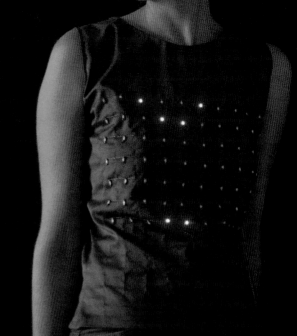

bracelets (2005 - ongoing)

Craft Technology Group, University of Colorado at Boulder, Department of Computer Science, Boulder, Colorado, USA

Keywords: bracelets, craft, beaded, wearable display, LED

The bracelets are woven on bead looms out of conductive thread. Beads and LEDs function as dynamic programmable displays that are almost as thin and flexible as classic beaded jewelry. They are controlled with soft circuitry, powered with flexible Lithium-ion batteries and can communicate with other electronic devices via Bluetooth.

Materials: beads, LEDs, conductive thread and fabric, electronics

Inspirations: traditional arts and crafts

LED clothing (2006)

Craft Technology Group, University of Colorado at Boulder, Department of Computer Science, Boulder, Colorado, USA

with Nwanua Elumeze

Keywords: wearable display, DIY

The shirt is a programmable wearable and acts as a low-resolution display. It is programmed with cellular automation and text animations. An embedded IR receiver allows the wearer to set its pattern with a PDA. The shirt was released as a do-it-yourself project that included detailed instructions on how to build one.

Materials: conductive thread, LEDs, electronics

Inspirations: MAKE magazine, CRAFT magazine

Leah Buechley

Laura Beloff & Erich Berger & Martin Pichlmair

Helsinki, Finland & Vienna, Austria

Biography: Laura is a PhD-candidate at the Planetary Collegium, Computing, Communications & Electronics, Faculty of Technology at the University of Plymouth. Her interests deal with individuals in the global society adapting to a highly complex technologically enhanced world and specializing in mobile, wearable objects. Her work examines private and public relationships to art and the individual's presence in a globally networked environment. Erich is the Chief Curator at LABoral Center for Art and Industrial Creation in Spain. Erich's artwork deals with information processes and feedback structures, which he investigates with installations, situations, performances and various interfaces. In his research and curatorial work he is focused on the trans-formation of every day life through technological conditions. Martin is Assistant Professor at the Institute for Design and Assessment of Technology, Department of Informatics at the Vienna University of Technology. He is a media artist, practitioner and theorist. His work fathoms the interstice between smart and dumb objects. In his research and publications, he focuses on the theory and practice of interactive art and design, from games and physical interfaces to community media and open source models.

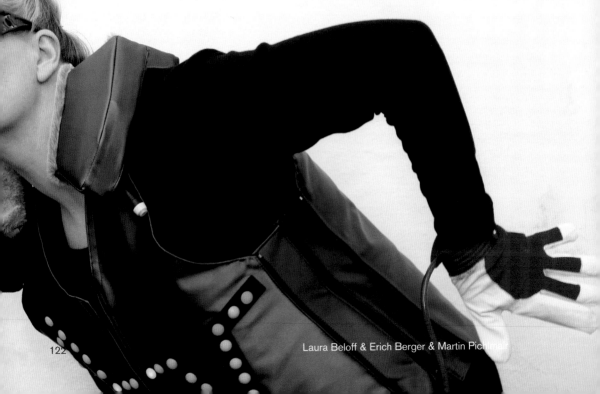

Laura Beloff & Erich Berger & Martin Pichlmair

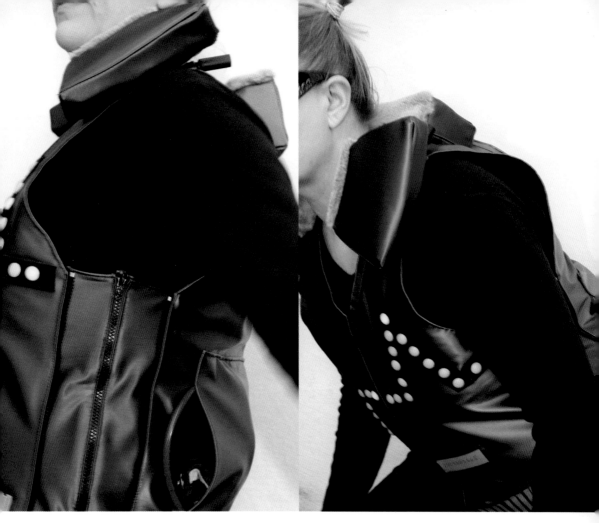

Heart-Donor (2007)

Porvoo, Finland
by Laura Beloff, Erich Berger
with Elina Mitrunen

Keywords: wearable artwork, presence, intimacy, memory, everyday life

Heart-Donor by Beloff & Berger with Mitrunen is a wearable artwork in the form of a vest, and is concerned with presence, intimacy, and memory in everyday life. Heart-Donor is made of custom built hard/software, mobile phone and textile. It explores social networks and life in a hybrid space. One collects 30 recordings of heartbeats, which are then stored into 30 small lamps embedded on the front of the vest and which blink in green. The color changes to blink in red when the person whose heartbeat is stored into the vest goes online with Skype. The wearer can then follow the selected social network of people, who are shifting their attention between the physical and virtual, wherever he may be and without dropping out of hybrid space.

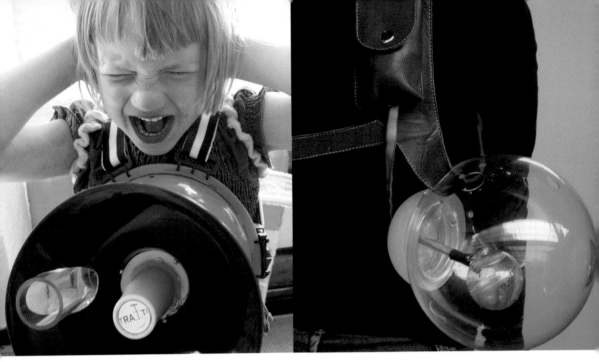

TRATTI (2006 – ongoing)

Vienna, Austria & Helsinki, Finland
by Laura Beloff, Martin Pichlmair
with Florian Gruber

Keywords: sound, music, wearable, children, device, mobile, networked

TRATTI makes funny noises. TRATTI is a wearable noise instrument for kids and a form of mobile wearable art. Once one's own voice is recorded, the TRATTI transforms it using ambient sound as a score. TRATTI connects to the universe and actual events from space can be heard as specific sound-signals. TRATTI contains custom written software for a camera equipped mobile phone, a microphone, a modified speaker-megaphone, and rechargeable batteries.

Inspiration: Luigi Russolo

The Fruit Fly Farm (2005 – 2006)

Oslo, Norway & Helsinki, Finland
by Laura Beloff
with Mika Raento, Bundes, Erich Berger

Keywords: mobile, networked, wearable, bio, organic

The Fruit Fly Farm is a work investigating the relationship between technological society and organic (insect) society, which is being observed by technology. The Fruit Fly Farm is built as a wearable object for people to adopt. It is a personal 'pet' and wearable system with public access provided via a mobile phone. The Fruit Fly Farm has a whole small-scale society under observation.

Inspiration: A rotten apple infested with by small flies.

Laura Beloff & Erich Berger & Martin Pichlmair

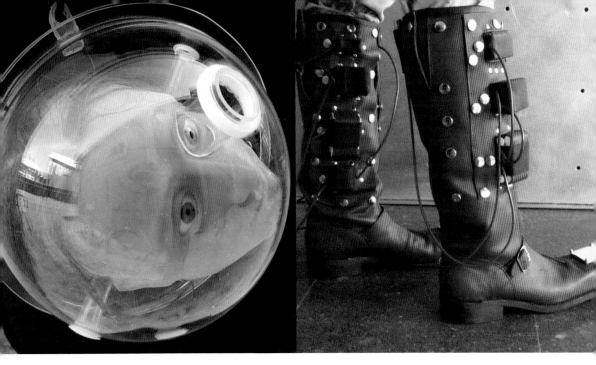

The Head (Wearable Sculpture) (2004 – 2006)

Oslo, Norway & Helsinki, Finland
by Laura Beloff
with Mika Raento, Bundes,
Juhani Rytkölä, Ari Arvola, Erich Berger

Keywords: mobile, networked, wearable, observation

The Head is a wearable sculpture with a connection to the Internet and public access provided via mobile phone/SMS. The Head is available for adoption by the public. Ideally the Head should follow its 'foster-parent' everywhere he or she may go. The public can access the Head via mobile phone by sending an SMS message. When the Head receives the SMS message it responds by capturing an image and recording a short sound. The image and sound are then sent back as a reply and automatically uploaded to Flickr.com.

Sevenmileboots (2003 – 2004)

Oslo, Norway & Vienna, Austria & Helsinki, Finland
by Laura Beloff, Erich Berger, Martin Pichlmair

Keywords: leather boots, networked, IRC chat, real time, audio, flâneur

Sevenmileboots are a pair of interactive boots with audio. When walking in the physical world one may suddenly encounter a group of people chatting in real time in the virtual world. The chats are heard as a spoken text is coming from the boots. Wherever you are with the boots, the physical and the virtual world will merge together and you become a cosmopolitan flâneur of hybrid space.

Laura Beloff & Erich Berger & Martin Pichlmair

Kate Hartman
New York, New York, USA

Biography: Kate is an interaction artist and researcher devoted to the study of what makes people tick. Her work in soft circuits seems to be the inevitable outcome of being the daughter of a fabric artist and an engineer. She chooses wearables as a platform for expression because it provides the opportunity to make work that is experienced in one's own personal space. Kate holds a B.A. in Film and Electronic Arts from Bard College and a Masters from the Interactive Telecommunications Program at New York University where she is currently a Resident Researcher. Her individual and collaborative work spans the fields of video, electronics, fashion, and telephony. Her work has been exhibited internationally and featured in the New York Times, BBC's World Service, NPR's Morning Edition, and IEEE Distributed Systems Online.

Muttering Hat (2006 – 2007)
New York, New York, USA

Keywords: audio, thought, humor, conceptual, sharing

The Muttering Hat is a conceptual piece that explores the notion of physicalizing thought. In our daily lives we often become overwhelmed by the noise of persistent, overlapping thoughts. Though we can try and tell each other what we are thinking, it is never quite the same as it would be to actually listen in. The Muttering Hat imagines a literal emptying. It illustrates what it would be like to take our internal mutterings and, in a playful manner, project them out into the world. Constructed of fleece, foam, batting, and Velcro, the Muttering Hat contains of an embedded audio system that generates muttering sounds.

Kate Hartman

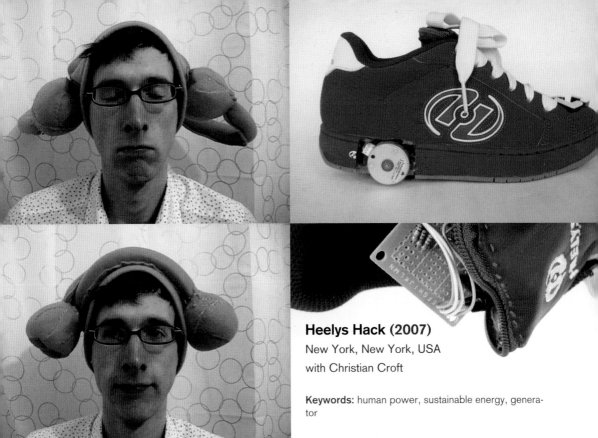

Heelys Hack (2007)

New York, New York, USA
with Christian Croft

Keywords: human power, sustainable energy, generator

These noises operate as a placeholder for whatever your internal soundtrack might be. Two muttering balls are tethered to the hat. In their resting state, they are stuck to the ears and all external noise is obstructed by the mutterings. However, they may also be detached, providing the wearer the opportunity to escape from the mutterings or to share them with a friend.

Inspirations: 'Wearable Body Organs' by Kelly Dobson, Eckhart Tolle 'The Power of Now'

Using the ever-popular roller shoe as a platform for development, the Heelys Hack harnesses the energy of the turning wheel through a series of gears that spin an embedded generator. The voltage produced can be used for a range of low-power applications ranging from localized light and sound to charging small electronics devices and to subversive urban data-mining experiments.

Inspirations: Joe Paradiso 'Energy Harvesting for Mobile Computing'

Kate Hartman

Urban Sonar (2006)

New York, New York, USA

with Kati London, Sai Sriskandarajah

Keywords: heart rate, proximity, data logging, visualization, mapping

Urban Sonar is a wearable sensing system that uses objective data to map a subjective experience. Ultrasonic range finders mounted in the jacket measure proximity to solid forms on all sides of the body. Conductive fabric strips, strapped around the fingers, serve as contact leads for a heart rate monitor that registers pulse.

Sensor data is logged on a mobile phone via Bluetooth and can be later interpreted as a time-based visualization.

Inspirations: 'Urban Atmospheres Project' by Intel Research, Eric Paulos, Tor Norretrander 'The User Illusion'

Go-Go Gloves (2006)

New York, New York, USA

Keywords: collage, puppets, dance party

Constructed of conductive fabric and thread, Go-Go Gloves are electronic gloves that control paper doll go-go dancers on a screen. With the slight motion of touching thumb to fingertip, two strangers can have a virtual on screen dance party. An accompanying control panel allows the players to select characters, backgrounds, and music.

Inspiration: 'Megatap 3000' by Jeff LeBlanc & Chris Karailla

(re)connect (2006)

New York, New York, USA

Keywords: soft circuit, conductive fabric

(re)connect is a garment that allows the wearer to turn inward and receive feedback from their own gestures and touch. When holding oneself, connections made between conductive fabric patches, which cover the hands and other points on the body, close electric circuits and cause mild vibrations along the back.

Inspirations: 'Hug Shirt' by Cute Circuit, 'Hug Jackets' by Despina Papadopoulos

Kate Hartman

Younghui Kim
New York, New York, USA

Biography: Younghui teaches Interaction Design and is Chief Creative Officer of Missing Pixel, an interactive media company in New York that she co-founded in 2000. Younghui's design projects have been recognized with several interactive design awards and presented at many prestigious international conferences. Merging her passion of design and technology, Younghui began to design interactive wearable projects. Her work was exhibited at the Emerging Technologies gallery at SIGGRAPH '04, FutureFashion, and the Gwangju Design Biennale and featured on Nippon TV, iChannel TV, as well as in various magazines and books. Younghui received her Masters degree from ITP at New York University and her BFA degree from the Parsons The New School For Design.

Stir-It-On (2007 - ongoing)

New York, New York, USA & Hongik University, Seoul, Korea

Keywords: wearable, reactive lights, LEDs, personal space

Stir-It-On is an interactive wearable skirt that reacts to any close encounter with its surface. The Stir-It-On skirt will has design patterns on the surface that will emit subtle light when stirred by a passing touch or rub. In crowded urban cities, many people pass near you or even touch you with their coats, jackets or bags. Stir-It-On skirt will have reactive lights that are subtle enough to be fashionable and beautiful enough to wear. The pattern of lights will be made of LEDs that are integrated into the fabric surface using different materials such as fiber optic wires, Luminex or layers of textiles that transmit gentle light.

Inspiration: Traveling Viequez Island in Puerto Rico.

HearWear: The Fashion Of Environmental Noise Display (2003 – 2005)

New York, New York, USA

with Milena Berry

Keywords: fashion, technology, urban noise, environmental, display, sound, wearables

HearWear is a wearable visual reflection of your auditory surroundings. The level of light emitted depends on the level of sound; the louder it is, the more your apparel lights up. The electronics are seamlessly integrated into the wearable design. The sound-detecting sensor is subtle and unnoticeable, and the LEDs and electro-illuminating wire are embroidered into the translucent textile. The project consists of 3 different skirts and a bag.

Inspiration: New York City

Technology Jacket (2003)

New York, New York, USA

with James Tu

Keywords: performance, technology, jacket, fashion, costume, theater

This project explores the idea of information flowing over everyday objects. Younghui and James attached a screen, lighting wires and blinking LEDs on the back of an existing jacket and used a Basic stamp for programming. Three switches inside of the pocket enable the performer to turn various features on or off.

Inspirations: Blade Runner, 'Afrofuturistic' performance at The Kitchen in New York.

Younghui Kim

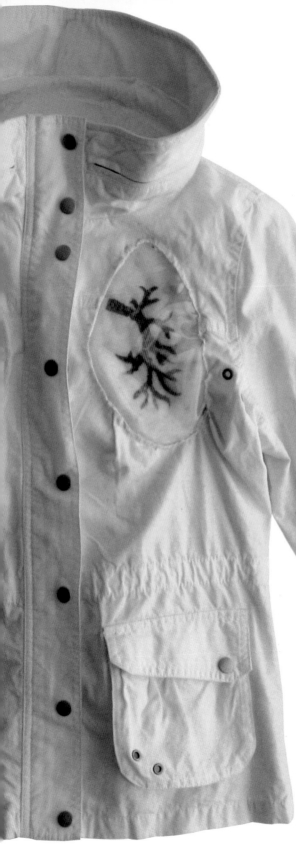

Fiona Carswe
San Francisco, Califor

Biography: Fiona is an Irish-born artist and designer who is interested in highlighting curious aspects of human interaction and revealing subtle truths about one's desires and self-perception. Her pseudo-functional, slightly absurdist body of work straddles the line between art and design and aims to cause people to reconsider the effect and motivation behind the designed 'products' that they use everyday. Her recent work explores visceral ways to visualize body data, such as a bikini that 'grows' moles in relation to sun exposure. Fiona received a Masters degree from ITP at New York University. She currently lives in San Francisco and works as a User Interface Engineer for Apple.

The Smoking Jacket (2007)
Interactive Telecommunications Program, New York University, New York, New York, USA

Keywords: data visualization, behavioral choices, smoking, jacket, visceral, emotional design

The Smoking Jacket is a conceptual, interactive, wearable piece, which promotes self-awareness in relation to the social pressures surrounding the behavioral choice of smoking. It serves as a visceral, iconographic feedback system and uses a carnivalesque absurdity as it presents information about the health effects through the medium

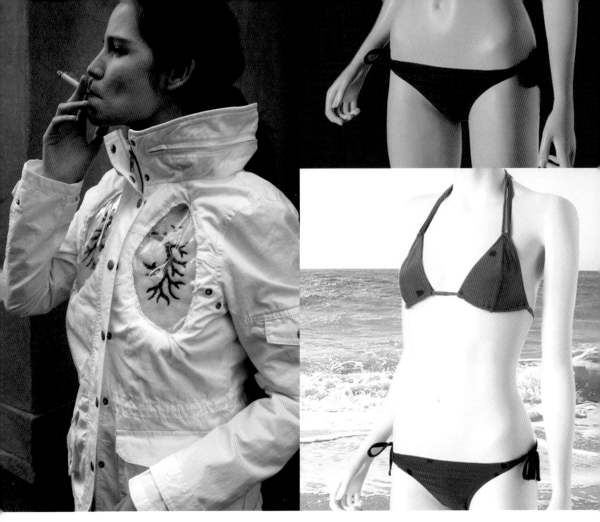

of fashion. While wearing the jacket, a smoker can exhale the smoke into a one-way air valve in the side of the collar. The smoke is then funneled into a pair of plastic enclosed, transparent 'lungs' on the front of the jacket, filling them with smoke. After repeated exposure to the cigarette smoke, the air filter linings of the lungs begin to permanently darken.

Materials: cloth, plastic tubing, air valves, air filters, embroidery

Inspirations: 'Smoke Doll' by Daniel Goddemeyer, 'Lung Ashtray' by Finding Cheska, ' Wearable Body Organs' by Kelly Dobson

Malignant Mole Bikini (2007)

Interactive Telecommunications Program, New York University, New York, New York, USA

Keywords: behavioral choices, data visualization, emotional design

The bikini appears normal when not in direct sunlight. However, when exposed to UV light dark moles begin to appear in various places on the bikini. This project was a result of exploring reflective design as it relates to the body, behavioral choices, and information displays.

Material: UV sensitive paint

Fiona Carswell

Clutch (2006)

Interactive Telecommunications Program, New York University, New York, New York, USA

Keywords: inter-human dependencies, codependent, survival technology, body warmth

Inter-human dependencies, such as the need for body warmth, can be lost in modern world technologies that aim for independence and self-reliance. With these codependent gloves, you must hold hands in order to heat up each other's hands, thereby promoting a physical and an additional emotional security. When you interlock fingers to hold hands, both heating elements are triggered through a series of magnets and conductive fabric, warming both the back of your hand, and the fingers of the other person.

Materials: conductive fabric and thread, magnets, thermion heating element, battery

Q Quilt (2005)

Interactive Telecommunications Program, New York University, New York, New York, USA with Nanna Halinen, Kate Hartman, Kati London, Megan MacMurray, Alice Tseng-Planas

Keywords: assistive technology, flexible interface, therapy

Q Quilt acts as a recording and playback device. Each square records or plays sounds when touched. The quilt's exterior hides a complex, soft, electronic circuit, which was constructed using conductive materials. The quilt can be used as a therapeutic communication tool for people with limited mobility who need a flexible interface. It can also be embroidered and used as a memorial or family storytelling quilt.

Materials: conductive fabric, batting, metal snaps, conductive thread, isd chip, cotton fabric, speakers, microphone

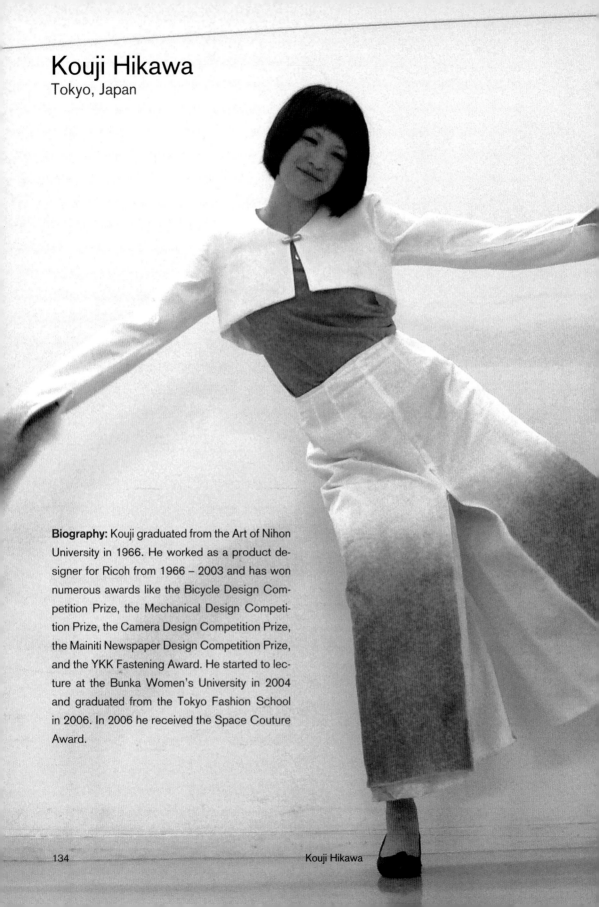

Kouji Hikawa
Tokyo, Japan

Biography: Kouji graduated from the Art of Nihon University in 1966. He worked as a product designer for Ricoh from 1966 – 2003 and has won numerous awards like the Bicycle Design Competition Prize, the Mechanical Design Competition Prize, the Camera Design Competition Prize, the Mainiti Newspaper Design Competition Prize, and the YKK Fastening Award. He started to lecture at the Bunka Women's University in 2004 and graduated from the Tokyo Fashion School in 2006. In 2006 he received the Space Couture Award.

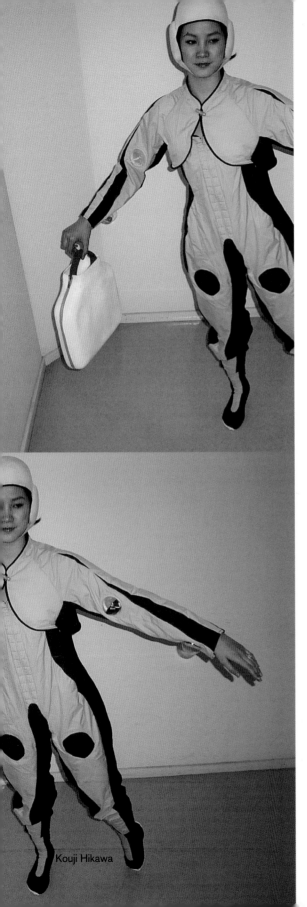

Kouji Hikawa

Space Suit and Space Suitcase (2006 - 2007)

Tokyo, Japan

Keywords: weightlessness, space, physical, information

As space tourism nears true realization, commercial space travel will very soon be available to the average person. However, the design of the classic space suit is disappointing in regard to the overall style, color, pattern, and the choice of material. The Space Couture contest, held by Eri Matsui in Japan, was established to conceive and design an official suit to be worn during space travel. In response the trompe-l'oeil silhouette body was designed. It specifically counters the illusion of being overweight due to the swelling caused by weightlessness. A capsule set on the sleeve of the space suit is actually a sensor that detects weightlessness. A clock shows the flight duration and the moments of weightlessness are reflected as G=0. With additional capsules, space tourists can experiment with what occurs in a weightless environment by inserting their favorite items. They could insert a gold fish, a flower, or an insect for example. Special protective headgear and gripping shoes were also designed. The Space Suitcase is the ultimate space travel accessory and the attached external screen can display, among other things, e-mail from an earthbound friend.

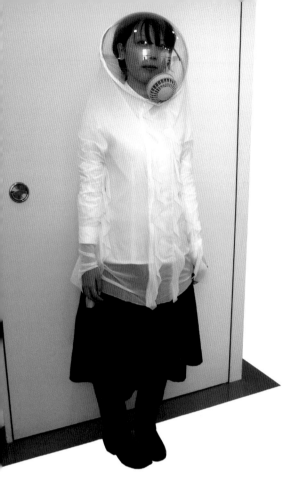

Cooling Wear (2008)

Tokyo, Japan

Keywords: cooling, global warming, future

In the summer of 2007, when the Space Suit was designed, 40 °C temperatures were recorded in Tokyo. With the rapid advancement of global warming the wearing of space suit type clothing should be considered. The Cool Wear features a fan that generates a cool breeze inside the helmet. A fragrance capsule that smells like lemon is built into the mesh of the jersey. This scent repels tropical mosquitoes and the diseases that they may carry.

Neck and Wrist Heater (2007)

Tokyo, Japan

Keywords: heating, wearable, carbon film heater

The Neck and Wrist Heater warms the entire body by directing heat, derived from a carbon film heater, to strategic points on the body. From those points, the heat is then distributed through the body's own circulatory system.

Kouji Hikawa

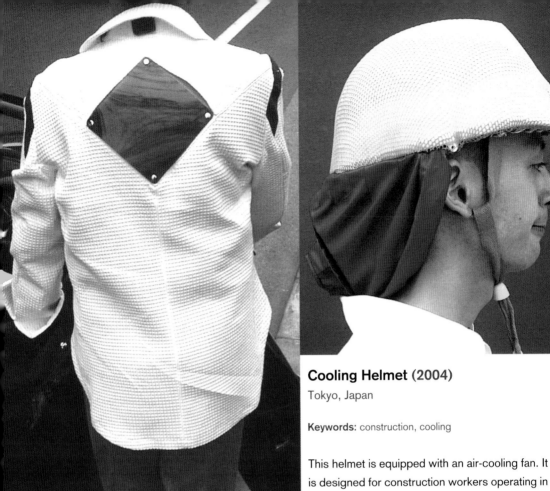

Cooling Helmet (2004)

Tokyo, Japan

Keywords: construction, cooling

This helmet is equipped with an air-cooling fan. It is designed for construction workers operating in the warm regions of the world. In the summer the temperature of a conventional helmet can reach 45°C. The cooling helmet is the solution and decreases the risk of heat related disorders.

Solar Jacket for Enthusiast (2005)

Tokyo, Japan

Keywords: solar, cooling

This is a cooling jacket for the convertible sports car enthusiast. Electricity is generated with the flexible solar film on the back of the jacket and powers a small fan that sits behind the collar and cools the neck.

Kouji Hikawa

CHAPTER **SEVEN**

7 Social Fabric

Philips Design

Headquarters in Eindhoven,
the Netherlands

Biography: Philips Design views the interaction between the human body, apparel and the near environment as the next big challenges. Skin is a particularly useful vehicle for new research and a fascinating subject. It has many functions; it is our largest sexual organ, an electrical network, an input device, a chemical and optical sensor, a display, a thermal regulator, a chemical filter and so on. Through the Skin Probe project, Philips Design explores the kind of materials that could emulate some of the skin's particular functions. It investigates how we will interact with an increasingly dematerialized product universe. In the not-too-distant future, as media becomes virtual, function and form will be separated. This presents an opportunity to completely rethink our interaction with products and content.

The Skin Probe Project (2006)
Bubelle – Blush Dress

Eindhoven, the Netherlands
with Stijn Ossevort, Sita Fisher, Oliver Gondorf,
Lucy Mcrae, Ollie Niemi, Nancy Tilbury, Rachel
Wingfield

Keywords: emotional sensing, LED, projector dress

The Skin Probe is part of a 'far-future' design research initiative to study emerging trends and behavior. It examines links with associated technologies that may ultimately have a significant impact on business. The project examines more 'analog' phenomena such as emotional sensing, and explores technologies that are 'sensitive' rather than 'intelligent'. Fashion is used as a medium to express the research, as apparel and textiles can be augmented with many new functionalities. Today a garment can be a highly complex interactive electronic or biochemical device. Rather than just being on or off, this marvelously intricate wearable prototype is designed to respond to an individual's body and to create a visual representation of one's emotions.

The Bubelle – the 'blushing dress' – behaves differently depending on who is wearing it, and therefore exhibits completely nonlinear behavior. A delicate 'bubble' surrounds it, that responds to skin contact by illuminating various patterns.
Materials: polyester, non-woven fabric, LED projectors, glass fibre rods

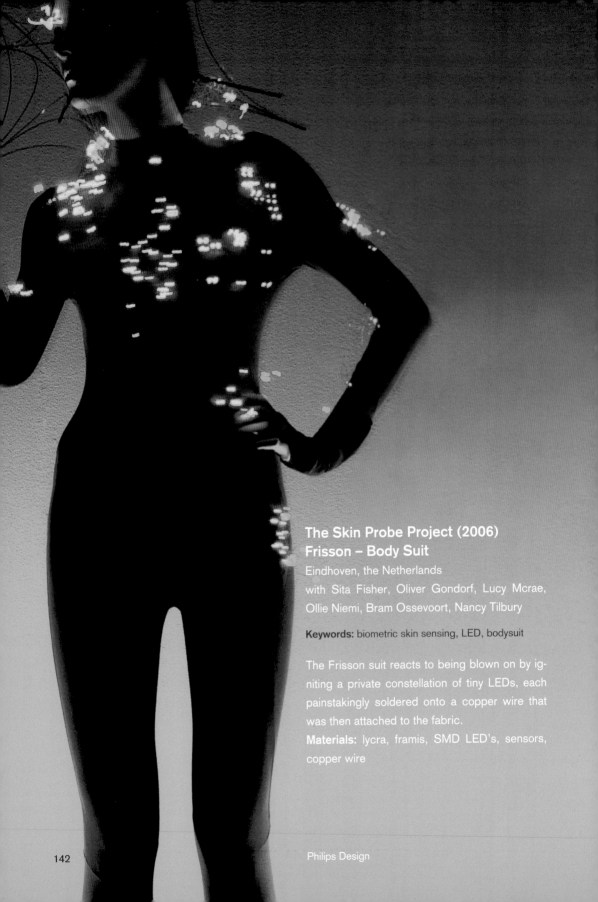

The Skin Probe Project (2006)
Frisson – Body Suit

Eindhoven, the Netherlands
with Sita Fisher, Oliver Gondorf, Lucy Mcrae,
Ollie Niemi, Bram Ossevoort, Nancy Tilbury

Keywords: biometric skin sensing, LED, bodysuit

The Frisson suit reacts to being blown on by ig-
niting a private constellation of tiny LEDs, each
painstakingly soldered onto a copper wire that
was then attached to the fabric.
Materials: lycra, framis, SMD LED's, sensors,
copper wire

Philips Design

New Nomads (2000)

Keywords: wearable electronics, entertainment, information

New Nomads is a collection of prototypes that build on Philips Design's initial work with wearable electronics and chart their exploration of smart apparel. The concept behind the project was to use smart apparel to provide people with better tools for communication, quick access to entertainment and information, and to provide users with greater freedom of action in a wide variety of fields.

ICD+ (2000)

Keywords: communication, workwear

Launched in 2000, the ICD+ line was the first tangible result of a collaborative effort between Levi's and Philips. ICD+ brings together Levi's know how in workwear and Philips's pioneering technology. The four jackets in the ICD+ line have a fully integrated communications system and ear-gear with wires concealed throughout the jacket that connect a mobile phone to a MP3 player with both being controlled by an independent unified remote.

Vision of the Future
Music T-Shirts (1995)

Keywords: music, solar cells

The Vision of the Future project presented a collection of concepts that suggested ways that technology could enhance our lives in the near future. Music T-Shirts allow the user to listen to their favorite music by simply plugging in the attached earpieces. The shirts are washable garments, use miniaturized in-ear speakers and incorporate solar cells to provide energy.

Philips Design

Jayne Wallace
Newcastle, UK

Biography: Jayne's background is in contemporary art-jewelry. Her recently completed doctoral research explored the confluence of digital technologies and jewelry. She has collaborated with theorists, computer scientists and electronics experts in the realization of digital jewelry as well as the conceptual and theoretical implications surrounding it. Her work focuses on the use of technologically enhanced jewelry to extend and enrich intimate interpersonal communications. She has published widely across the fields of art, design, craft and human-computer interaction. In her current role as researcher in fine art at Newcastle University she is exploring the expressive power of ceramics in the development of digital jewelry.

Journeys Between Ourselves (2007)

Newcastle, UK

with Patrick Olivier, Daniel Jackson, Cas Ladha, Andrew Monk, Peter Wright, Mark Blythe

Keywords: digital-jewelry, emotional significance, meaningfulness

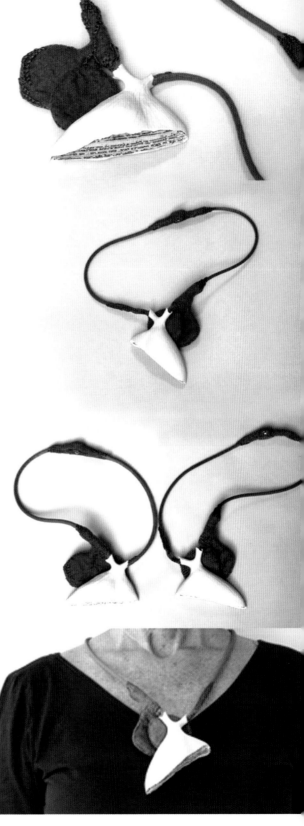

Journeys... are a pair of digital neckpieces custom made for a mother and daughter participating in Jayne's research. The forms of the neckpieces are influenced in part by a Kay Nielsen illustration that is cherished by the couple. The neckpieces are responsive to touch; the touch of one causes the second to tremble gently. This interaction is a tactile echo that reflects their closeness and feelings for each other.

Materials: porcelain, paper, felt, light sensors, motors, motes, accelerometers, batteries

Inspirations: A. Dunn 'Hertzian Tales: Electronic products, aesthetic experience and critical design', Malin Lindmark Vrijman

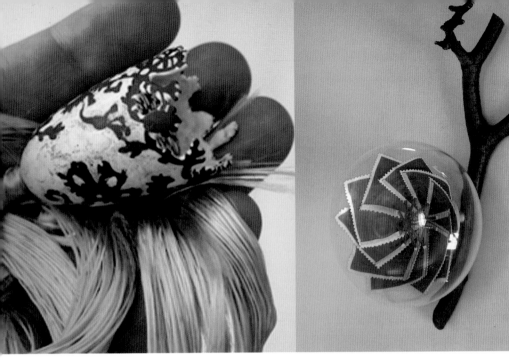

Sometimes Our Dreams & Memories Can Visit Us (2005 – 2006)

Newcastle, UK
with Patrick Olivier, Daniel Jackson

Keywords: digital-jewelry, emotional significance, meaningfulness

Sometimes… is a digital neckpiece custom made for Faith, a participant in Jayne's research. The piece echoes some of Faith's old and cherished objects as well as her dreams and personal stories. It is a dreamy space where reality and fantasy overlap and is a wearable home for stories and memories. It is a way for their echoes to 'visit' Faith from time to time through silent film sequences that play on digital displays in near radius to the neckpiece.

Materials: metal, porcelain, synthetic silk, Bluetooth components

Blossom (2005)

Newcastle, UK

Keywords: digital-jewelry, emotional significance, meaningfulness

Blossom is a hand-worn jewelry object custom made for Ana, a participant in Jayne's research. It is symbolic of her precious relationship with her family in Cyprus. The piece resides with Ana in London, but is remotely connected to a rain sensor planted on Cypriot family land. Once the sensor registers a predetermined quantity of rain, which may take months, a signal is sent to the jewelry-object and the structure inside opens like a flower blossoming.

Materials: wood, glass, silver, vintage postage stamps, nitinol wire, electronic components

Jayne Wallace

Traces (2005)

UK

Keywords: digital-jewelry, emotional significance, meaningfulness

Traces is about jewelry and made for a jeweler who doesn't wear jewelry, but who highly values the medium, the history and social context of jewelry objects. Porcelain and velvet pieces evoke an antique jewelry case. The digital aspect reflects Emma's descriptions of her daughter, particularly her voice, the songs she sings to herself and Emma's desire to always be there for her. Each porcelain clasp shaped object captures audible elements of the surrounding environment and is a conceptual reflection on how heirloom objects, through marks of wear and tear, reveal aspects of their owners.

Jayne Wallace

Mouna Andraos
New York, New York, USA
Montreal, Canada

Biography: Mouna is a designer and artist working on interactive objects and installations as well as in the mediums of web, electronics and video. In recent years, she has been fascinated by the idea of electronic jewelry and the intersection of established crafts with emerging technologies. She has received many awards for her web-based work including, Interactive prizes from both Communication Arts magazine and ID magazine, a CyberLion in Cannes and Best of Show at the South by South West festival. She holds a Masters degree from New York University and a Bachelors from Concordia University. Mouna was recently an R&D fellow at Eyebeam's OpenLab in New York City and is currently an adjunct professor at NYU's Interactive Telecommunications Program.

Address (2007 – ongoing)
New York, New York, USA
Produced with the support of Eyebeam
with Sonali Sridhar, Christopher Cummings, Melissa Cohen, Andy Doro

Keywords: digital anchor, location, displacement, home, connections

Address is a handmade piece of electronic jewelry created with Sonali Sridhar. When first acquiring the pendant, you select a place that you consider to be your anchor ñ your birthplace, your home, or perhaps a place you long to be. Once the jewelry is initialized it displays how many kilometers you are from that location. As you take Address around the world with you, it serves as a personal connection to that place, making the world a little smaller or maybe a little bigger.
Materials: silver, acrylic, wood, electronics

Mouna Andraos

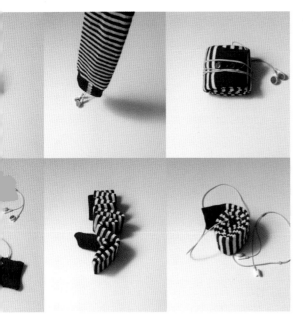

Sock Pod (2006)

New York, New York, USA

Keywords: MP3 player, music, portable, consumer electronics, soft circuits

The Sock Pod is a meter long music player that can be wrapped around your body, folded into a small ball or left hanging around your neck. It can be skinned with any other pair of knee-high socks stitched together. The Sock Pod also comes with a full set of instructions so you can modify it or build your own from scratch.

Materials: hacked MP3 player, conductive thread, electronics, rubber buttons, strippy socks

Necklights (2006)

New York, New York, USA
Produced with the support of Eyebeam
with Sonali Sridhar

Keywords: necklace, light, rubber, silicone, soft, casted, broche, accessory

Necklights are small colored lights encasted inside rubber or silicone that can be worn as pendants or pinned to clothes as brooches. Necklights are hand made and each one is a unique combination of color and design. The circuit behind Necklights is itself built like a piece of jewelry using small beads and conductive thread.

Mouna Andraos

Ayah Bdeir
New York, New York, USA

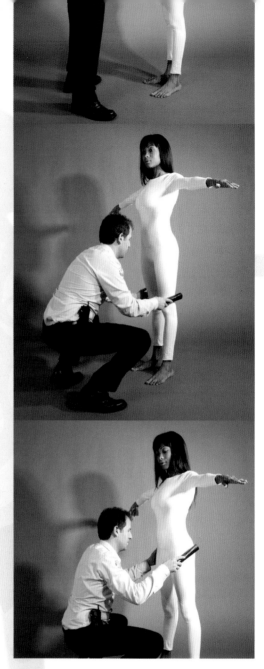

Biography: Ayah is an engineer, designer and activist. With an upbringing between Lebanon, Canada and the United States, Ayah's work examines the role technology plays in cross-cultural communication. In her work, Ayah attempts to create technologies that promote human rights and redress power discrepancies between citizens and authority structures. Her work has appeared in several technical conferences as well as in numerous festivals and fashion shows. She recently earned her Masters from the MIT Media Lab as part of the Computing Culture Group. Ayah is currently a research fellow at the Eyebeam R&D Open Lab in New York.

<random> search (2007)

Computing Culture Group, MIT Media Lab, Cambridge, Massachusetts, USA

Keywords: e-textile, bodysuit, pressure sensor, patdown, digital record

<random> search is an instrument that acts as a neutral, quantifiable witness to the screening process. A subtle, reactive undergarment detects and records any investigative body search. Undetectable, wearable pressure sensors are distributed across the undergarment and transform it into a silent witness. When activated, the suit, acting like our external memory, provides a digital record of the search encounter. The technology is personal, and does not compel a course of action on the wearer, but rather provides him/her with clear evidence that can be used for analysis and to incriminate.

Materials: quantum tunneling composites, steel thread, metal mesh, conductive Velcro, number6 microcontroller, cotton, spandex

Inspirations: S. Rushdie 'Step Across This Line', M. Foucault 'Discipline and Punish', E. Said 'Out of Place', The Stanford Prison Experiments

Ayah Bdeir

Arabiia (2006)

OpenStitch, LocationOne Gallery, New York

Keywords: arab stereotypes, convertible outfit, performance, wearables

Aside from Daisy Duck with her dance of the 7 veils, and the mute abiding second-class citizen in a black burka, few images spring to mind when thinking of an Arab woman. Arabiia is a caricature of media stereotypes typically associated with Arab women. This convertible outfit is equipped with two servo motors and a switch and enables its wearer to voluntarily choose which of two extreme representations fits her mood and audience.

Inspirations: Hussein Chalayan, L. Arthur 'Undressing religion', online image search for Arab woman

Ayah Bdeir

kiNET (2005)

MIT Media Lab, Cambridge, Massachusetts, USA
with Sergio Araya

Keywords: e-textiles, animated surfaces, flexor pattern, magnetism

kiNET is a maliable wall with an animated surface that uses flexor patterns, microcontroller circuits and solenoids. The surface is active and no longer merely an opaque plane; rather it is a dynamic intervention in space that provokes human interaction. KiNET establishes a new relationship between the human body and architecture, one that challenges the usually neutral and stable role of matter.

Materials: ABS plastic, copper solenoids, ATTiny23

Inspirations: Merleau-Ponty 'Phenomenology of perception', L. Howell 'Compliant Mechanism', N. Gershenfeld 'FAB: The Coming Revolution on Your Desktop'

Teresa Almeida

Kuala Lumpur, Malaysia

Biography: Teresa is an artist, designer and educator. She is interested in the relationship between art, technology, wearables and social sculptures. Her work is an exploration of dynamic structures fashioned to the body for use in public spaces. She holds a Masters degree from the Interactive Telecommunications Program at New York University. She is currently living and working in Malaysia where she is a lecturer in Design Research at LUCT, Faculty of Design Innovation in Cyberjaya.

Lags (2007)
Kuala Lumpur, Malaysia

Keywords: Batik textile, traditional, technology, jet lag, life

Social jet lag is, according to research, putting us at risk of chronic fatigue and manifests itself when our body´s circadian rhythm is out of sync. Lags are designed to counter social jet lag. Eye-Lag consists of a pair of goggles equipped with a warm soft yellow light inside that simulates reassuring sunlight. HeadLag is a bracelet and soft pillow, for when one needs to nap. Lags are constructed using the free accessories handed out on intercontinental flights, lo-tech electronics and applied textiles that use traditional Batik materials and Malaysian wax-resist patterning techniques.

Materials: lags, traditional Batik materials, wax-resist patterning techniques, miscellaneous electronics, LEDs, conductive thread and Velcro, batteries, micro fan, touch switch

Inspirations: P. Staple 'Flights of Fancy' (Frieze), W. Gibson 'Pattern Recognition' (New Scientist), research on social jet lag

Yuga (2005)

Ljudmila-Ljubljana Digital Media Lab, Ljubljana, Slovenia

with Luka Frelih, Marcela Okretic

Keywords: wearable, noise, felt, urban space, social space

Yuga is a set of wearable coping mechanisms and consists of a belt and a handbag. Both objects are literally attention getters. The belt interacts with the environment using a sensor that detects physical proximity and movement. The handbag assists in managing feelings of alienation by emitting a brief composition when activated, also calling attention back to the user's presence.

Materials: Arduino, Ping sensor, speakers, electronics

Inspirations: François-Xavier Courrèges, K67 kiosk by Sasha J. Mächtig, J. Kristeva 'Strangers to Ourselves'

Modes for Urban Moods (2005)

Interactive Telecommunications Program, New York University, New York, New York, USA

with Michiru Murakami

Keywords: wearable, noise, felt, urban space, social space

Modes for Urban Moods are a suite of wearable coping mechanisms that explore our relationships to public spaces and that materialize invisible aspects of social networks. Space Dress inflates on the wearer's command and is designed to cope with stress, anxiety and claustrophobic situations or to simply provide additional comfort. It was originally designed for rush hour use on the NYC subway system.

Materials: rip-stop nylon, micro fans, small electronics, switch

Inspirations: archigram.net, Rei Kawakubo, Lucy Orta, N. Bourriaud 'Relational Aesthetics', H. Lefebvre 'Everyday Life in the Modern World'

Cat Mazza
microRevolt

Troy, New York, USA

Biography: Cat is a 2007 Rockefeller Renew Media fellow and Assistant Professor of New Media at UMass, Boston. She is the founder of microRevolt, which focuses on combining craft and digital technologies while commenting on the history of labor activism. microRevolt projects introduce contemporary craft hobbyists to digital tools like freeware knitPro and then engage them in activist projects. It has been featured in numerous exhibitions worldwide, including the contemporary textile exhibition Radical Lace and Subversive Knitting at the Museum of Arts and Design in New York. In addition, microRevolt participated in the Prix Ars Electronica, where it received a 'Digital Communities' award. microRevolt projects have been featured in various publications, including the New York Times, KnitKnit, MIT's Leonardo Electronic Almanac and World Changing: A Users Guide to the 21st Century.

Ottoman Hack (2007)
Troy, New York, USA

Keywords: knitting, knitting-machine, pattern, software

The Ottoman Hack was created for the Hackers and Haute Couture Heretics exhibit at the Garanti Gallery in Istanbul. The project was a query into how hacking and heresy can be applied to the field of subversive fashion. It involved hacking an Ottoman Pillow from the VAKKO fashion collection, an upscale Turkish fashion brand. The traditional Turkish floral was transformed into a knit pattern using knitPro freeware. The final knitted design includes the IP address of a website created for needlecraft file sharing. The Ottoman Hack was created with an electronic hobbyist-knitting machine.

KnitPro (2004 – 2005)

Troy, New York, USA
with Eric St. Onge

Keywords: freeware, knitting, patterns

knitPro is a free web application that translates digital images into needlecraft grid patterns (www. microRevolt.org/knitPro). knitPro is based on the tradition of pre-industrial craft circles to freely share patterns and pass them down from generation to generation. knitPro digitally mimics this tradition. Thousands of patterns are uploaded to the website each week by craft hobbyists worldwide.

Cat Mazza, microRevolt

Ebru Kurbak & Mahir M. Yavuz

Linz, Austria & Istanbul, Turkey

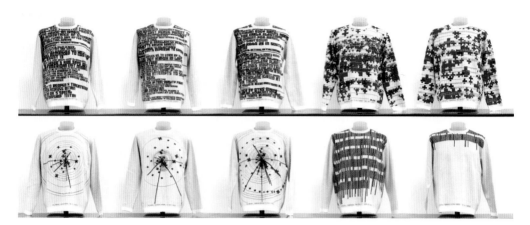

Biography: Ebru and Mahir are both PhD candidates at the University of Arts and Industrial Design Linz, Austria. They collaborated on various projects while working together as instructors at the Istanbul Bilgi University Department of Visual Communication Design. News Knitter is their first project that contributes to the wearable realm. Their main focus is creating 'daily wearables', which on one hand involve an innovative, digitally enhanced, pre-production process and on the other hand are produced, packed and exhibited using conventional methods.

for a knitted sweater. The system consists of two different types of software: one that receives the content from live feeds the other converts it into visual patterns. A fully computerized flat knitting machine produces the final output. Each News Knitter sweater is the unique result of a specific news day or time period.

News Knitter (2007)

Linz, Austria & Istanbul, Turkey

Keywords: knitting, data visualization, news, rss feeds

News Knitter is a data visualization project, which focuses on knitted garments as an alternative medium for displaying large-scale data. The system converts information, gathered from live RSS news feeds, and incorporates it into clothing. News from the Internet that is broadcast within 24 hours or a pre-defined period is analyzed, filtered and converted into a unique visual pattern

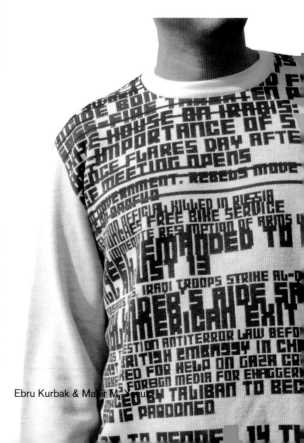

Ebru Kurbak & Mahir M. Yavuz

Fabienne Blanc & Patrick Rüegg

Aarau, Switzerland

Biography: Patrick attended the Swiss-Italian College of Art 'Liceo Artistico' based in Zurich, and has since continued his studies in Industrial Design at the Fachhochschule Nordwestschweiz in Aarau. He is currently based in Zurich as an artist at atelier 'Schafferei'. Fabienne went to college and majored in modern languages. In addition, she studied pharmacology in Basel and continued her studies in Media Art at the Fachhochschule Nordwestschweiz in Aarau. In 2007 she exhibited a project entitled 'Synesthesia' in the Kunstraum Aarau. She is currently an artist based in Aarau and Gränichen.

be-geistert (2007)

Aarau, Switzerland

with Roland Brönnimannt

Keywords: analogous display, scarf, knitting, credit-card data, pacman ghosts

A magnetic stripe reader captures credit card data from a customer. Software then converts the credit card information into pure text. A pattern emerges as this information is further transformed into binary codes, with every number '1' being substituted by a graphical ghost. The code is printed on paper to be read by the scanner of the knitting machine. The personal credit card data is then knitted into a 100% cotton scarf in green and black.

Inspirations: www.sode.li, hello.eboy.com, www.mintymonkey.com

CHAPTER **EIGHT**

8

Sonic
Landscape

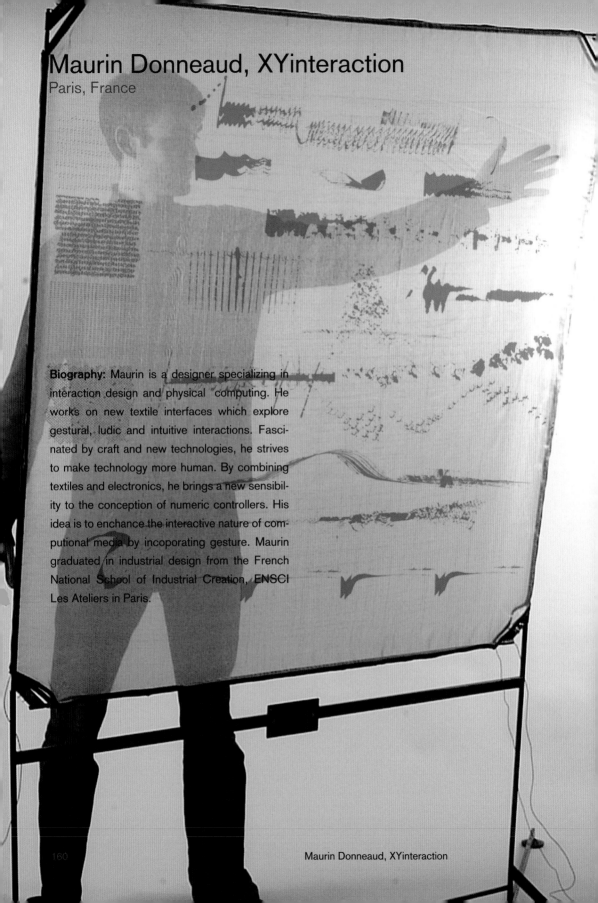

Maurin Donneaud, XYinteraction
Paris, France

Biography: Maurin is a designer specializing in interaction design and physical computing. He works on new textile interfaces which explore gestural, ludic and intuitive interactions. Fascinated by craft and new technologies, he strives to make technology more human. By combining textiles and electronics, he brings a new sensibility to the conception of numeric controllers. His idea is to enchance the interactive nature of computional media by incoporating gesture. Maurin graduated in industrial design from the French National School of Industrial Creation, ENSCI Les Ateliers in Paris.

Textile XY : A Textile Interface For Playing Electronic Music (2007 – 2008)

Paris, France

with Marco Marini, Roland Cahen, Vincent Rioux, Vincent Roudaut

Keywords: musical textile, interface, interaction, tactile, e-textile, sensor

The XY interactive textile is a large tactile interface for playing electronic music. The performer plays it simply by moving his/her hand over its surface. This textile interface allows users to compose and interpret electronic music through choreographed movements. This textile interface involves the whole body in the musical interpretation. Like a music score, the sound elements are graphically represented on the fabric, giving the composer the ability to locate and play them.

Inspirations: ENIGMES, Leah Buchley 'A new aesthetic for electronics', 'Dialectric' by Laura and Lawrence MacCary

Electronic Music Performance With XY Textile Interface (2007)

Paris, France

with Marco Marini

Keywords: performance, musical textile, interface, textile controller

The XY interactive textile is a large tactile interface used by Marco Marini a French Electro-Acoustic composer. A textile score was created in collaboration with this artist and in his performances Marco interpretes this interactive score. The movement of his hands on the textile surface triggers musical leitmotives while each graphic pattern allows Marco to localise and play a sound. His role is transformed as he becomes both musican and dancer which creates a unique mis-en-scene of the score. Facing the audience, Marco shows how the movements of his hands bring the music to life.

Maurin Donneaud, XYinteraction

Magdalena Kohler & Hanna Wiesener
Berlin, Germany

Biography: After finishing a goldsmith apprenticeship in 2001, Magdalena worked as a freelance jewelery artist in Austria. Since 2004 she has studied fashion design at the University of the Arts in Berlin. Hanna majored in cultural studies and art history at Humboldt University, Berlin and Paris from 2000 until 2004. Since 2004 she has studied product design and interactive systems at the University of the Arts in Berlin.

TRIKOTON - The Voice Knitting Collection (2007)
Berlin & Apolda, Germany
with Design Reaktor Berlin

Keywords: spoken messages, knitting patterns

TRIKOTON focuses on the human voice, its different recording and reproduction techniques, and the connection between communication and fashion. The frequency band of a spoken message is converted into a binary code for knitting patterns. GELSOMINA is a mechanical voice knitting machine from the 70s that was hacked to become interactive. A microcontroller and 24 small engines are used to imitate a pattern card that is directly generated by voice signals. This online based process makes it possible to transfer a personal and unique spoken message into a fashion piece.

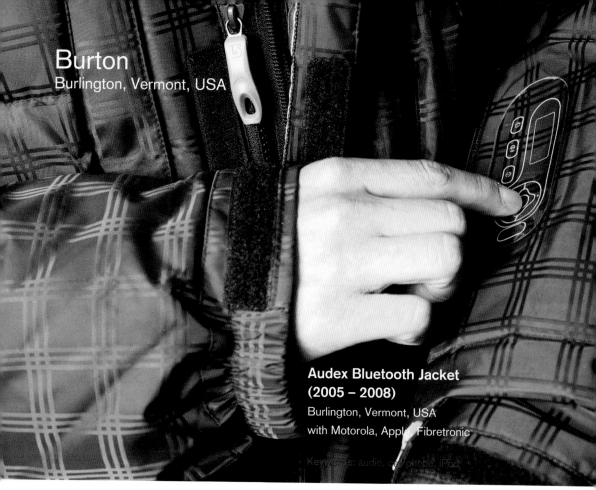

Burton
Burlington, Vermont, USA

**Audex Bluetooth Jacket
(2005 – 2008)**
Burlington, Vermont, USA
with Motorola, Apple, Fibretronic

Keywords: audio, cell phone, iPod

Biography: Burton Snowboards is a snowboard company soley dedicated to the creation and perfection of a wide range of snowboarding equipment and apparel. Founded in 1977, they are headquartered in Burlington, Vermont with international offices in Innsbruck, Austria, Tokyo, Japan and Sydney, Australia. Burton has fueled the growth of snowboarding worldwide through its team of top snowboarders and through their international Open Snowboarding Championships. Burton's products continue to evolve to meet the needs of their team riders. Their garments incorporate the latest wearable technologies to provide enhanced communication and entertainment features.

The imbedded Audex system operates via a removeable control module on the jacket sleeve and allows the wearer to interact with their mobile phone and iPod. The system connects to the mobile phone via a Bluetooth wireless link. Wired connections to the iPod and stereo speakers enable the wearer to select music via the control module. Wires are hidden for seamless, unobtrusive wearability, and the connectors are designed to be washable. The control module has large tactile feedback buttons for easy operation while wearing gloves. Stereo speakers are built into the hood of the jacket and a microphone is embedded in the upper section near the collar. Phone and iPod zip safely into specially designed pockets for a perfect fit.

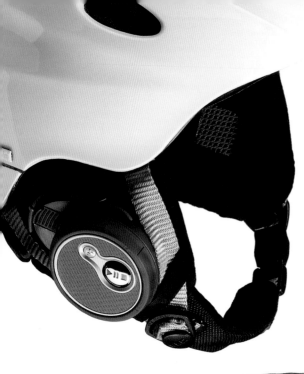

R.E.D. Audex (2005 – 2008)

Burlington, Vermont, USA
with Motorola, Apple

Keywords: audio, cell phones, iPod

The Audex helmet utilizes Bluetooth wireless technology. To operate the Audex features, wearers simply press a large call button on the side of the helmet that is easy to use while wearing gloves. The call button allows the wearer to answer, end and make mobile phone calls as well as other functions. The headset easily detaches from the helmet and can be worn on its own.

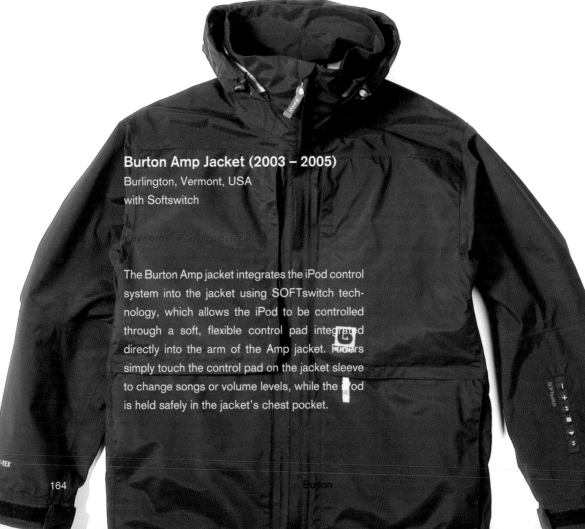

Burton Amp Jacket (2003 – 2005)

Burlington, Vermont, USA
with Softswitch

Keywords: iPod, audio, jacket

The Burton Amp jacket integrates the iPod control system into the jacket using SOFTswitch technology, which allows the iPod to be controlled through a soft, flexible control pad integrated directly into the arm of the Amp jacket. Riders simply touch the control pad on the jacket sleeve to change songs or volume levels, while the iPod is held safely in the jacket's chest pocket.

Burton Amp Pack (2003 – 2005)

Burlington, Vermont, USA
with Softswitch

Keywords: iPod, audio, backpack

The Burton Amp Pack integrates an iPod control system using SOFTswitch technology, which allows the iPod to be controlled through a soft, flexible control pad built into the pack's shoulder strap. The Amp Pack features a secure iPod storage pocket, a headphone port located on the shoulder strap, an easy-access side entry laptop compartment and padded ergonomic shoulder straps for ultimate comfort.

Analog Clone MD Jacket (2002 - 2003)

Burlington, Vermont, USA
with Sony, Softswitch

Keywords: Walkman, audio

The Analog Clone MD is a snowboard jacket with a built-in mini-disc system. The fabric of the jacket has electronic switching capabilities made possible by combining conductive textile materials and flexible composites. Snowboarders can control the MD player with touch-sensitive control buttons located on the sleeve.

Nike
Portland, Oregon, USA

Biography: Nike started with a handshake between two visionaries, Bill Bowerman and the University of Oregon runner, Phil Knight. They and their team evolved and grew the company that became Nike from a US-based footwear distributor, to a global marketer of athletic footwear, apparel and equipment. The emotion of sport provides the inspiration while Nike's attitude to new technology and ideas provide the innovation.

Nike+ (since 2006)
Portland, Oregon, USA
with Apple

Keywords: motivation, running, audio feedback, ergonomic design, weather protection

With Nike+ footwear wirelessly connected to your iPod nano, information on time, distance, calories burned and pace is stored and displayed on the screen; real-time audible feedback is also provided through headphones. The kit includes an in-shoe sensor and a receiver that attaches to the iPod. After a workout, simply connect your iPod nano to a Mac or PC to automatically sync and store workout data. You can then view and evaluate personal training goals through a dynamic, customized workout log on www.nikeplus.com.

Nike

Nike Amp+ (2007)
Portland, Oregon, USA
with Apple

Keywords: wristband, remote control, Nike+ iPod receiver

This is a wristband that works with the Nike+ iPod receiver to remotely provide runners with quick, easy access to progress updates and music. Runners can now keep their iPod nano securely stored in their Nike+ integrated pocket or armband and access their PowerSong or verbal feedback without missing a step. The Nike Amp+ captures data of a run through a signal from the sensor in Nike+ footwear. Runners can also remotely fast forward and rewind, browse through songs, adjust volume, and pause workouts with ease from an interface embedded into the strap.

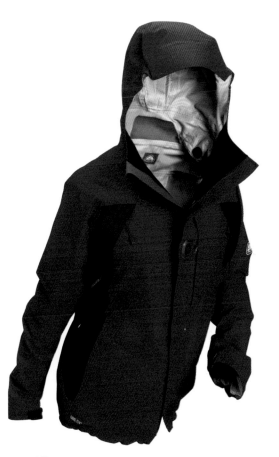

COMMVEST (2003 – 2005)
Portland, Oregon, USA

Keywords: push-to-talk, mountain, communication

Nike used the insights of mountain rescue teams and ski patrols to design an ergonomic, quick-access communications vest with an embedded speaker near the ear, a microphone near the mouth and a push-to-talk button at the chest. The push-to-talk tab has 2 buttons that need to be squeezed in order to activate the radio, decreasing the possibility of unintentional microphone activation.

Fibretronic

Skipton, UK & Hong Kong

Biography: Fibretronic is a leading developer, manufacturer and supplier of soft electronic technologies and components designed specifically for application in clothing and soft goods. The company can embed any type of electronic functionality into flexible substrates for use in garments, bags, sportswear and wearable soft accessories. Fibretronic's product range includes keypads, switches, sensors, textile data cables, lighting systems and communications accessories.

BlueWear Handsfree Module (2007)

Skipton, UK & Hong Kong

Keywords: wearable communication, BlueWear handsfree module

Fibretronic's unique BlueWear module is a self-contained soft accessory for the hands free operation of mobile phones. The module incorporates a speaker, a microphone and a call answer/hang-up button. Also incorporated are volume controls for the speaker and a mini USB port for battery charging. The product attaches to the outside of a garment or bag using Velcro or snaps and allows the wearer to receive calls without having to remove their mobile phone handset from the safety of a pocket.

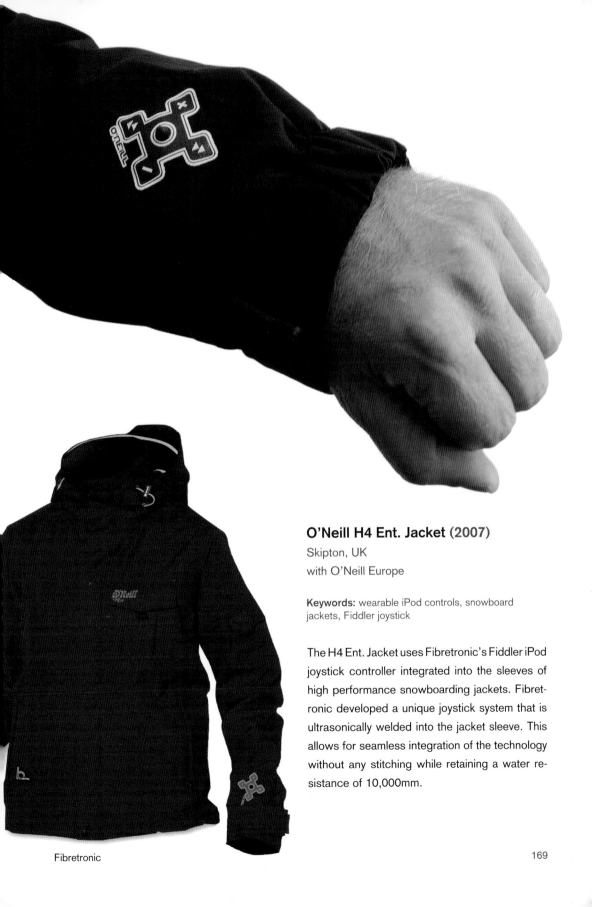

O'Neill H4 Ent. Jacket (2007)

Skipton, UK

with O'Neill Europe

Keywords: wearable iPod controls, snowboard jackets, Fiddler joystick

The H4 Ent. Jacket uses Fibretronic's Fiddler iPod joystick controller integrated into the sleeves of high performance snowboarding jackets. Fibretronic developed a unique joystick system that is ultrasonically welded into the jacket sleeve. This allows for seamless integration of the technology without any stitching while retaining a water resistance of 10,000mm.

Fibretronic

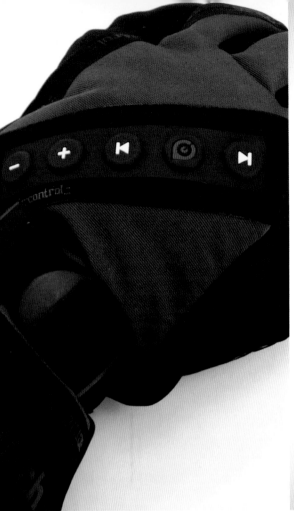

Reusch Sonic Control Glove (2006)

Skipton, UK

with Reusch International License (Spain)

Keywords: wireless iPod controls, sonic control glove, wearable keypad

The glove incorporates Fibretronic's RF wireless keypad system integrated into the back of the hand along with a wireless transmitter located in a specially designed waterproof pocket in the cuff of the glove. Using a receiver connected to the iPod, the commands from the keypad can be sent to the iPod remotely.

Levis Red Wire DLX Jeans (2006)

Hong Kong

with Levi Strauss & Co Europe S.C.A. (Belgium)

Keywords: wearable iPod controls, Red Wire DLX jeans, Fiddler joystick

A five function joystick controller is integrated into the watch pocket of the jeans along with an audio socket for the connection of earphones. A textile data cable carries the joystick commands and audio signals to a dedicated iPod pocket. Here, the textile cable connects to a specially designed interface cradle that acts as a docking station and protective holder for the iPod.

Fibretronic

O'Neill
Warmond, The Netherlands

Biography: O'Neill, the original Californian surf, snow and lifestyle brand, was founded in 1952 by a young man with an unstoppable passion for surfing named Jack O'Neill. He pioneered the world's first neoprene wetsuit and opened up his first surf shop in Santa Cruz. O'Neill's set of core values, innovation in style and technology, has seen the brand devote itself to the evolution of action sports. The company's HDivision has gone on to develop a range of groundbreaking wearable electronics.

NavJacket (2008 – 2009)
Warmond, The Netherlands
with ROAD Group, MyGuide, Fibretronic

Keywords: GPS, navigation, snowboarding

The NavJacket allows you to easily navigate through the mountains with the help of an integrated display on the sleeve and audio instructions in the hood. Simply enter your desired location and let the NavJacket guide you effortlessly down the slopes. Your current speed, up-to-date local weather forecasts, and in-depth details about your route, such as distance and time have all been incorporated into the flexible display sleeve on the jacket. Using your mobile phone connected to the GPS unit, 3D views of the resorts will also be available. An additional innovative feature of the NavJacket is a friend finder function, which will allow you to either track down friends, or choose to follow their path through the slopes.

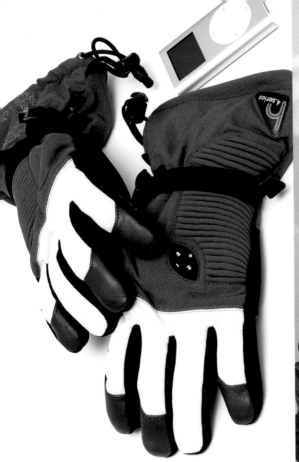

H4 Series (2007 – 2008)

Warmond, The Netherlands
with Fibretronic

Keywords: Walkie-Talkie, MP3, mobile phones

The Walkie-Talkie Jacket is aimed at the more adventurous freerider., This jacket features a walkie-talkie connector and convenient chest pocket for safe device storage. The jacket's collar features an integrated speaker and microphone with a 'push-to-talk' button in the windflap that keeps you connected to friends. The Fat Controller incorporates a wireless remote control for iPod MP3 players, allowing the wearer to control tune selection via a discrete, thumb-controlled joystick woven into the top of the left-hand glove.

H3 Series (2006 – 2007)

Warmond, The Netherlands
with Interactive Wear

Keywords: snowboarding, camera, audio

The Campack allows the user to record their sessions without removing the camera from the pack by incorporating a safe and protective housing for a camcorder into the backpack and a separate lens fitted to a flex. The small, hi-definition lens can be attached to goggle straps or helmets while the basic operating functions for the camera are remotely controlled by a joystick integrated into the shoulder strap.

H2 Series (2005 – 2006)

Warmond, The Netherlands
with Eleksen, True Solar Automony

Keywords: Bluetooth, snowboarding, solar, iPod

The Integrated Solar Backpack incorporates two flexible solar panels and a Bluetooth module. In optimum light conditions the solar cells provide charge to the users' iPod, mobile phone and Bluetooth module via a USB recharging system. Once installed the iPod can be controlled via a soft control panel located on the packs left shoulder strap.

The HUB (2004 – 2005)

Warmond, The Netherlands
with Infineon

Keywords: MP3 player, Bluetooth, snowoarding, mobile phone

An invisible, durable and unhindering wiring system is woven into the jacket allowing the user to control their MP3 player via a control pad blended into the fabric on the left arm. The HUB incorporates Bluetooth technology and allows the rider to make and receive calls using voice recognition dialing.

CHAPTER **NINE**

9 Material Witness

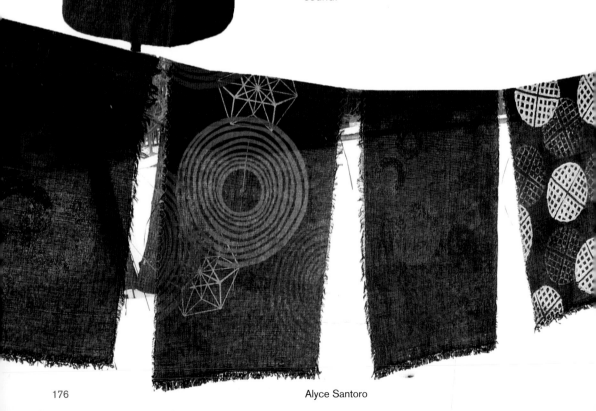

Alyce Santoro
Fort Davis, Texas, USA

Biography: Alyce is a sound and installation artist with a background in biology and scientific illustration. While racing small sailboats as a child she noticed short strands of cassette tape that sailors often use as wind indicators. She remembers thinking that, if the wind hits the tape just right, she would be able to hear whatever had been recorded onto the tape. Many years later she learned about Tibetan Buddhist prayer flags that are hung in auspicious locations where the wind can 'activate' the sounds and carry their blessings around the world. This inspired Alyce to create a fabric woven from actual recorded sound.

Alyce Santoro

Sonic Fabric (2001 – ongoing)

Distributor since 2007: Designtex, New York, New York, USA

Weavers: J. C. Lafond, Manville, Rhode Island, USA & Shangri-La Crafts, Katmandu, Nepal

Keywords: cassette tape, sonic fabric, audible, recycled, textile

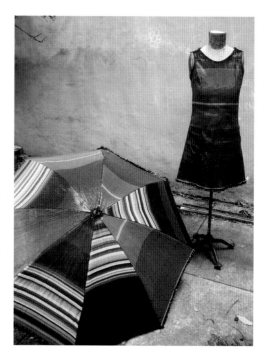

Sonic Fabric is a versatile, durable, audible textile woven from 50% recorded audiocassette tape and 50% polyester thread. Since the tape retains its magnetic properties throughout the weaving process, sound can be emitted from the material by running an apparatus made from a tape head along its surface. The fabric has a canvas texture and a slightly metallic luster. Before the tape is woven, it is recorded with a variety of layered sounds collected and compiled by the designer.

Inspirations: Joseph Beuys, J. Bass 'Smile of the Buddha: Eastern Philosophy and Western Art', The Freesounds Project http://freesound.iua.upf.edu/index.php

Alyce Santoro

Marcelo Coelho

Cambridge, Massachusetts, USA

Biography: Marcelo is a graduate student at the Ambient Intelligence Group at the MIT Media Lab. His work explores how material technologies and computation can aid in the design of responsive garments, objects and spaces, and provide more meaningful interfaces for our personal and social activities. His art and computational explorations have been published and exhibited at the Societe des arts technologiques, VAV Gallery, Digifest, Collision Collective, SIGGRAPH, ISWC, Ubicomp and CHI, among others.

Shutters (2007)

MIT Media Lab, Cambridge, Massachusetts, USA

with Steve Helsing, Analisa Russo, Elly Jessop

Keywords: textile, responsive façade, shape memory alloy, soft display

Shutters is a kinetic e-textile membrane for environmental control and communication within an architectural and wearable context. It consists of a curtain composed of actuated louvers that can be individually addressed for precise control of ventilation, daylight incidence and information display. Shutters' soft mechanics is based on the electronic actuation of 32 strands of shape-memory alloy. Each strand can be precisely controlled to angle the louvers and dynamically adjust their aperture, which regulates shade and ventilation and also displays images and animations. Shutters' substrate is built from a fire retardant wool felt which is ideal for complex laser cutting patterns and the integration of electronics and conductive threads. This responsive building façade can also be scaled for the construction of kinetic wearable displays, developing smart garments that inspire sartorial whimsy and creative expression. By combining smart materials, textiles and computation, Shutters creates living environments and work spaces that are more energy efficient, while being aesthetically pleasing.

Inspirations: Kinetic sculptures by Tim Prentice.

Sprout I/O (2006)

MIT Media Lab, Cambridge, Massachusetts, USA

Keywords: textile, shape memory alloy, kinetic, fur

Sprout I/O is a kinetic fur that can capture and replay the physical impressions we leave in our environment. It combines embedded actuators with a texturally rich substrate that is soft and fuzzy, to create a dynamic structure where every fur strand can sense physical touch and be individually moved. Sprout I/O is constructed from wool felt, shape-memory alloy and conductive threads.

Inspiration: The unpredictable fusion of a shag carpet and a kraken's tentacles.

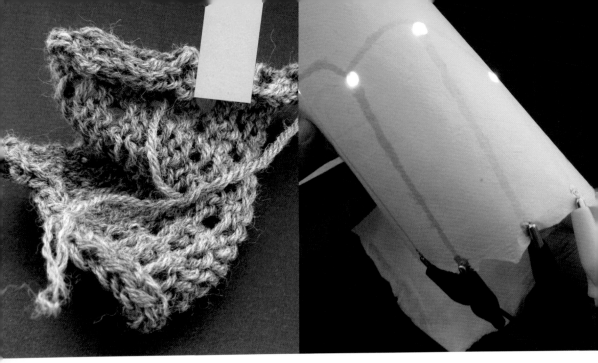

Soft Mechanics (2007 - ongoing)

MIT Media Lab, Cambridge, Massachusetts, USA

with Analisa Russo, Aria Reynolds

Keywords: soft machines, shape memory alloy, mechanics, knitting

Soft Mechanics focus on the development of taxonomy of kinetic elements to guide the design of wearable machines. It is primarily focused on aesthetics as well as the shapes and movements of the body. While traditional mechanics are predicated on the physics of hard materials, Soft Mechanics draws its inspiration from the soft surfaces, rich textures and traditional techniques of textiles.

Inspiration: Leonardo da Vinci's basic machine elements, Christopher Polhem's Machine Alphabet

Pulp-Based Computing (2006 - ongoing)

XS Labs, Montreal, Canada

with Joanna Berzowska, Lyndl Hall

Keywords: electronic paper, conductive inks, paper-making, embedded electronics

Pulp-Based Computing is a series of explorations that combine smart materials, papermaking and printing. By integrating electrically active inks and fibers during the papermaking process, it is possible to create sensors and actuators that behave, look, and feel like paper. These composite materials, not only leverage the physical and tactile qualities of paper, but can also convey digital information.

Inspiration: Traditional papermaking techniques

Marcelo Coelho

Zane Berzina

London, UK

Biography: Zane works on interdisciplinary projects across the fields of science, technology, design and the arts. Her research revolves around responsive and interactive textiles, new textile materials as well as biomimetics. Her practice-based PhD completed in 2005, at the University of the Arts in London, explored skin as a naturally intelligent material and examined its aesthetic and functional potential for translation into responsive and active textile systems. Currently she is a CHRRCT, Goldsmiths College, University of London, an Associate of the Goldsmiths Digital Studios and a co-founder and Creative Director of the e-text+textiles initiative in Riga, Latvia.

E-Static Shadows (2007 – 2009)

Goldsmiths, University of London, UK & In-square, London, UK & TITV - Textile Research Institute Thuringia-Vogtland, Germany & Queen Mary University of London, UK
with Janis Jefferies, Jackson Tan, Andres Melo, Natalie Stingelin-Stutzmann

Keywords: responsive environments, e-textiles, electrostatics, LEDs

The research project 'E-Static Shadows' (funded by AHRC) explores the speculative and poetic potential of the static electricity that surrounds our interactions in urban environments. The study investigates how electrostatic energy generated by human interactions could be translated into other types of energy for the development of responsive textile systems. These systems will be capable of detecting, processing and displaying electrostatic charges as dynamic audio-visual patterns. Ideally, these poetic translations, embedded in the soft medium of cloth, shall provoke a higher awareness of the electrostatic waves surrounding our habitat and initiate playful interactions between the viewer(s) and the space.

Materials: conductive threads, LEDs, transistors, woven or stitched e-textile systems, power supply

Inspirations: M. Shelley 'Frankenstein', A. Dunne 'Hertzian Tales: Electronic Products, Aesthetic Experience, and Critical Design', 'E-Static' by Jackson Tan, 'D-Tower' by Nox, 'Tri-Aura' by Frances Geesin, Shihoko Fukumoto, Frame, View on Colour, Future Materials

Zane Berzina

System I (2006)

London, UK
with TITV - Textile Research Institute Thuringia-Vogtland, Germany

Keywords: responsive membrane, color change, e-textiles

System I mimics skin properties that are regulated by our nervous system. The operating principle is based on the properties of thermochromic materials which change color when reacting to an increase or decrease in heat initiated by electric stimuli. When the electrical circuit is open the entire textile system undergoes fluctuating color changes.

Inspirations: skin biology, biomimetics, 'Electric Plaid' by International Fashion Machines, XSLabs

Skin Architecture (2004)

London College of Fashion, University of the Arts London, London, UK

Keywords: poly-sensual, color change, olfactory, e-textiles

Skin Architecture offers a sensory experience that simultaneously involves sight, smell and touch. The magnified skin pieces are visually animated by low electric stimuli passing through conductive threads integrated into the silicone objects. As the resistance heat radiates, the color change patterns increase until the entire piece changes color, while simultaneously releasing relaxing aromas.

Materials: silicone, thermochromic inks, aromatic oils, conductive threads, remote control, power supply

Inspirations: skin biology, biomimetics, 'Electric Plaid' by International Fashion Machines, XSLabs

Zane Berzina

Touch Me Wallpaper (2003 – ongoing)

London, UK

Keywords: responsive membrane, skin, color change, touch sensitive

Touch Me Wallpaper is an interactive sensory-appeal textile membrane that changes color in reponse to environmental or human heat. People are invited to interact with the wallpaper by touching it and creating their own bodily heat patterns, which are temporarily recorded on the wall until they fade away completely. The wall acts like a visual thermometer to changes in levels of heat initiated by human skin warmth by creating body prints of various intensities.

Materials: thermochromic inks, flame retardant nonwovens

Inspirations: D. Anzieu 'The Skin Ego', 'Chromazone' by Karim Rashid, table with a thermochromic finish by FLASK

Sensory Screen (2002 – 2006)

London College of Fashion, University of the Arts
London, London, UK

Keywords: responsive membrane, skin, color change, e-textile

Sensory Screen contributes to the underlying concept of skin as sensor, display and communicator. It is a medium that is capable of reflecting our reactions to various psychological or physical stimuli coming from the outer world. Linear patterns occur in places where semi-conductive threads are incorporated when an electric current passes through.

Materials: thermochromic inks, conductive threads, nonwovens, remote control, power supply

Inspirations: E. Lupton 'Skin: Surface, Substance and Design', C. Benthien 'Haut, Literaturgeschichte – Körperbilder – Grenzdiskurse'

Zane Berzina

Grado Zero Espace
Empoli, Italy

Biography: Grado Zero Espace is company specializing in design, innovation and technology. Their mission is to develop new materials and technologies for industry with the aim of improving the quality of life. The company acts in partnership with many industrial branches and research fields including the European Space Agency. Their innovative materials and ideas are finding myriad applications in fibers, fabrics, composite textile structures, extreme sport equipment and safety equipment.

K-Cap (2007)

Empoli, Italy

with European Space Agency

Keywords: anatomical comfort, transpiration, thermal regulation

K-Cap is a balaclava designed especially for high altitude use. It is being developed as part of a project for the design and development of specialized clothing equipment to be used during a scientific expedition on Mt. Everest. It consists of a memory active membrane, which modifies its physical structure according to variations in temperature, copying the behavior of human skin. In addition it has two layers of bi-stretch fabric that render the structure 'active', allowing complete freedom of movement.

Materials: shape memory membrane, bi-stretch warp-knit fabric

Hinoki LS (2007)

Empoli, Italy
with European Space Agency

Keywords: antibacterial, antiseptic, thermal regulation, relaxing property, eco friendly fabric

Hinoki fiber holds particular properties that make it fit for use in clothing. The fiber comes from the Eastern Cypress tree and has intrinsic antibacterial and antiseptic properties. Moreover the well-known relaxing properties of Hinoki allow this fiber to become a 'therapeutic' instrument in alignment with feng shui principles.

Materials: Hinoki cypress fabric

SpaceBra (2006)

Empoli, Italy
with European Space Agency

Keywords: body conscious, body active, body sculpture, shape memory effect

SpaceBra is a wearable vital-functions monitoring system with medical, sport and fashion applications that takes advantage of the conductive and superelastic properties of Shape Memory Alloys. SpaceBra can detect changes in body form that may indicate a potential health problem (medical), monitors heart rate (sports), and can change shape to provide varying levels of support (fashion).

Materials: shape memory fabric, knitting fabric

Wearable Cooling Systems (2002)

Empoli, Italy
with Corpo Nove

Keywords: cooling system, ergonomics, comfort, silk looking

The Cooling Jacket is based on a technology developed in America in the Sixties and incorporated into the work clothing at some nuclear facilities. GZe cooperated with the brand Corpo Nove to redesign the cooling circuit and transform its conventional features. They also upgraded its technological aspects making it lighter and more efficient. It is applied on mechanics' suits on the McLaren Mercedes racing team.

Materials: silver silk, plastic tubes, nomex

Oricalco Shirt (2001)

Empoli, Italy
with European Space Agency

Keywords: smart alloys, self-ironing shirt, **crystallog**raphic configuration

The Thermal Shape Memory Alloy is characterized by its extraordinary ability to recover any shape, pre-programmed, upon heating. The fabric used on for the sleeves of the Oricaloco shirt could be programmed to shorten immediately as the room temperature became a few degrees hotter. The fabric can be screwed up into a hard ball, pleated and creased and then automatically pop back to its original shape with just exposing it to hot air (even a hair dryer).

Materials: shape memory knitting fabric

Voltaic

New York, New York, USA

Biography: Voltaic was founded in 2003 by Shayne McQuade to develop green energy solutions and sustainable products. Through environmentally intelligent designs, Voltaic solar bags give students, travelers and outdoor lovers the ability to stay powered-up anywhere. Voltaic's objective is to push the envelope in the development of sustainable products.

Generator (2008)

New York, New York, USA

Keywords: solar, bags, environmentally friendly, recycle

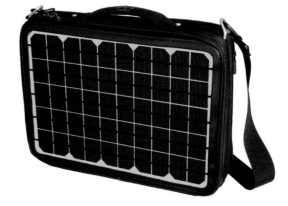

Voltaic's Generator bag uses a single solar panel to produce up to 14.7 watts of power. A full day of sunlight generates enough power for fully charge a typical laptop. The bag also charges virtually all other handheld electronics. The bag includes a battery pack custom designed to efficiently capture and store solar power so it is available whether the sun is up or not. It holds the equivalent of a full laptop charge, and delivers power at voltages required by laptops and other devices. Adaptors are included for easy connection to common laptops, phones and universal plugs. Devices can also be connected via a car charger or the USB plug built into the battery.
Materials: PET, solar panels

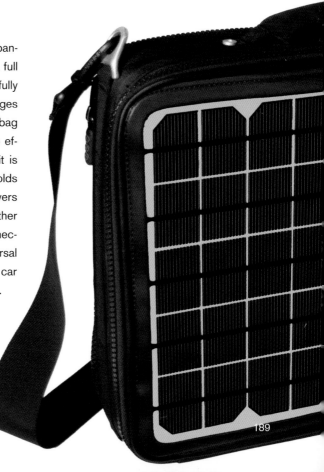

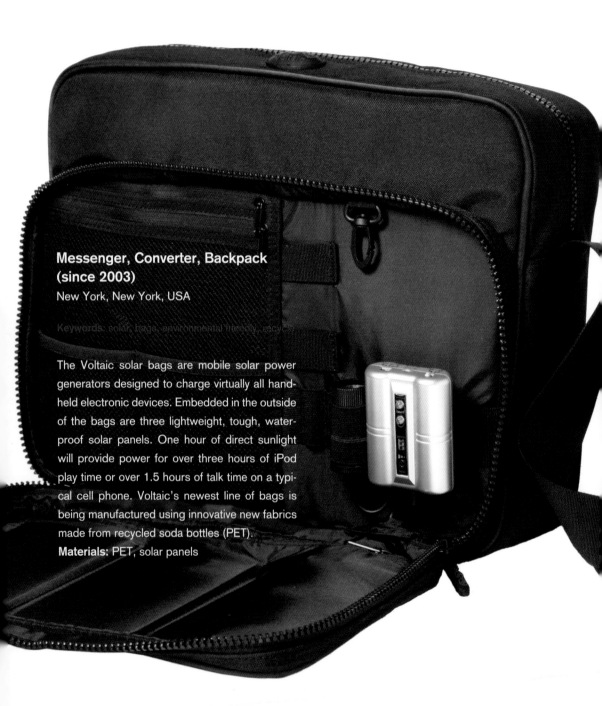

Messenger, Converter, Backpack (since 2003)
New York, New York, USA

Keywords: solar, bags, environmental friendly, recycle

The Voltaic solar bags are mobile solar power generators designed to charge virtually all hand-held electronic devices. Embedded in the outside of the bags are three lightweight, tough, water-proof solar panels. One hour of direct sunlight will provide power for over three hours of iPod play time or over 1.5 hours of talk time on a typi-cal cell phone. Voltaic's newest line of bags is being manufactured using innovative new fabrics made from recycled soda bottles (PET).

Materials: PET, solar panels

Ivo Locher, Sefar

Heiden, Switzerland

Sefar PowerMatrix (2008)

Heiden, Switzerland
with Marcel Strotz, Christoph Maurer, Hugo Mueller

Keywords: electronic fabric, conductive fabric, smart textile

Biography: Ivo is part of the electronic fabrics R&D team at Sefar. Sefar is a worldwide leading manufacturer of monofilament precision fabrics. The electronic fabrics team focuses on the development of fabric circuit boards, fabric heating and fabric sensors. In 2006, Ivo completed his PhD degree in Electrical Engineering in the field of wearable computing at ETH in Zurich. Prior to that, he received his MSc degree in signal processing at UCLA.

PowerMatrix is a hybrid fabric consisting of woven polyester monofilament yarn and copper alloy wires. Each copper wire itself is coated with an electrical insulation varnish to prevent short-circuiting among the cross-running wires. The copper wire grid in the fabric features a spacing of about 1mm. PowerMatrix has a weight of about 74g/m2 and a high air flow. The fabric integrates regularly spaced black marker filaments. These markers help when placing and interconnecting electrical components within the fabric. Eventually, PowerMatrix can be used as an entirely flexible circuit board.

WarmX
Apolda, Germany

Biography: WarmX developed a patented warming-technology, which makes it possible for users to feel well and to move freely at low temperatures. WarmX uses the easy and efficient warming-technology in the development of textile products that generate warmth without wires. Their products are made using flat-knitting technology. WarmX is a family based company that has produced flat-knitted garments since 1896.

WarmX (since 2005)

Apolda, Germany
with Michele Stinco, Gerald Rosner, Christoph Mueller

Keywords: heatable underwear, silver-coated **polyamid** yarn

WarmX is actively heatable underwear that warms different areas of the body. Silvered threads are integrated into a knitted garment and supplied with power by a small controller. The garment warms up directly on the skin and without heating wires. The seamless tights consist of a silver-coated polyamid yarn and warms the knees and feet. The yarns produce an antimicrobial effect and reduces odor. The tights are supplemented by the new warmX silverSun. This skin tight shirt was developed using bodymapping principles and actively heats the kidney area of the wearer.

WarmX

Elisabeth de Senneville
Paris, France

Biography: Since 1980, Elisabeth is well known for innovation in new fabrics like holograms, len ticular, neopren, photoluminescent and woven optic fibers. She collaborates with groups like Nissan, Arche, Peugeot, Decathlon Damart, and Salomon. Her objective is to integrate ecology and poetry into cloth and design technology. In the future, she wants to develop new fabrics that help us all to better adapt to urban life. In 2003 she was given an 'Innovation Award'; she also teaches innovation at ENSAD in Paris.

Velowear (2007)
Paris, France

Keywords: light-emitting, photoluminescent, biking

The Velowear line was created using a new, re cently patented, photoluminescent fabric. You can 'load' this fabric with light from a lamp or the sun and it will then provide light for about 12 hours. This is a magical cloth for bike and motor cycle riders.

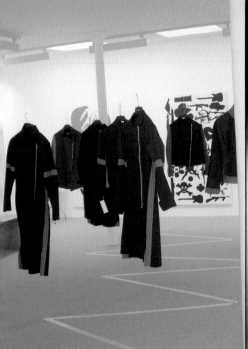

Art Couture (2005 – ongoing)

Paris, France

Keywords: art, fashion, exhibition

The Art Couture line is generally exhibited in an Art Gallery context and has been presented alongside fine art pieces in Paris and Saint Tropez. The goal is to strengthen the links between art and fashion while creating truly unique experiences and products for patrons. The project provides insights into the relationships between art, innovation and fashion and how they will interact in the future. Every two months Elisabeth selects a Parisian gallery and an artist to collaborate with. At the gallery clients are fitted and orders are taken to be delivered the following week.

Flexible Screen Clothing (2003)

Paris, France
with France Telecom

Keywords: display, mobile phone, soft screen

Flexible Screen Clothing is a line of clothing designed for France Telecom. The concept was called Create Wear and involved clothing with an embedded soft screen that uses LEDs to allow users to load images from their mobile phone.

Elisabeth de Senneville

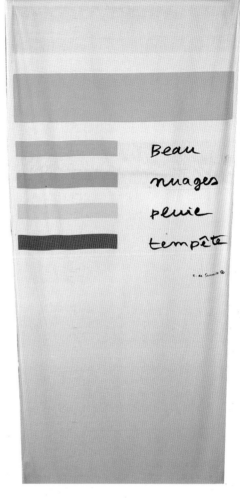

Anti-Pollution (2002)

Paris, France

Keywords: anti-pollution

Anti-Pollution is a unique technology that acts as a filter against urban pollution. This new product has many applications in clothing and houseware. In addition, it features bold prints further blending the worlds of art and technology.

Meteo Blind (2001)

Paris, France

Keywords: microfiber, humidity, weather

The Meteo Blind is both poetic and technologic in its design. The print is micro-encapsulated and responds to air humidity. It uses an easy to read color code that allows the user to predict the coming day's weather.

Elisabeth de Senneville

Project Websites

▮ Project Websites

Electronic Fashion

Hussein Chalayan
www.husseinchalayan.com

Ying Gao
www.exercicesdestyle.com
http://cavaaller.blogspot.com

Angel Chang
www.angelchang.com

CuteCircuit
www.cutecircuit.com

Kerri Wallace
www.kerriwallace.com

Elena Corchero
www.lostvalues.com

Ebru Kurbak & Ricardo Nascimento & Fabiana Shizue
www.popkalab.com/th.html

KnoWear
www.knowear.net

Interactive Interfaces

XS Labs
www.xslabs.net
www.berzowska.com
www.uttermatter.com
www.dimainstone.com

Suzi Webster
www.suziwebster.org

Barbara Layne, Studio subTela
http://subtela.hexagram.ca

Diana Eng
www.blogginginmotion.com
www.dianaeng.com

Stijn Ossevoort
www.linkedin.com/in/sostechnologydesign

Maggie Orth, International Fashion Machines
www.ifm.com

Linda Worbin
www.worbin.com/linda

Scientific Couture

Donna Franklin
www.bioalloy.org/projects/micro-be.html
www.symbiotica.uwa.edu.au

Manel Torres, Fabrican
www.fabricanltd.com

Tobie Kerridge
www.biojewellery.com
www.materialbeliefs.com

Sensual Being & Tangible Touch

Jenny Tillotson
www.smartsecondskin.com
www.indie911.com/film/animation/scentsory-design
www.transhumanism.org/gallery/jt.htm

James Auger & Jimmy Loizeau
www.auger-loizeau.com
www.smellplus.co.uk

Adidas
www.adidas.com

Textronics
www.textronicsinc.com
www.numetrex.com

Cati Vaucelle
http://web.media.mit.edu/~cati

Hannah Perner-Wilson & Mika Satomi
www.massage-me.at

Kai Eichen & Marit Mihklepp & Hanna Tiidus
www.arukad.ee/et/projects/dynamical_textiles/springon

Wearable Explorations

Despina Papadopoulos, Studio 5050
www.5050ltd.com

Leah Buchley
www.thehighlowtech.com
www.arduino.cc
www.sparkfun.com

Laura Beloff & Erich Berger & Martin Pichlmair
www.realitydisfunction.org
http://tratti.attacksyour.net
http://randomseed.org

Kate Hartman
www.katehartman.com

Younghui Kim
www.absurdee.com

Fiona Carswell
www.fionacarswell.com

Kouji Hikawa
http://lacoyta-e-fashion.blogspot.com

Social Fabric

Philips Design
www.design.philips.com

Jayne Wallace
www.ncl.ac.uk/culturelab/research/jwdoctoral.htm
www.jaynewallace.info

Mouna Andraos
www.missmoun.com
www.electroniccrafts.org
www.junksoup.com/address

Ayah Bdeir
www.ayahbdeir.com

Teresa Almeida
www.banhomaria.net

Cat Mazza
www.microrevolt.org
http://66.34.35.248

Ebru Kurbak & Mahir M. Yavuz
http://casualdata.com/newsknitter

Fabienne Blanc & Patrick Rüegg
www.be-geistert.ch
www.acar2.org

Sonic Landscape

Maurin Donneaud, XYinteraction
http://xyinteraction.free.fr

Madgalena Kohler & Hanna Wiesener
www.trikoton.com

Burton
www.burton.com

Nike
www.nike.com

Fibretronic
www.fibretronic.com

O'Neill
www.oneill.com

Material Witness

Alyce Santoro
www.alycesantoro.com
www.sonicfabric.com
www.designtex.com

Marcelo Coelho
www.cmarcelo.com

Zane Berzina
www.skinstories.com
www.zaneberzina.com

Grado Zero Espace
www.gzespace.com

Voltaic
www.voltaic.com

Sefar
http://powermatrix.sefar.com

WarmX
www.warmx.de
www.smarttextiles.net

Elisabeth de Seineville
www.e2senneville.com

Materials

❚ Materials

Conductive Fabric & Velcro

Aracon | conductive thread
www.micro-coax.com/pages/technicalinfo/ARACON/aracon_about.asp

Bekaert | conductive fabrics, threads and shielding textiles
www.bekaert.com/bft/Products/Innovative%20textiles.htm

Flextex | conductive fabric
www.flextex.com/emilshieldinglcondlfabric.html

Hook and Loop | conductive Velcro
www.hookandloop.com/site/product.cfm?id=electrically_conductive_velcro_hook_and_loop

Less EMF | conductive fabric, thread, Velcro, paint, ex-static fabric
www.lessemf.com

Metalline | conductive fabric
http://ajinelectron.co.kr/main/index.php

Noble Biomaterials | anti-static and conductive materials
www.noblebiomaterials.com/category.asp?itemid=51

Shieldex Trading | conductive fabric, thread, fabric zipper tape
www.shieldextrading.net

Conductive Thread

Fine Silver Products | conductive thread, fabric, tape
www.fine-silver-productsnet.com

Hedgehog Handworks | metal wrapped conductive threads
www.hedgehoghandworks.com/catalog/metal_thread_index.shtml

JDR - Brazilian Elegance | metal wrapped conductive threads
www.jdr-be.com/metal-lurex.htm

Lame Lifesaver | conductive thread
http://members.shaw.ca/ubik/thread/order.html

Syscom Advanced Materials | conductive polymer/metal hybrid yarn
www.amberstrand.com

T&L Barnes | metal wrapped conductive thread
www.tlbarnes.com

Textura Trading Company | stainless steel conductive thread
www.texturatrading.com

Tinsel Trading Company | vintage metal threads and fabric
www.tinseltrading.com

TITV Greiz | Elitex, a silver coated yarn
www.titv-greiz.de

Conductive Adhesive Tapes

3M | conductive tapes
http://solutions.3m.com

The Tape Works | liquid tape
www.thetapeworks.com/liquid-tape.htm

Conductive Powders and Paints

Acheson Industries | conductive screen printable silver inks and graphite-based pastes
www.achesonindustries.com

Amazing Magnets | ferrofluid
www.amazingmagnets.com/index.asp?PageAction=VIEWPROD&ProdID=108

Atlantic Equipment Engineers | metal powders and compounds
www.micronmetals.com

Chemtronics | conductive pen
www.chemtronics.com

DuPont | carbon and silver conductors
www.dupont.com

Elemental Scientific | carbon graphite powder
www.elementalscientific.net

SPI Supplies | conductive powders and paints
www.2spi.com/catalog/spec_prep/cond_paints.html

Other Conductive Materials

Briwax | metal wool
www.briwax-online.com/GMT.html

Devcon | metal filled epoxy adhesive
www.devcon.com/devconcatsolution.cfm?catid=34

Ercon | sensor materials
www.erconinc.com/home.htm

Seal Science | conductive rubber
http://sealscience.com/conductive_rubber.aspx

Zoflex | conductive rubber
www.rfmicrolink.com/zoflex.html

Anti-Static Products

Antistatic Industries | anti-static products
https://www.antistaticindustries.com

StaticFaction | distributor of Thunderon anti-static products
www.staticfaction.com

X-Static | silver fiber
www.x-staticfiber.com

Isolating and Model-Making Materials

Environmental Technology | easy cast resins
www.eti-usa.com/consum/index.html

FormFX | liquid rubbers, plastics, medical adhesives, alcohol-based body inks
www.formfx.eu

Panipol | polyaniline products
http://panipol.fi

Resin Technical Systems | resin
www.resintek.co.uk

Shape Lock | modelling and mould making, quick and easy
www.shapelock.com

Smooth-on | rubber, plastics, foam, adhesives
www.smooth-on.com

Soltor Plastics | acrylic glass
www.solterplastics.com/plastics

Teknor Apex | advanced polymer materials
www.teknorapex.com/index.html

Von Roll | electrical insulating materials
www.vonroll.com

Specialty Fabrics

Difco | protective and high performance fabrics
www.difcoperformance.com

Dupont | high-tech textiles
www.dupont.com

Foster-Miller | electro textiles
www.foster-miller.com

Gorix Ltd. | high-tech textiles
www.gorix.com

Industrial Fabrics Association International | not-for-profit trade association

representing the specialty fabrics industry
www.ifai.com

Luminex | light-emitting fabric
www.luminex.it

Material Connexion | innovative materials lexicon
www.materialconnexion.com

Offray Speciality Narrow Fabrics | smart textiles, static dissipative

products

www.osnf.com

Schoeller | high-tech textiles
www.schoeller-textiles.com

Scientific Instrument Services | ceramic blankets and cloths
www.sisweb.com/catalog/04/A69

Sedo Chemicals | neoprene
www.sedochemicals.com

Fusible and Fabric Glue

AllStitch LLC | Spray On Fusible Web
www.allstitch.net/product/606-spray-on-fusible-web-65-oz-3764.cfm

Fabrics Unlimited | fusible
www.fabricsunlimited.net/instfuweb.html

Hancock Fabrics | Dritz FrayCheck Liquid Seam Sealant
www.hancockfabrics.com/jump-12/PRODUCT/16282.shtml

Products A LA CARTE | Pellon fusibles
www.shoppellon.com/index.php?main_page=index&cPath=68

Quilting Warehouse | fusible web, fusible tape
http://store.quilting-warehouse.com/batting---interfacing-fusibleweb.html

Red Rock Threads | fusible, invisible and water soluble thread
www.redrockthreads.com/misc-thread/fusible-thread.asp

Save-on-crafts | Aleene's Flexible Stretchable Fabric Glue, great as

isolator for conductive fabric
www.save-on-crafts.com/fabricglues.html

Sulky | Sulky Sticky Self-Adhesive Tear-Away Stabilizer
www.sulky.com/stabilizers/sticky.php

Metal Sewing Accessories

Prym | sewing and needlework accessories
www.prym-consumer.com

YKK | fastening products
www.ykkfastening.com

Sensors

Conductive Technologies | electro-chemical sensors, membrane switches,

flexible heaters
www.conductivetech.com

Eleksen | textile touchpads
www.eleksen.com

Flexpoint | bend and flex sensors
www.flexpoint.com

Images | many different sensors and actuators
www.imagesco.com

Interlink Electronics | force-sensitive resistors and touchpads
www.interlinkelectronics.com

International Fashion Machines | wall dimmer
www.ifmachines.com

Microstrain | wireless sensors
www.microstrain.com

Piezo Systems | piezo elements
www.piezo.com

Stella | stretchable electronics
www.stella-project.de

Textronics | wearable sensors
www.textronicsinc.com

Xsens | motion, orientation and position measurement
http://xsens.com

Actuators

B&H Color Change Ltd. | thermochromic ink
www.thermochromicinks.com

Color Change Corporation | thermochromic and photochromic ink
www.colorchange.com

CTI Extreme Inks | thermochromic etc ink
www.ctiinks.com/default.asp

Dynalloy | Flexinol, shape memory alloy
www.dynalloy.com

E-Ink | electronic paper displays
www.eink.com

Hallcrest | temperature triggered color changing technology
www.hallcrest.com

Matsui | thermochromic pigments, aroma ink, photopia, a UV light

sensitive photochromic ink
www.matsui-color.com

Melcor | thermoelectric cooling solutions
www.melcor.com/ptseries.html

Memory Metalle GmbH | shape memory alloys
www.memory-metalle.de

Mymotors & Actuators GmbH | flat motors
www.mymotors.de

Precision Microdrives | precision motion control components
www.precisionmicrodrives.com

SAES Smart Materials | shape memory alloys
www.shape-memory-alloys.com

Tayco | temperature sensors and flexible heaters
www.taycoeng.com/products.htm

Veriflex | shape memory
www.crg-industries.com/products.htm

Communication and Connections

ABACOM | embedded RF and network devices
www.abacomdirect.com

Bluetooth | Bluetooth solutions
www.bluetooth.com/Bluetooth/Products

Fibretronic | soft electronic components
www.fibretronic.com

Lemos International | radio communication
http://lemosint.com

Moog | slip rings
www.polysci.com

Novonic | textile cable
www.novonic.de

SkyeTek | RFID
www.skyetek.com

Woven Electronics | woven circuits
www.wovenelectronics.com

XBee | wireless communication modules
http://newmicros.com

Power

Powerfilm | flexible solar panels
www.powerfilmsolar.com

Solar Home | flexible, portable, modular solar systems
www.SolarHome.org

Solar World | think, flexible solar panels
www.solar-world.com/PowerFilm.htm

Total Power Solution | batteries
www.all-battery.com

Microbattery | micro batteries
www.microbattery.com

Displays

Best Hong Kong | cheap LEDs
http://besthongkong.com

Dupont | electroluminescence
www.dupont.com

Fabcell | non-emissive, multi-color fabric module
http://idl.sfc.keio.ac.jp/project/fabcell

Fresnel Technologies | plastic optical lenses
www.fresneltech.com

Glowire | electroluminescent wire
www.glowire.com

LED-Flex | LED tubes
www.mulelighting.com/products2.asp?id=2

LEE Filters | lighting and camera filters
www.leefilters.com

Lytec | electroluminescent wire
www.coolight.com

MARL | LEDs
www.leds.co.uk

Oryon Technologies | Elastolite
http://oryontech.com

Pacel | EL displays
www.pacel.co.uk

Philips | Lumalive
www.lumalive.com

Plastic Logic | flexible displays
www.plasticlogic.com

Rogers Corporation | electroluminescent lighting systems
www.rogerscorporation.com

Super Bright LEDs
www.superbrightleds.com

Physical Computing Platforms

Arduino
http://arduino.cc

Basic Stamp
www.parallax.com

D-Tools
http://hci.stanford.edu/dtools

Euro Circuits
www.eurocircuits.com

GoGo Board
www.gogoboard.org/cocoon/gogosite/home.xsp?lang=en

Handyboard
http://handyboard.com

Lilypads
http://thehighlowtech.com

LogoChip
www.wellesley.edu/Physics/Rberg/logochip/distribution

MakingThings
www.makingthings.com

MidiTron
http://miditron.com

Phidgets
www.phidgets.com

Wiring
www.wiring.org.co

Microcontrollers

ATMEL
www.atmel.com

Basic micro
www.basicmicro.com

Microchip
http://microchip.com

Micromint
http://micromint.com

Netmedia
http://basicx.com

Paralleay
www.parallax.com

Electronics and Prototyping

All Electronics | online electronics surplus distributor
www.allelectronics.com

CSD | online electronics distributor
www.csd-electronics.de

Digikey | online electronics distributor
www.digikey.com

Electronic Goldmine | online electronics surplus distributor
http://goldmine-elec.com

Farnell | online electronics distributor
www.farnell.at

Fluke | multimeters
www.fluke.com

JAMECO | online electronics distributor
www.jameco.com

JAMECO Robot Store | robotic kits, parts & more
www.robotstore.com

Mouser Electronics | electronic component distributor
http://mouser.com

PCB milling | printed circuit board milling
www.pcbmilling.com

Radioshack | shop and online electronics distributor
www.radioshack.com

RS | online electronics distributor
www.rs-components.com/index.html

Small Parts | the hardware store for researchers and developers
www.smallparts.com

Solarbotics | mature hobby robotics and electronics company
www.solarbotics.com

Sparkfun | online electronics distributor
www.sparkfun.com

Software

Cycling '74 | Max/MSP
www.cycling74.com

Processing | open source programming language and environment
http://processing.org

Pure Data | software by Miller Puckette
http://crca.ucsd.edu/~msp/software.html

▌Methods & Tools

Sewing, Embroidery and Quilting

Babylock | sewing, embroidery, quilting and serging machines
www.babylock.com

Bernina | embroidery, quilting, home decoration, sewing and handicraft
www.bernina.com

Brother | home sewing & embroidery machines
www.brother-usa.com

Burda Style | open source sewing
www.burdastyle.com

Husqvarna Viking | sewing machines
www.husqvarnaviking.com

Janome | sewing machines
http://janome.com

MicroRevolt | convert image to embroidery pattern
www.microrevolt.org/knitPro

Nolting | quilting machines
www.nolting.com

Pfaff | sewing machines
www.pfaff.com

Singer | sewing machines
www.singerco.com

Knitting and Crochet

Discontinued Brand Name Yarns | bargain prices yarn
www.discontinuedbrandnameyarn.com

Knitty | little perls of wisdom
www.knitty.com

Loop | online yarn shop and more
www.loopyarn.com

Shima Seiki | flat knitting machines
www.shimaseiki.co.jp

Stoll | flat knitting machines
www.stoll.com

Weaving

The DesignScope Company | textile software
www.designscopecompany.com

Digital Weaving | digital Jacquard loom
http://weaving.tronrud.no

Arm | electronic loom
http://arm-loom.ch

Felting

Craftgossip | blog network
http://felting.craftgossip.com

The Woolery | how-to
www.woolery.com/Pages/felting.html

Fusing

HIX Heat Presses | lightweight, portable and hobby heat transfer presses
http://hixheatpress.com

Printing

Digitaltextile | digital textile printing
www.digitaltextile.com/equipment.htm

Mimaki | digital printer & ink
www.mimaki.co.jp/english/top/index.php

Roland | digital printer
www.rolanddga.com

HP | digital printer
www.hp.com

BASF | ink
www.basf.com

DYSTAR | ink
www.dystar.com

Laser Cutting and Engraving

Alltec
http://217.243.167.125

EuroLaser
www.eurolaser.com

FKM Sintertechnik
www.fkm-sintertechnik.de/leistungen_de

GCC
www.gccworld.com

GravoGraph
www.gravograph.com

Laser Cutting Textiles and Fabric for Fashion Industry
www.lasercutfabric.com

LaserPro
www.laserprona.com

VersaLaser
www.ulsinc.com/versalaser

Rapid Prototyping

3D Systems | FDM, MJM, SLA, SGC and SLS
www.3dsystems.com

Dimension Printing | FDM and MJM
www.dimensionprinting.com

EOS | SLS
www.eos.info

Euromold | World fair for mould making and tooling
www.euromold.com

Fab Lab MIT | explores how the content of information relates to its

physical representation
http://fab.cba.mit.edu

Kira Corporation | LOM
www.kiracorp.co.jp

Optomec | SLS
www.optomec.com

ProMetal | SLS
www.exone.com/eng/technology/x1-prometal

Roland | CNC
www.rolanddga.com/asd

Solidimension | LOM
www.solidimension.com

Solidscape | FDM and MJM
www.solid-scape.com

Stratasys | FDM and MJM
www.stratasys.com

ZCorp | 3D printing
www.zcorp.com

Bibliography

∎ Theory, Fashion & Technology

Antonelli, Paola: Safe: Design Takes On Risk. Museum of Modern Art, New York, 2005.

Anzieu, Didier: The Skin Ego. Yale University Press, New Haven, CT, USA, 1989.

Barfield, Woodrow & Caudell, Thomas: Fundamentals of Wearable Computers and Augmented Reality, Lawrence Erlbaum Associates, London, 2001.

Barnard, Malcom: Fashion as Communication. Routledge, London, New York, 2002.

Barrett, Cyril: Wittgenstein, Ludwig, Lectures and Conversations on Aesthetics, Psychology, and Religious Beliefs. University of California Press, Berkeley, Los Angeles, 2007.

Barthes, Roland: The Fashion System. University of California Press, Berkeley, Los Angeles, CA, USA, 2007.

Baudrillard, Jean: The System of Objects. 2nd edn, Verso, London, New York, 2005.

Bradley, Quinn: Techno Fashion. Berg, Oxford, UK, 2002.

Bradley, Quinn: The Fashion of Architecture. Berg, Oxford, UK, 2003.

Breward, Christopher & Evans, Caroline: Fashion and Modernity. Berg, Oxford, UK, 2005.

Bolton, Andrew: The Supermodern Wardrobe. V&A Publications, London, 2002.

Bourriaud, Nicolas: Relational Aesthetics. Les presses du réel, Paris, 2002. (French)

Csikszentmihalyi, Mihaly & Robinson, Rick E: The Art of Seeing – An Interpretation of the Aesthetic Encounter. The Paul Getty Trust Office of Publications, Malibu, USA, 1990.

Dunne, Anthony: Hertzian Tales: Electronic Products, Aesthetic Experience and Critical Design. RCA CRD Research Publications, London, 1999.

Dunne, Anthony & Raby, Fiona: Design Noir. The Secret Life of Electronic Objects. Birkhäuser, Basel, Switzerland, 2001.

Dvorak, Joseph L: Moving Wearable Technology into the Mainstream: Taming the Borg. Springer, New York, 2007.

Eco, Umberto: Travels in Hyperreality. Harvest Books, Fort Washington, PA, USA, 1990.

Eco, Umberto: History of Beauty. 2nd edn, Rizzoli, New York, 2005.

Eng, Diana & Zee Drieu, Natalie: Techstyle: Create Wired Wearables and Geek Gear. Wiley, 2008.

Entwistle, Joanne: The Fashioned Body. Fashion, Dress and Modern Social Theory. Polity Press, Cambrige, UK, 2000.

Evans, Caroline et al: Hussein Chalayan. Nai Publishers - Groninger Museum, Rotterdam, 2005.

Evans, Caroline: Fashion at the Edge: Spectacle, Modernity, and Deathliness. Yale University Press, New Haven, CT, USA, 2007.

Featherstone, Mike & Burrows, Roger: Cyperspace, Cyberbodies, Cyberpunk. Cultures of Technological Embodiement. Sage Publications, London, 1995.

Gale, Colin & Kaur, Jasbir: Fashion and Textiles. An Overview. Berg, Oxford, UK, 2004.

Gershenfeld, Neil A: When Things Start to Think. Henry Holt, New York, 1999.

Greenfield, Adam: Everyware. The dawning age of ubiquitous computing. New Riders, Berkeley, CA, USA, 2006.

Hables Gray, Chris (Ed): The Cyborg Handbook. Routledge, New York, London, 1995.

Harraway, Donna: Simians, Cyborgs, and Women. The Reinvention of Nature. Free Association Books, London, 1991.

Hodge, Brooke & Mears, Patricia & Sidlauskas, Susan: Skin + Bones: Parallel Practices in Fashion and Architecture. Thames & Hudson, London, 2006.

Jeffries, Janis (Ed): Textile, The Journal of Cloth & Culture, Digital Dialogues 1: Textiles and Technology, Volume 2, Issue 3. Berg Publishers, Biggleswade, UK, 2004.

Jeffries, Janis (Ed): Textile, The Journal of Cloth & Culture, Digital Dialogues 2: Textiles and Technology, Volume 3, Issue 1. Berg Publishers, Biggleswade, UK, 2005.

Koda, Harold: Extreme Beauty: The Body Transformed. Metropolitan Museum of Art, New York, 2001.

Kurzweil, Ray: The age of the spiritual machines. When computers exceed human intelligence. Penguin Books, New York, 1999.

Lawson, Bryan: How Designers Think: The Process of Design Demystified. 3rd edn, Architectural Press, Oxford, UK, 1997.

Lee, Suzanne: Fashioning the Future. Tomorrow's Wardrobe. Thames & Hudson, London, 2005.

Lumsden, Joanna (Ed): Handbook of Research on User Interface Design and Evaluation for Mobile Technology, Vol 1 & 2. IGI Global, Hershey, PA, USA, 2008.

Lupton, Ellen (Ed): Skin. Surface, Substance + Design. Princton Architectural Press, New York, 2002.

Lupton, Ellen (Ed): D.I.Y.:Design it Yourself. Princeton Architectural Press, New York, 2006.

Lurie, Alison: The Language of Clothes. Henry Holt and Company, New York, 2000.

Marzano, Stefano & Aarts, Emille: The New Everyday View on Ambient Intelligence. 010 Publishers, Rotterdam, 2003.

McLuhan, Marshall: Understanding Media – The Extension of Man. MIT Press, Cambridge, MA, USA, 1995.

McQuaid, Mathilda (Ed): Extreme Textiles. Designing for High Performance. Princeton Architectural Press, New York, 2005.

Moggridge, Bill: Designing Interactions. MIT Press, Cambridge, MA, USA, 2007.

Negroponte, Nicholas: Being Digital. Vintage Books, New York, 1996.

Norman, Donald A: The Invisible Computer. MIT Press, Cambridge, MA, USA, 1997.

Norman, Donald A: Emotional Design. MIT Press, Cambridge, MA, USA, 2004.

O'Mahony, Marie: Cyborg: The Man-Machine. Thames & Hudson, New York, 2002.

Papadakis, Alexandria & Papadakis, Andreas: Innovation – From Experimentation to Realisation. New Architecture Group, London, 2003.

Pentellini, Claudia & Stohler, Peter (Eds): Body Extensions. Art, Photography, Film, Comic, Fashion. Arnoldsche, Munich, 2004. (German & French)

Philips Design: New Nomads. An Explorations of Wearable Electronics by Philips. 010 Publishers, Amsterdam, 2000.

Picard, Rosalind W: Affective Computing. MIT Press, Cambridge, MA, USA, 1997.

Plant, Sadie: Zeros & Ones: Digital Women & The New Technoloculture. Fourth Estate, London, New York, 1997.

Rheingold, Howard: Tools for Thought: The History and Future of Mind-Expanding Technology. 2nd edn, MIT Press, Cambridge, MA, USA, 2000.

Shishoo, Roshan: Textiles in Sports. Woodhead Publishing, Cambridge, UK, 2005.

Smith, Courtenay & Topham, Sean: Extreme Fashion. Prestel, Munich, 2005.

Smith, Marquart & Morra, Joanne: The Prosthetic Impulse, From a Posthuman Present to a Biocultural Future. MIT Press, Cambride, MA, USA, 2005.

Steffen, Alex: Worldchanging: A User's Guide for the 21st Century. Harry N. Abrams, New York, 2006.

Sterling, Bruce: Shaping Things. MIT Press, Cambridge, MA, USA, 2005.

Troy, Nancy J: Couture Culture: A Study in Modern Art and Fashion. MIT Press, Cambridge, MA, USA, 2003.

Turkle, Sherry (Ed): Evocative Objects: Things We Think With. MIT Press, Cambridge, MA, USA, 2007.

Turkle, Sherry: The Second Self: Computers and the Human Spirit. 20th edn, MIT Press, Cambridge, MA, USA, 2005.

Vinken, Barbara: Fashion Zeitgeist – Trends and Cycles in the Fashion System. Berg, Oxford, UK, 2005.

Warwick, Alexandra & Cavallaro, Dani: Fashioning the Frame. Boundries, Dress and the Body. Berg, Oxford, UK, 2001.

Watkins, Susan M: Clothing: The Portable Environment. Iowa State Press, 1995.

Wilcox, Claire: Radical Fashion. Victoria and Albert Museum, London, 2001.

Wilson, Elizabeth: Adorned in Dreams: Fashion and Modernity. University of California Press, Berkeley, CA, USA, 1985.

Worbin, Linda: Dynamic Textile Patterns. Designing with Smart Textiles. Chalmers University of Technology, Göteborg University, Göteborg, Sweden, 2006.

❙ Materials, Textiles & Technology

Ballard Bell, Victoria & Rand, Patrick: Materials for Design. Princeton Architectural Press, New York, 2006.

Black, Sandy: Fashioning Fabrics. Contemporary Textiles in Fashion. Black Dog Publishing, London, 2006.

Braddock Clarke, Sarah E & O'Mahony, Marie: Techno Textiles 2. Revolutionary Fabrics for Fashion and Design. New York, Thames & Hudson, 2006.

Braddock, Sarah E & O'Mahony, Marie: Techno Textiles. Revolutionary Fabrics for Fashion and Design. New York, Thames & Hudson, 1998.

Braddock, Sarah E. & O'Mahony, Marie: Sportstech. Revolutionary Fabrics, Fashion and Design. New York, Thames & Hudson, 2002.

Brownell, Blaine: Transmaterial. A Catalog of Materials that Redefine our Physical Environment. Princeton Architectural Press, New York, 2006.

Brownell, Blaine: Transmaterial2. A Catalog of Materials that Redefine our Physical Environment. Princeton Architectural Press, New York, 2008.

Hibert, Ros: Textile Innovation: Traditional, Modern and Smart Textiles. Line, London, 2005.

Horowitz, Paul & Hill, Winfield: The Art of Electronics. 2nd edn, Cambridge University Press, Cambridge, MA, USA, 1994.

Igoe, Tom: Making Things Talk: Practical Methods for Connecting Physical Objects. Make Books, 2007.

Kasap, Safa & Capper, Peter (Eds): Electronic and Photonic Materials. Springer, New York, 2006.

Matério: Material World 2: Innovative Materials for Architecture and Design. Birkhäuser, Basel, 2007.

O'Sullivan, Dan & Igoe, Tom: Physical Computing. Sensing and Controlling the Physical World with Computers. Thomson, Course Technology, Boston, 2004.

Redström, Johan. & Redström, Maria & Mazé, Ramia (Eds): IT + TEXTILES. Edita Publishing Oy, Helsinki, Finland, 2005.

Ritter, Axel: Smart Materials in Architecture, Interior Architecture, and Design. Birkhäuser, Basel, Switzerland, 2007.

Scherz, Paul: Practical Electronics for Inventors. Mc-Graw-Hill, New York, 2000.

Shishoo, Roshan (Ed): Textiles in sport. Woodhead Publishing, Cambridge, UK, 2005.

Stroud, Marion Boulton: New Material as New Media: The Fabric Workshop and Museum. MIT Press, Cambride, MA, USA, 2002.

Tao, Jianhua et al: Affective Computing and Intelligent Interaction. First International Conference, ACII 2005. Springer, Berlin, Heidelberg, 2005.

Tao, Xiaoming (Ed): Wearable Electronics and Photonics. Woodhead Publishing, Cambridge, UK, 2005.

Tao, Xiaoming (Ed): Smart fibers, fabrics, and clothing. Woodhead Publishing. Cambridge, UK, 2001.

Wolf, Wayne: Computers as Components. Principles of Embedded Computing System Design. Morgen Kaumann Publishers, San Francisco, 2001.

Blogs & Websites

Blogs & Websites

boingboing | A Directory Of Wonderful Things
www.boingboing.net

Cool Hunting | Intersection of art, design, culture and technology
www.coolhunting.com

Cordless Threads by Fiona Carswell
www.cordlessthreads.com

CORE77 | Industrial Design Supersite
www.core77.com

Craft | Dedicated to the renaissance of craft
www.craftzine.com

Design Boom | Industrial design today
www.designboom.com

Doors of Perception | Starting new conversations on design and
innovation
www.doorsofperception.com

Electroniccrafts | Small resource for hand made electronics
www.electroniccrafts.org

engadget | Everything new in gadgets and consumer electronics
www.engadget.com

Etsy | Your place to buy & sell all things handmade
www.etsy.com

Fashionable Technology | The Intersection of Design, Fashion, Science,
and Technology
www.fashionabletechnology.org

Horizon Zero | Issue 16: Wear: Issue dedicated to wearable technologies
www.horizonzero.ca

i heart switch by Alison Lewis
www.iheartswitch.com

INDEX | Design to improve life
www.indexaward.dk

info gargoyle | A community for hi-tech information gatherers
http://igargoyle.com

information aesthetics | Form follows data - data visualization & visual
communication
http://infosthetics.com

instructables | The World's Biggest Show and Tell
www.instructables.com

Make | Technology on your time
www.makezine.com

NewScientistTech | Ultimate science and technology website
www.newscientisttech.com

Next Nature | Culturally emerged nature
www.nextnature.net

OPEN Loop.ph by Rachel Wingfield
http://open.loop.ph/bin/view/Openloop/WebHome

Physical Computing by Tom Igoe
http://tigoe.net/pcomp/index.shtml

Pop Wuping | Culture of mobility
www.popwuping.com

PSFK | Trends and Inspirations, Fashion
www.psfk.com/category/fashion

RHIZOME | Emerging artistic practices that engage technology
http://rhizome.org

SENSORY IMPACT | The culture of objects
www.sensoryimpact.com

SHINY SHINY | A girl's guide to gadgets
www.shinyshiny.tv

Showstudio by Nick Knight
www.showstudio.com

Sparkfun | Sharing ingenuity
www.sparkfun.com

Stylefuture | Cutting-edge fashion
www.stylefuture.com

talk2myShirt | Everything you want to know about Wearable Electronics
www.talk2myshirt.com/blog

Tech D.I.Y. | Mothers and kids make and learn together
http://techdiy.blogspot.com

Technology Review | Published by MIT
www.technologyreview.com

textually.org | All about texting, SMS and MMS
www.textually.org

The Raw Feed | Where technology and culture collide
www.therawfeed.com

Think Geek | Stuff for smart masses
www.thinkgeek.com

twenty1f | Fashion for the 21st century - where fashion meets technology
www.twenty1f.com

Wearables Central | Wearable Computing Links and News Archive
http://wearables.blu.org

We-make-money-not-art | Intersection between art, design and technology
www.we-make-money-not-art.com

WIRED | Daily technology news website
www.wired.com

Institutes

❙ Institutes

Acar2, Basel, Switzerland
www.acar2.org

ANAT, Reskin, Adelaide, Australia
www.anat.org.au/reskin

Carnegie Mellon, Pittsburgh, PA, USA
www.cmu.edu

Chalmers University of Technology, Gothenburg, Sweden
www.chalmers.se/en

Central Saint Martin, Innovation, London, UK
www.csm.arts.ac.uk/csm_new_knowledge.htm

Concordia University, Montreal, Canada
www.concordia.ca/clusters/textiles

Distance Lab, Scotland, UK
www.distancelab.org

ENSCI Les Ateliers, Paris, France
www.ensci.com

ETH Wearable Computing Lab, Zurich, Switzerland
www.wearable.ethz.ch

Eyebeam, New York, NY, USA
www.eyebeam.org

Fraunhofer-Gesellschaft, Munich, Germany
www.fraunhofer.de

Georgia Tech, Atlanta, GA, USA
www.gatech.edu

Goldsmiths, University of London, London, UK
www.goldsmiths.ac.uk

Hexagram Institute, Montreal, Canada
www.hexagram.org

Hyperwerk, Basel, Switzerland
http://hyperwerk.ch

IBM Wearable Lab, various locations around the world
www.research.ibm.com

Interactive Institute, Kista, Sweden
www.tii.se

Interactive Telecommunications Program, New York University, New York, NY, USA
www.itp.nyu.edu

London College of Fashion, London, UK
www.fashion.arts.ac.uk

Mediamatic, Amsterdam, Netherlands
www.mediamatic.net

MIT Media Lab, Cambridge, MA, USA
http://media.mit.edu

Napier University, Engineering, Computing & Creative Industries, Edinburgh, UK
www.napier.ac.uk/fecci/Pages/default.aspx

National University of Singapore, Singapore
www.nus.edu.sg

Newcastle University, Culture Lab, Newcastle, UK
www.ncl.ac.uk/culturelab/research/jwdoctoral.htm

Parsons The New School for Design, Communication, Design, Technology, New York, NY, USA
http://cdt.parsons.edu

Royal College of Art, Design Interactions, London, UK
www.interaction.rca.ac.uk

Stanford University, Paolo Alto, CA, USA
www.stanford.edu

Symbiotica, Perth, Australia
www.symbiotica.uwa.edu.au

TITV, Textile Research Institute, Thuringia-Vogtland, Germany
www.titv-greiz.de

University College of Borås, Textile Department, Borås, Sweden
www.hb.se/ths/english

University of Colorado, Computer Science, Boulder, CO, USA
www.cs.colorado.edu

University of Arts and Industrial Design, Interface Culture, Linz, Austria
www.interface.ufg.ac.at

University of Bremen, Bremen, Germany
www.uni-bremen.de

University of Toronto, Electrical and Computer Engineering, Toronto, Canada
www.ece.utoronto.ca

University of Wales, School of Art, Media and Design, Newport, UK
http://artschool.newport.ac.uk/welcome.html

University of Western Australia, Perth, Australia
www.uwa.edu.au

Virginia Tech, Blacksburg, VA, USA
www.ccm.ece.vt.edu/etextiles

Events

▌ Events

Ambience08, Smart Textiles, University College of Borås, Sweden
www.smarttextiles.se/Ambience08

Ars Electronica, Linz, Austria
www.aec.at

Avantex, Frankfurt am Main, Germany
http://avantex.messefrankfurt.com

CHI, alternating locations
www.CHI2008.org

Dorkbot, various locations worldwide
http://dorkbot.org

E-Culturefair, Amsterdam, The Netherlands
www.e-culturefair.nl

electronic-text textiles, Riga, Latvia
www.e-text-textiles.lv

Enter3, Prague, Czech Republic
http://enter3.org/index.php?lang=en&node=117

Extreme Textiles, New York, NY, USA
www.cooperhewitt.org/exhibitions/extreme_textiles/index.asp

Fleshing Out, Virtuell Platform, Amsterdam, The Netherlands
www.virtueelplatform.nl/article-3554-en.html

Futurotextiles, Lille, France
http://iis5.domicile.fr/lille2004/lille3000/sitev2_english/expositions.asp

Futurefashion, Pisa, Italy
www.cutecircuit.com/futurefashion

IFA – consumer electronics unlimited, Berlin, Germany
www1.messe-berlin.de/vip8_1/website/MesseBerlin/htdocs/www.ifa-berlin/en/About_IFA/index.html

International Symposium on Wearable Computers (ISWC), alternating locations
www.iswc.net

ISPO, Innovations, Munich, Germany
www.ispo-winter.com/en/Home/cn/vi/viin/innovations

Maker Faire, alternating locations
http://makerfaire.com

MobileHCI, alternating locations
www.MobileHCI2008.org

MUM, Mobile and Ubiquitous Multimedia, Oulu, Finland
www.mum2007.oulu.fi

Our Cyborg Future?, Newcastle, UK
www.dott07.com/go/cyborg

Pervasive, alternating locations
www.pervasive2008.org

Radical Lace and Subversive Knitting, Museum of Arts & Design, New York, NY, USA
www.madmuseum.org/site/c.drKLI1PIlqE/b.1506945/k.3AD7/Radical_Lace__Subversive_Knitting.htm

Reskin, WearNow Symposium, Canberra, Australia
www.anat.org.au/reskin

Sk-interfaces, Liverpool, UK
http://humanfutures.fact.co.uk

Seamless, Boston Museum of Science, Boston, MA, USA
http://seamless.sigtronica.org

Senseware, Tokyo Fiber 07, Tokyo, Japan
http://tokyofiber-jc.jp

Siggraph, alternating locations
www.siggraph.org

Smart and Intelligent Textiles, Nanotextiles, alternating locations
www.intertechpira.com

Social Fabrics, Dallas, TX, USA
www.socialfabrics.org

Textile Institute World Conference, alternating locations
www.texi.org

The Space Between, Perth, Australia
www.thespacebetween.org.au/exhibition.html

THREADS, Wearable Art Fashion Show, Jersey City, NJ, USA
www.jerseycitymuseum.org/calendar.cfm?calid=51

Ubicomp, alternating locations
http://ubicomp.org/ubicomp2008

▍Photo Credits

Numbers refer to pages on which illustrations appear
(a=above, b=below, c=center, l=left, r=right)

Electronic Fashion

28 – 31: Chris Moore, 32 – 33: Michel Laforest, 34l: Anne-Marie Durand-
Laflamme, 34r: Michel Laforest, 35: Dan Lecca, 36l: Dan Lecca, 36r: Lee
Clower, 37: Lee Clower, 38 – 42: CuteCircuit, 43 – 44: Kerri Wallace, 45
– 46: Elena Corchero, 47: Stefan Agamanolis, 48 – 49: Ricardo
Nascimento, 50 – 53: Peter Allen

Interactive Interfaces

56 –61: XS Labs, 62 – 63: Jordan Benwick & Suzi Webster, 64: Hesam
Khoshneviss, 65al: Barbara Layne, 65ar: Hesam Khoshneviss, 65bl:
Hesam Khoshneviss, 66: Sam Doroff, 67a: Doug Eng, 67b: Diana Eng,
68l: Evan Scheele, 68r: James Patten, 69: Ignasi Gamez, 70: Alphonse
Telemonde, 71l: Ivan Gasparini, 71r: Deepak Pakhare, 72 - 74: David
Clugston, 75a: IFM Design Studio, 75b: Maggie Orth, 76: Maggie Orth,
77: Anna Persson & Linda Worbin, 78 – 79: Linda Worbin

Scientific Couture

80 - 81: Oron Catts & Ionat Zurr, 82 - 83: Gary Cass, 84: Tobey Black &
Sharon Clusters, 85: Robert Firth, 86 - 87: Gene Kiegel, 88l: Adam
Parker, 88r: Fabrican Ltd, 89 – 91: Michael Venning & Nikki Stott & Tobie
Kerridge

Sensual Being and Tangible Touch

94: Tomek Sierek, 95l: Don Baxendale, 95r: Guy Hills, 96l: Guy Hills, 96r:
CTIA Wireless Convention, 97: Poppy Berry, 98l: Poppy Berry, 98r:
James Auger & Jimmy Loizeau 99: James Auger & Jimmy Loizeau, 100
– 101: Adidas, 102 – 103: Textronics, 104a: Yasmin Abbas, 104b: Cati
Vaucelle, 105l: Cati Vaucelle, 105r: Leonardo Bonanni, 106: Cati
Vaucelle, 107: Mika Satomi & Friedrich Kirschner, 108 – 109: Kai Eichen
& Marit Mihklepp & Hanna Tiidus

Wearable Explorations

136: Alex Reeder, Rory Nugent, Kyveli Vezani, 113 – 115: Nick James, 115l: Nick James, 115r: Ion Constas, 116l: Despina Papadopoulos, 116r: Ion Constas, 117l: Despina Papdopoulos & Ion Constas, 117r: Marcelo Krasilcic, 118 - 121: Leah Buchley, 122 – 123: Anu Akkanen, 124l: Laura Beloff, 124r: Anu Akkanen, 125l: Laura Beloff, 125r: Laura Beloff & Erich Berger & Martin Pichlmair, 126: Sai Sriskandarajah, 127l: Sai Sriskandarajah, 127ar: Kate Hartman, 127br: Mike Dory, 128a: Sai Sriskandarajah, 128lb: Kate Hartman, 128rb: Kate Hartman, 129: Younghui Kim, 130: Kate Kunath & Younghui Kim & Marc Vose, 131 - 133: Fiona Carswell, 134 – 137: Kouji Hikawa

Social Fabric

140 – 143: Philips Design, 144 – 147: Jayne Wallace, 148: J. Nordberg, 149: Mouna Andraos, 150: Daniel Korhov, 151a: Kate Kunath, 151b: Sergio Araya, 152: Teresa Almeida, 153l: Pietro Romani, 153r: Maria Mayer, 154: microRevolt, 155a: microRevolt, 155b: Carrie Dashow. 156: Ebru Kurbak & Mahir M. Yavuz, 157: Fabienne Blanc & Patrick Rüegg

Sonic Landscape

160 - 161: Maurin Donneaud, 162: Magdalena Kohler & Hanna Wiesener, 163– 165: Burton, 166 – 167: Nike, 168 –169: Fibretronic, 170l: Fibretronic, 170r: Levis Strauss & Co, 171 –173: O'Neill

Material Witness

176 – 179: Alyce Santoro, 178 – 180: Marcelo Coelho, 181 – 182: Jackson Tan, 183l: Raimo Lielbriedis, 183r: Zane Berzina, 184: Zane Berzina, 185 – 188: Grado Zero Espace, 189 – 190: Voltaic, 191: Ivo Locher, 192: WarmX, 193 – 195: Elisabeth de Seineville

▌Acknowledgements

Thanks to

Andrew Chetty	Katherine Moriwaki
Angela Fössl	Olga Okunev
Sonja Hammerschmid	Sabine Pümpel
Manfred Lechner	Melinda Rackham
Suzanne Lee	Josh Rubin
Alison Lewis	Alexander Sadezky
Colleen Macklin	Christa Sommerer
Amanda McDonald Crowley	Sven Travis

All contributors for their submissions and valuable comments.

And all those who made this book possible in particular:

interfaceculture

Kunstuniversität Linz,
Interface Culture

PARSONS THE NEW SCHOOL FOR DESIGN

Parsons The New School For Design,
Communication, Design & Technology

ImpulsProgramm creativwirtschaft by austria wirtschaftsservice is the first
nationwide initiative to promote the creative industries of Austria. Its aim is
to recognize creative industries as an important economic asset. Through
tailored funding, economic education and public awareness campaigns
SMEs, in the creative sector, are assured of getting the support that they
deserve.

I Biography

Sabine Seymour is an innovator and trend spotter who is focused on next generation 'wearables' and the intersection between aesthetics and function. She is the CEO and Chief Creative Officer of Moondial, which develops fashionable wearables and consults on fashionable technology to companies worldwide. She is a faculty member at Parsons The New School For Design in New York and the University of Arts and Industrial Design in Linz, Austria. Sabine curates, exhibits and lectures internationally and has been published worldwide.